omegawatches.com

T0088749

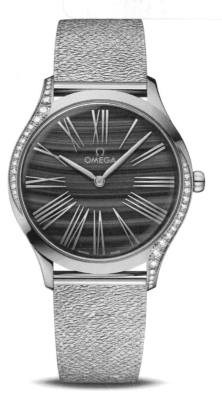

TRÉSOR COLLECTION

KAIA GERBER'S CHOICE

Surrounded by fashion from a very young age, Kaia Gerber is no stranger to the modelling world. While following her famous mother onto the most exclusive runways and photoshoots, she is now choosing to walk a unique path, bringing her own sense of style and personality to the role. It's a family passion, with a very bright future.

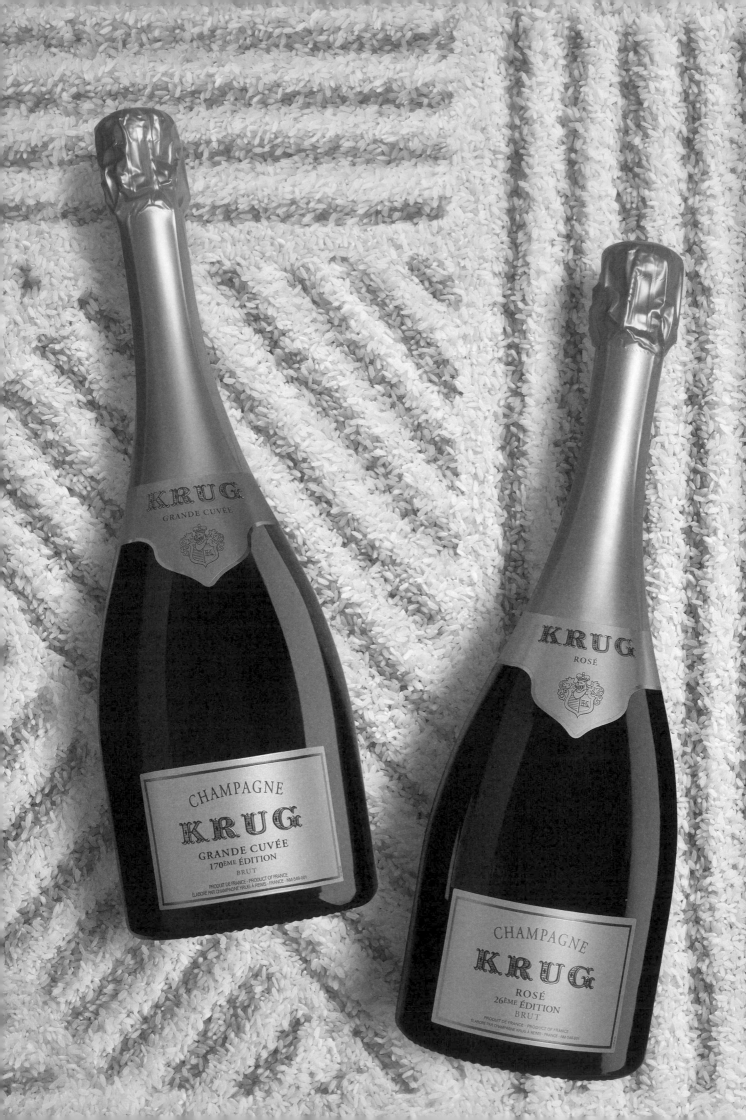

One plot, one wine, one ingredient.

A cornerstone of Krug's savoir-faire, individuality is the art of understanding that every plot of vines gives birth to a unique wine, itself a single ingredient in Krug Champagnes.

As a tribute to our craftsmanship, each year the House of Krug invites chefs around the world on a culinary journey around a single ingredient and the many pleasures it can reveal when paired with a glass of Krug Grande Cuvée or Krug Rosé.

This year, we celebrate Rice.

CHAMPAGNE

Krug Champagne ©2022, Imported by Moët Hennessy USA, Inc., New York, NY. Please drink responsibly.

DISCOVER OUR COLLECTION

AUSTRALIA DUBAI MALAYSIA MALDIVES MAURITIUS
MEXICO MONTENEGRO RWANDA SOUTH AFRICA

oneandonlyresorts.com

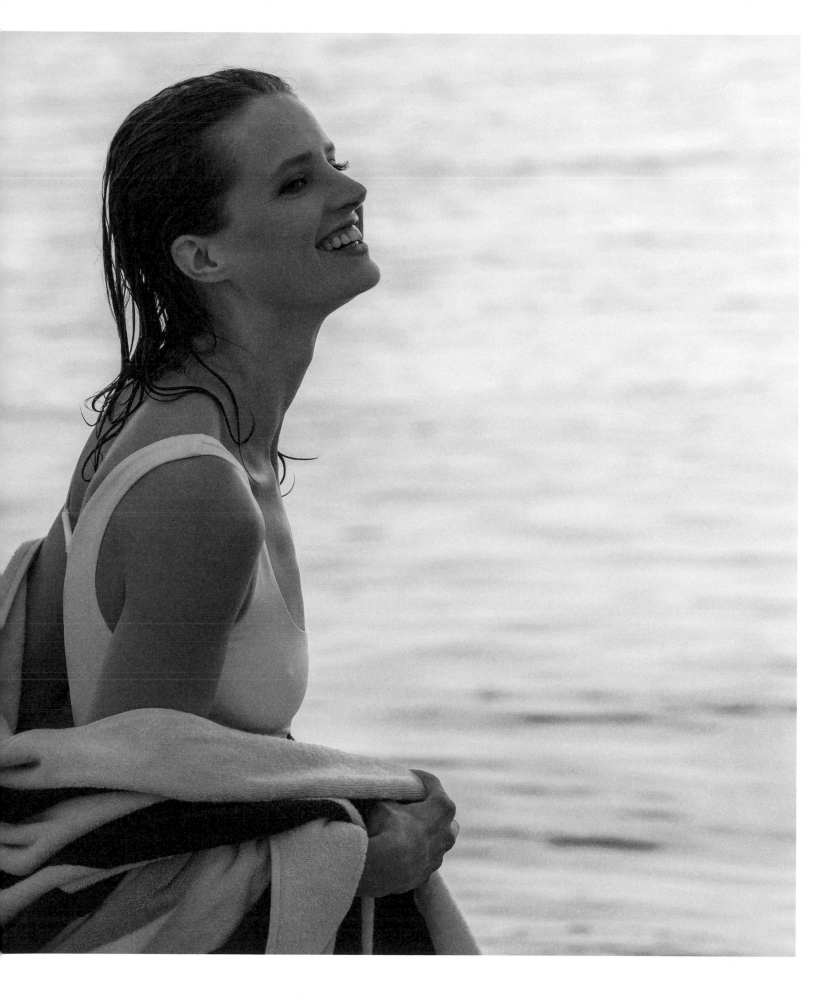

One&Only

RESORTS & PRIVATE HOMES

Handcraft meets high technology. Made in Berlin.

MYKITA

Visit one of our MYKITA Shops in Bangkok, Barcelona, Berlin, Hamburg, Los Angeles, Mexico City, Munich, New York, Osaka, Paris, Taipei, Tokyo, Washington, and Zurich or shop online at mykita.com

Grass

KINFOLK

MAGAZINE
—

EDITOR IN CHIEF	John Burns
EDITOR	Harriet Fitch Little
ART DIRECTOR	Christian Møller Andersen
DESIGN DIRECTOR	Alex Hunting
COPY EDITOR	Rachel Holzman
DESIGN ASSISTANT	Abbie Lilley

STUDIO
—

PUBLISHING DIRECTOR	Edward Mannering
STUDIO & PROJECT MANAGER	Susanne Buch Petersen
DESIGNER & ART DIRECTOR	Staffan Sundström
DIGITAL MANAGER	Cecilie Jegsen

—

CROSSWORD	Mark Halpin
PUBLICATION DESIGN	Alex Hunting Studio
COVER PHOTOGRAPH	Paul Rousteau

The views expressed in *Kinfolk* magazine are those of the respective contributors and are not necessarily shared by the company or its staff. *Kinfolk* (ISSN 2596-6154) is published quarterly by Ouur ApS, Amagertorv 14, 1, 1160 Copenhagen, Denmark. Printed by Park Communications Ltd in London, United Kingdom. Color reproduction by Park Communications Ltd in London, United Kingdom. All rights reserved. No part of this publication may be reproduced, distributed or transmitted in any form or by any means, including photocopying or other electronic or mechanical methods, without prior written permission of the editor in chief, except in the case of brief quotations embodied in critical reviews and certain other noncommercial uses permitted by copyright law. The US annual subscription price is $75 USD. Airfreight and mailing in the USA by WN Shipping USA, 156-15, 146th Avenue, 2nd Floor, Jamaica, NY 11434, USA. Application to mail at periodicals postage prices is pending at Jamaica NY 11431. US Postmaster: Send address changes to *Kinfolk*, WN Shipping USA, 156-15, 146th Avenue, 2nd Floor, Jamaica, NY 11434, USA. Subscription records are maintained at Ouur ApS, Amagertorv 14, 1, 1160 Copenhagen, Denmark. SUBSCRIBE: *Kinfolk* is published four times a year. To subscribe, visit kinfolk.com/subscribe or email us at info@kinfolk.com. CONTACT US: If you have questions or comments, please write to us at info@kinfolk.com. For advertising and partnership inquiries, get in touch at advertising@kinfolk.com.

WORDS
—

Precious Adesina
Allyssia Alleyne
Alex Anderson
Katie Calautti
Ed Cumming
Stephanie d'Arc Taylor
Daphnée Denis
Bella Gladman
Anissa Helou
Robert Ito
Rosalind Jana
Tal Janner-Klausner
Tara Joshi
Lyra Kilston
Nathan Ma
Kyla Marshell
Emilie Murphy
Okechukwu Nzelu
Hettie O'Brien
John Ovans
Sala Elise Patterson
Shiromi Pinto
Caitlin Quinlan
Debika Ray
Asher Ross
Kabelo Sandile Motsoeneng
George Upton
Korsha Wilson

STYLING, SET DESIGN, HAIR & MAKEUP
—

Rebecca Alexander
Michelle Elie
Ludivine François
Helena Henrion
Marie Labarre
Jèss Monterde
Giulia Querenghi
Taii Schmoll
Ben Skervin
Stephanie Stamatis
Sandy Suffield

ARTWORK & PHOTOGRAPHY
—

Lauren Bamford
Mary Ellen Bartley
Natalia Evelyn Bencicova
Denis Boulze
Luc Braquet
Justin Chung
Cayce Clifford
Asaf Einy
Sarah Espeute
Lasse Fløde
Jan Groover
Marsý Hild Þórsdóttir
Alixe Lay
David Levene
Zhong Lin
Salva López
Nik Mirus
Christian Møller Andersen
Abelardo Morell
Ryan Mrozowski
Charles Negre
Clément Pascal
Paul Rousteau
Marcus Schäfer
David Selander
Yana Sheptovetskaya
Mária Švarbová
Aaron Tilley
Emma Trim
Dennis Weber
Xiaopeng Yuan

PUBLISHER
—

Chul-Joon Park

VIPP

V1 Kitchen

The chef's home office

Our modular kitchen is built to be used.
Nothing but stainless steel, powder-coated
endurance and a workstation made for
the most demanding guests.

VIPP.COM

WELCOME
The Weather Issue

Be it the subject of awkward small talk in the office or the call to arms at an international summit, the weather is a topic of perennial interest and importance: It's both daily life and global crisis, and this issue of *Kinfolk* takes readings that span the full barometer.

In a special section starting on page 114, we meet two weather-obsessed individuals trying, in their different ways, to help us better understand climate systems. In London, Hettie O'Brien meets physicist Friederike Otto, who calls for a "new way of doing climate science" by equipping people with the facts about extreme weather events as quickly as possible. And in Israel, Tal Janner-Klausner meets Jerusalem's favorite weatherman, Boaz Nechemia, who, having spent his childhood measuring rainfall in cups, now provides his snow-mad city with accurate and amusing forecasts. "There's a gap between what you hear on the radio and the television and what a person experiences," he explains. "People want accuracy about the sensation."

Our talented contributors have brought a year's worth of wild weather to these pages: Chef Anissa Helou fuses Lebanese and Indonesian cuisine into one comfort food menu that's perfect for stormy weather; set designer Sandy Suffield and photographer Aaron Tilley seed miniature clouds to pay homage to the works of artist René Magritte; and writer Caitlin Quinlan explores how Hollywood blows us away with wild weather narratives. Our fashion editorials offer inspiration for summer style come rain or shine: In Drip Drop, photographer Paul Rousteau brings rainwear—and the rain—into a Parisian studio; and in Under the Sun, *Kinfolk* art director Christian Møller Andersen charts the transformative pleasure of a long, hot day on the Italian island of Alicudi.

Elsewhere in the issue, we celebrate the private passions of accomplished creatives: architect Giancarlo Valle's infatuation with dollhouse-sized models; Norwegian pop star Sigrid's obsession with *The Sims*; fashion editor Michelle Elie's lifelong love affair with outfits so extravagant she needs an assistant to act as her hands during fashion week. "The minute you put on a piece of clothing, you are already telling [a story about] yourself," she says.

We hope that these profiles and the issue as a whole fuels your own creative passions, and perhaps introduces you to a few new ones.

WORDS
JOHN BURNS
HARRIET FITCH LITTLE

CESAR

Photo Andrea Ferrari | Styling Studiopepe | Ad Garcia Cumini

Portraits of me.

Kitchen: **Unit**
Design: **García Cumini**

Milano • New York • Paris

cesar.it

CONTENTS

"Ask for as much advice as possible." (Hannah Traore – P. 61)

B&B ITALIA

design Mario Bellini - bebitalia.com

camaleonda
dieci, cento modi di vivere

THE WEATHER
A breezy guide to the atmosphere.

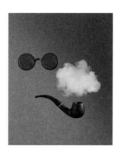

DIRECTORY
Columns, a crossword and credits.

Photograph: Paul Rousteau

HOUSE OF
FINN JUHL

finnjuhl.com

Part 1.
STARTERS
Slow TV, Norwegian pop and West African food.
20 — 50

HERE COMES THE SUN
A spotlight on the summer solstice.

In far northern latitudes, hope arrives on December 21. The next night will be one merciful second shorter; a week later, night has relinquished a minute and a half to day. For ancient people, the struggle to survive until spring must have seemed just a little easier as the sun offered more of its feeble warmth each day after the winter solstice. But how to know when to start hoping, when to celebrate that momentous shift?

About 7,000 years ago, people began building wood and stone circles to mark out the sun's path, from its extreme northern rise in summer to its farthest southern set in winter. Cattle herders built the earliest known example of these at Nabta Playa, a dry lake bed deep in the Sahara. Over the next 2,000 years, people all over the world assembled hundreds of similar structures. The most monumental of these, Stonehenge in England, was an intricate astronomical instrument that recorded the complex movements of the sun and moon, but most boldly dramatized the sunset at winter solstice.[1] Pilgrims approaching the immense sandstone circle saw it as a huge, dark wall—broken only by a bright, vertical slit passing through its center. The low sun slid down this narrow opening, throwing a shaft of orange light toward the assembly watching from an upright marker in the center of the avenue—the Heel Stone.

Being built on gently sloping ground, Stonehenge not only marked that crucial sunset, but also gave people the ability to arrest and prolong it. As archaeologist Lionel Sims explains: "When approaching the monument from the Heel Stone, walking at a sedate pace at winter solstice sunset, the artifice is created of holding the setting sun still, the upward movement of the walker's eye exactly counterbalancing the sinking motion of the sun." That fleeting power to channel and control the sun, to delay the onset of the year's longest night must have been intoxicating.

Over the millennia, people around the world have exercised this godlike ability through architecture. On the summer solstice, priests at Teotihuacán, Mexico, acknowledged the setting sun from on top of the city's Pyramid of the Sun. As they gazed toward the horizon over the Avenue of the Dead, the last rays reflecting off their dress of feathers and gold made them like deities to the shadowed throng below. At Angkor Wat, in Cambodia, the omnipotent Khmer emperor standing at the summit of his temple palace—a model of mythical Mount Meru—turned to watch over his vast domain as the solstice sun rose or set through the four corners of his moated gardens. And on Fajada Butte in New Mexico, the ancient Pueblo people assembled a structure that drove a hot, shimmering dagger of light— shaped from the noontime sun on the summer solstice—through a spiral carved in its red sandstone cliff face. The spiral also marked out the inexorable progression of the sun as the seasons advanced toward winter and back again to summer.

Visitors to these ancient sites can still watch the same celestial events, detect their slow, steady rhythms and feel shades of the human-gods who framed the cycles of the sun.

(1) At the summer solstice, druids, pagans and old-fashioned hippies descend on Stonehenge by the thousands. The gathering was banned in 2020, due to the pandemic, but around one hundred revelers managed to break in. Organizers stopped a livestream video shortly after their arrival.

WORDS
ALEX ANDERSON
PHOTO
DENNIS HALLINAN

Photo: Getty Images

STAGE FRIGHTS
The logic of theater superstitions.

A few words of advice: If you ever find yourself backstage at a theater or attending a rehearsal, make sure not to whistle and, if you're the last one to leave, don't switch all the lights off. If the play happens to be Shakespeare's *Macbeth,* remember to only refer to it as "the Scottish play"—the success of the production could depend on it.

Some of these superstitions originally made perfect sense. The first stagehands were thought to be sailors, hired for their knowledge of knots and ropes. As they did on a ship, the sailors would use coded whistles to communicate and—though many now believe such stories to be apocryphal—a careless whistle could cause chaos with the scene changes. Similarly, the single "ghost light" that is always left on somewhere in a theater, supposedly to appease resident spirits, also helps prevent anyone stumbling over the backstage clutter of sets, costumes and props.

Other superstitions are less easily understood. The paranoia around *Macbeth,* for example, has been explained variously as a conviction that the witches' spells are real or a belief that the play itself is cursed. Yet the question of whether the actors actually set store by these superstitions is arguably beside the point. They are part and parcel of the long tradition—and drama—of being an actor, fostering a sense of camaraderie within a theater or company.[1] And in any case, if you were preparing to perform in front of a live audience—with all the thrilling potential for something to go catastrophically wrong—then you too might find yourself looking for a little extra luck. Just in case, of course.

(1) Whereas actors use "break a leg" to mean good luck, circus performers say *merde*, which means "shit" in French. One theory is that the presence of excrement from carriage horses was once thought to suggest a large audience.

WORDS
GEORGE UPTON
ARTWORK
RYAN MROZOWSKI

GO TO HELL
Devil's advocate, be gone.

WORDS
OKECHUKWU NZELU
PHOTO
CHARLES NEGRE

Picture the scene. You're in the zone, having a discussion you feel strongly about. Perhaps it's your position on climate change, or your (justified) preference for dogs over cats. You deliver a passionate, beautifully constructed argument. And then you hear it: "Okay, but just playing devil's advocate here...."

Of all the ways people use rhetoric, the position of devil's advocate must be among the most frustrating. It is a title assumed by those who want to advance an argument they are unwilling to endorse outright. In theory, this can be a good thing: Our position in a debate should be decided by facts, rather than the reverse. Thus, someone with little or no personal investment in their own argument may be able to provide valuable insight.

And, indeed, the term has laudable origins. It began as an office within the Catholic Church in the 16th century, when Pope Sixtus V formally established the role of *Advocatus Diaboli*—a person whose job it was to scrutinize the track record of candidates for beatification or canonization. The church needed someone to present possible opposition to its intentions, ensuring a thorough examination of the facts.

The problem with this sort of contrarianism in day-to-day conversation is that debate is partly about engagement with another human being: Whatever your position, it's never as satisfying when your opponent's heart isn't really in it. Moreover, playing devil's advocate allows frivolous, facile arguments to square up to earnest, carefully constructed ones. Claiming to be "just the devil's advocate" grants people leave to ignore the normal responsibilities of reasonable debate, allowing them to present anomalies as trends, to introduce unverified assertions and to obscure exactly the kind of nuance they claim to provide.

The broader aim of debate is to find truth. From there, those in power might make policy or legislation, but most people just want to know what's what. It's easier to get there if we agree to mean what we say, stick to the facts and let the chips fall where they may.

PIERRE THIAM

WORDS
KORSHA WILSON
PHOTO
CAYCE CLIFFORD

From West Africa to the world.

Pierre Thiam, the chef behind Harlem's Teranga, Nok in Lagos and Pullman in Dakar, is America's foremost expert on West African cuisine and an advocate for the ingredients, dishes and people of West Africa. It's quite the contradiction that Thiam has dedicated much of his life and work to introducing West African cuisine to Americans, when so much of it shows up in their life already. Maybe it would be more accurate to say that Chef Thiam works to reframe Americans' understanding of a cuisine that is inextricably linked to their country. "Talking about that connection between Africa and America is a way to honor and credit our ancestors," he says.

KORSHA WILSON: Your work is driven by a core mission to promote West Africa on a global stage. How did that come about?

PIERRE THIAM: When I was a young cook in New York City at a fine dining restaurant, New York was called the "food capital of the world," but Africa wasn't being represented. When I wanted "my" food, I went to Caribbean or Southern restaurants. I grew up in a wonderful food culture in Senegal and I wanted to bring the cuisines of my origin to the conversation. I started making Senegalese food for my coworkers and thought this food would be a good way to tell the story of how West African food changed in different environments like America and the Caribbean. That realization kept me growing. It was bigger than me and I became more than a cook. The plate was telling a story. It's a medium that transcends borders and time. You see our contributions in a vivid way that you can smell and taste. Your senses are a part of it.

KW: And now you've owned restaurants, written books and traveled the world telling that story.

PT: I didn't have a plan. I felt that need—a craving for my food—and I knew my fellow immigrants were probably craving it too. But I also thought that people who are curious about this part of the world must want to try it. I started a catering business and I opened a restaurant in the early 2000s in Bed-Stuy, Brooklyn. When I was writing *Senegal* [Thiam's 2015 cookbook], I had to think of substitutions for ingredients because my audience was in the US, but I wanted to stay true to those flavors. It was very well received and I thought about how I could bring these ingredients to more people.

KW: The food world is really interested in West Africa right now, yet the influence of this region has been here for hundreds of years. How do you think about that in your work?

PT: I'm really just establishing facts that are easy to document and find. You see Southern dishes being appropriated and credited to white cooks and this is my way of having that conversation, it's just on the plate. Oftentimes in this country we're uncomfortable with the conversation of how West Africa and America are linked, but food is a really great way to make it easy to digest. No pun intended.

KW: Your packaged goods company, Yolélé, was started in 2017 and feels like it's pushing that mission forward.

PT: *Yolélé* is a Fulani word. I'm part Fulani and I wanted to call it that after the nomadic group. Our ancestors transcended borders with their food. There's a deep well of thousands and thousands of recipes and I can put the food on a plate so we don't forget them or the people that worked so hard to create them. It really started with wanting grains like fonio to be available to me in the US and wanting to create economic opportunity. Yolélé is now available in the US and will be available in Europe and Africa soon. It's time that the rest of the world finds it.

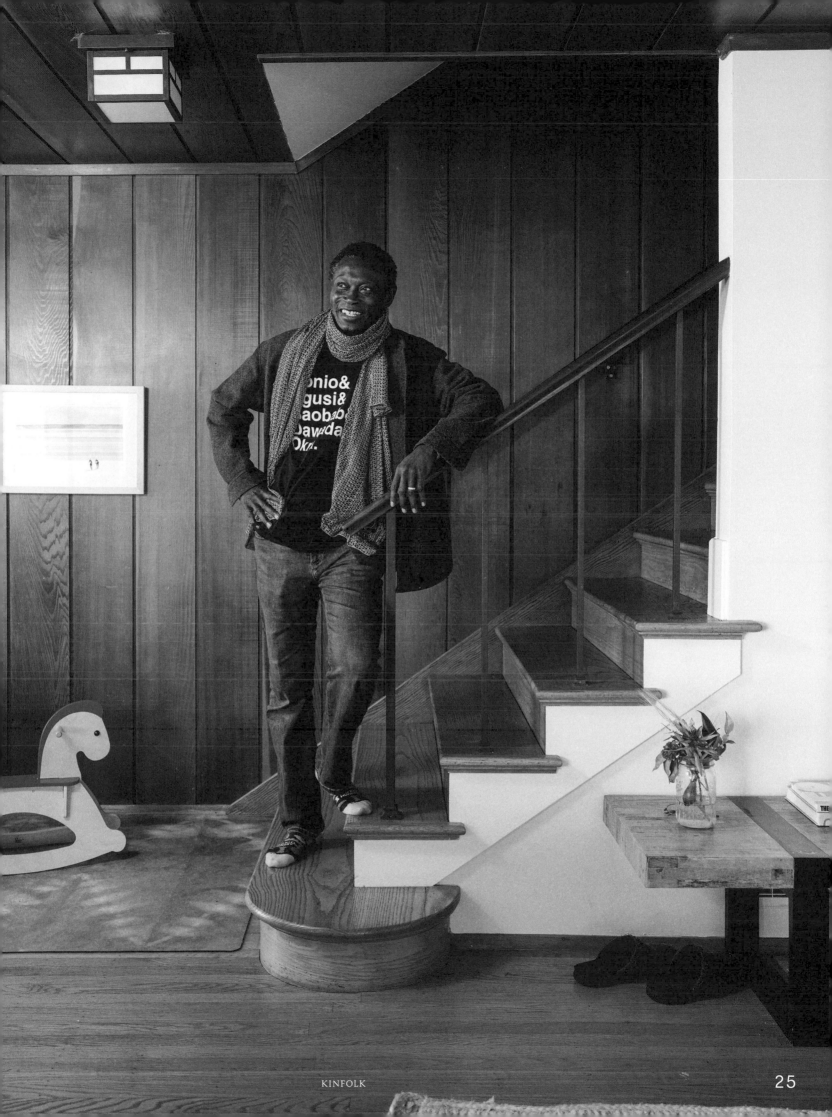

GROSS PROFIT
The hidden help of disgusting things.

Model: Lu Xia. Photo Assistant: Yuanling Wang

There's a scene in Pixar's *Inside Out* (2015) that gives a physical form to disgust. Throughout the movie, a young girl's emotions are shown as characters inside her brain. At one point her father attempts to feed her broccoli, which the character of Disgust deems dangerous, instructing the girl's brain to get rid of it. The young girl flicks the food away. "Well, I just saved our lives. You're welcome," Disgust gloats.

Disgust (the real life emotion) is a feeling of revulsion or disapproval triggered by something unpleasant.[1] Throughout history, the feeling has been associated with perceived danger—whether it's safe to eat a moldy piece of meat, for example. In late 2021, *The New York Times* ran a longform on the topic with the grand but perhaps not totally misplaced title "How Disgust Explains Everything." "[It is] a piece of evolutionary hardware designed to protect our stomachs that expanded into a system for protecting our souls," wrote author Molly Young. "[It] shapes our behavior, our technology, our relationships. It is the reason we wear deodorant, use the bathroom in private and wield forks instead of eating with our bare hands."

Young is particularly interested in the work of the academic Paul Rozin, who started studying the subject in the 1980s, looking first at disgust as a response to food, then as an unwanted reminder that we are animals (in terms of excretion, blood, sex and death, for example) and eventually as a social response. "Liberals say that conservatives are disgusting. Conservatives say that welfare cheaters are disgusting," one of Rozin's students, Jonathan Haidt, wrote in a co-authored paper with Rozin and two others in 1997.

But a recent study claims that disgust—especially when associated with germs—can be overcome. Researchers at Concordia University in Canada and the University of New South Wales in Australia looked into whether they could train a group of people with "high levels of concern about contamination" to engage in two disgusting tasks: touching a dead cockroach and drinking out of an unused urine sample container. Their findings showed that participants who read a text that encouraged them to consider the feeling of disgust as normal, harmless and temporary alongside thoughts such as "I can deal with disgusting things" had lower levels of disgust afterward. Participants who read how unlikely it is that their fears would come to fruition also felt less disgusted. "There has actually been a study conducted where a cockroach and a human finger touched the same dirty kitchen floor … the human finger produced several times the amount of bacteria the cockroach did," one of the texts read.

One thing all the research on the topic shows is that disgust isn't an emotion we need to get rid of, but it's also worth reminding ourselves that most of the outcomes and concerns that we imagine as a result of it are unlikely to happen.

(1) Disgust is conveyed by a wrinkled nose and brow, and—in extremis—an open mouth and stuck-out tongue. It is not a coincidence that these are the same facial movements that precede vomiting.

WORDS
PRECIOUS ADESINA
PHOTO
ZHONG LIN

SIGRID

WORDS
TARA JOSHI
PHOTOS
LASSE FLØDE

Scandipop's fresh face on stagecraft and *The Sims*.

At 25 years old, Sigrid Raabe is already a Scandipop stalwart. The Norwegian singer-songwriter, who goes by her first name, makes buoyant songs with lyrics that bite back at the fickle pop machine. Take her first international single, 2017's "Don't Kill My Vibe," which was a takedown of a songwriting session where collaborators had undermined her, or her 2022 collaboration with rising British star Griff, "Head On Fire," which explores their experiences as young women in the music industry.

Despite being a bold presence behind the mic and onstage, Raabe is often painted as being shy and reserved in person. When we talk in early spring, ahead of the release of her second album, she says that these expectations are something she's still grappling with.

TARA JOSHI: I read that, when touring stopped during lockdown, you struggled with separating your self-esteem from your job. What's your relationship with work like now?

SIGRID RAABE: It takes a massive toll on your self-confidence that you're not able to do the thing you feel like is *your thing*. There's a lot of things in my life that I'm not good at, but being onstage and being on tour? I feel good at it. Other times, my profession is quite vain and self-absorbed, but at least with touring we can create a nice moment together with everyone who's in the audience. When that was taken away . . . yeah, it comes to a point where you lose motivation.

TJ: How would your loved ones describe you, beyond your profession?

SR: They would just say I'm a massive noob! I think my whole family is still in shock that I'm an artist. My parents were quite worried about me in my childhood because I was so introverted that I think they were a bit like, "How's she gonna make it in the big world outside her hometown?"

TJ: Were you a musical child?

SR: I did piano for 10 years. I kind of tricked my piano teacher into thinking I could read notes, but I was basically just watching and copying. So in the end, when it started to get a bit more difficult he was like, "You can't really read notes, can you?" He was so cool though. And then I did dancing for 10 years, which was really fun, and theater. I was a proper music-dance-drama kid!

TJ: Do you still play *The Sims*?

SR: Oh, my God! Do you play *Sims*?

TJ: Yes.

SR: This is so nice! A fellow *Sims* player! Yeah, I still play. My whole childhood, my older sister, Johanne, and I were obsessed. Then I stopped playing for a few years, but when you're touring you've got a lot of time off while you're traveling, and so I started playing again. It got to a point where it was slightly creepy—where I just loved playing normal life on *Sims*. I think everything around me was so abnormal with constant flights and all, so I wanted to play *Sims* where it was like, they had a cat, they would go to work, get home, cook dinner, go to bed. Doing a song in Simlish for the *Sims* soundtrack was definitely a career highlight. My sister and I talk about it the same way some people talk about playing Glastonbury.

TJ: You were talking about being a shy child. To what extent does that carry through to how you perform onstage?

SR: I'm still that shy kid. Oh, that sounds like such a cliché! I think it's been confusing for me and the people around me that I can be so energetic and almost cocky onstage—I can run around and be like, "Ha ha ha, I don't care!" But then as soon as I'm offstage I have to sit alone in my hotel room and watch Netflix. That balance is something I'm talking about on my new record. It's about slowly growing up, about letting go of things, overthinking and how much risk you're willing to take in your

Raabe grew up in the small port town of Alesund, Norway. She recorded her first song at Ocean Sound Recording—a small studio surrounded by sea and mountains—in order to avoid spending too much time away from her family given the demands already imposed by touring.

life. There's my life in Norway, which is very safe, cozy and chill because I've made it that way—it's my proper home base. I just cook and I watch my favorite TV shows. I hang out with my close friends and family and boyfriend. And then my life in LA, London and New York is the complete opposite. My single "It Gets Dark" is about that balance between those two lives and how you feel like there's a piece of you missing no matter where you are.

TJ: To what extent do you identify with Scandipop as a label for your work?

SR: It's very relevant to my work. There's so much good music coming out of Scandinavia. I love the way people sing here— there's a lot of slightly haunting voices that feel a bit mysterious and magical: Lykke Li, even Robyn. In Norway the metal scene is massive, so I wonder if, because the music community in Norway is small and we all kind of know each other, maybe the genres blend into each other more here, and give us interesting pop music. Sometimes I think it works because, when English is your second language, you hear the melodies before you hear the lyrics, which makes us very melody-oriented. I think the dramatic scenery and weather of Norway must have translated into my music—I do love dramatic choruses and everything being a bit intense.

TJ: You've been subjected to a lot of commentary on your aesthetic choices, questioning the "authenticity" of your casual image. Has it gotten easier to ignore the longer you've been doing this?

SR: I wish I could say that, but no. I think I've been pretty lucky with the media overall, and I know people questioning if how I dress is marketing is probably minor in the bigger picture, but it felt quite invasive, being told who you are and how you are. But I just thought, *Fuck it, I know this is how I dress; I can wear what I want.*

TJ: I think you sound freer on the new music.

SR: It's interesting you think it sounds more open and free, because the process of writing was so different. We had to do things in a more secluded way: Most of the record was made in Copenhagen with a writer and producer—Caroline Ailin and Sly, plus Emily Warren came and wrote a couple of songs with us. But most of it was three of us in a studio, going swimming between writing sessions. I didn't have any promo to do or any traveling. So I was very in the moment for the first time in a long time. It was a completely different way of writing to doing an odd day here or there, and I feel like that made the music breathe a bit more.

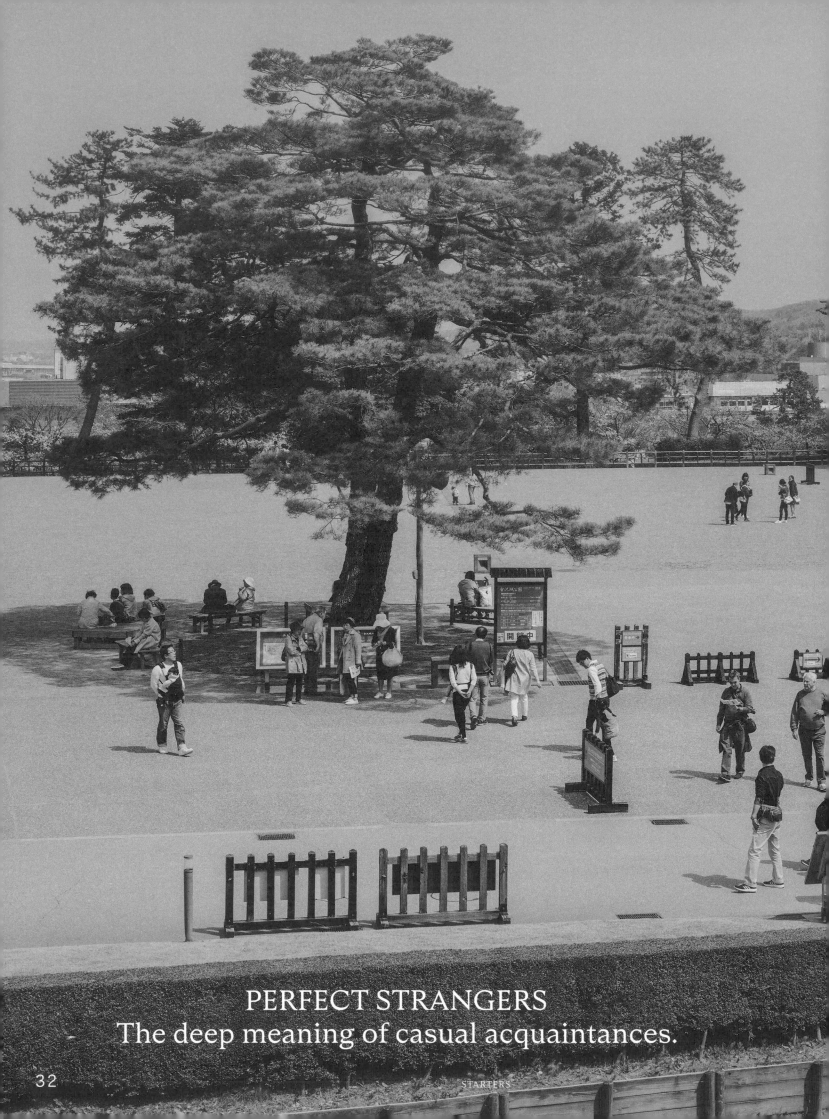

PERFECT STRANGERS
The deep meaning of casual acquaintances.

WORDS
ALEX ANDERSON
PHOTO
SALVA LÓPEZ

The barista cheerfully remembers your regular order and has it started before you've said hello. Warmed inwardly, cup in hand, you step onto the sidewalk, and a passerby—the older woman who walks her sweet terrier every morning—greets you with a familiar smile. These are not friends, exactly, but people you are pleased to run into because they confer a sense of belonging. They are a part of your community, and you are a part of theirs. *New York Times* columnist Jane E. Brody refers to them as "consequential strangers" with whom we form convivial relationships through cordial gestures and brief, affable conversations.

Repeated, casual encounters of these sorts etch a network of relations formed of "weak ties"—a phrase sociologist Mark Gra novetter introduced in 1973 to contrast with stronger family and friendship connections. He points out that these passing interactions do far more than brighten daily routines. They are also "vital for an individual's integration into modern society," because they help us participate in broader flows of ideas than we would otherwise. Occasionally, the brief conversation with a friend of a friend results in a book recommendation, mention of a new café opening across town, or an invitation to come together in some shared pursuit.

Communications expert Malcolm R. Parks explains that because we usually form strong social ties with people who share our viewpoints—family members, classmates and coworkers—we "tend to reinforce and recycle information that we already know." Weak ties, in contrast, establish bridges for information exchange between these tighter social groups, and thereby, he says, "contribute to large-scale social cohesion." Being a regular at a coffee shop or chatting with an acquaintance on the street adds more than a smile to the day; it helps build an agreeable community of mutual interest and neighborly support.

33

34

WARDROBE MALFUNCTION
Why does the fashion in films so often disappoint?

WORDS
ROSALIND JANA
PHOTO
MÁRIA ŠVARBOVÁ

Paul Thomas Anderson's *Phantom Thread* (2017) is a film about a man obsessed with dressmaking. At one point, dissatisfied with a lace and zibeline silk gown made for a royal wedding, Reynolds Woodcock takes a step back, mutters "It's just not very good, is it?" and then collapses.

Strangely, for a film all about fashion, the same question could be leveled at many of the clothes we see on screen. The gowns that Woodcock brings into being are often more dowdy than dreamlike. This caused some confusion when the movie was first released. Was it intentional—a reflection of the somber sartorial mood in London in the 1950s—or was it just that the costume designer didn't hit the mark?

The costuming of films and TV shows that adopt fashion as their subject can be fraught. Take the more recent (and much lighter) example of *Emily in Paris*, a show that has been hate-watched for its star Lily Collins' outfits as much as for its clichés about the City of Love.[1] All zany colors and checkerboard bucket hats, Collins' wardrobe choices clash violently with their chic surroundings. More than that, they set people's teeth on edge. After all, she's not meant to be a bad dresser, is she?

Nick Rees-Roberts, professor of media, culture and communications at the Sorbonne Nouvelle University and author of *Fashion Film: Art and Advertising in the Digital Age*, thinks there are several different things at play when it comes to our expectations of fashion films. In the case of a designer biopic, or even a fictive imagining of a historic couture house as with *Phantom Thread*, we care more about accuracy and creative process. But when it comes to other genres, clothes are important because they speak to the character and the particular, sometimes exaggerated, world they inhabit. If it's a send-up like *Zoolander* or *Ready to Wear (Prêt-à-Porter)*, he explains, you're already in a realm of "very caricatured or clichéd sorts of ideas about what goes on behind the scenes." With something like *Emily in Paris*, "it's not realism, it's rom-com. . . . The point is to use costume in an almost cartoony way." In other words, perhaps Emily's terrible fashion works because she's meant to stick out.

The popularity of particular brands and fashion references wax and wane. Some have stood the test of time, while others have become relics of bygone ages where bodycon and big belts ruled. With this in mind, it is easy to feel sympathetic to the costume designer's dilemma: If they aim to speak to current trends and moods, they will inevitably fall in and out of fashion favor. Sometimes, if there's a lag between production and release, this could mean that certain details seem oddly dated even by the time it's broadcast.

This might be why so many films we now see as style classics—*In the Mood for Love*, say, or *A Bigger Splash*—aren't fashion films so much as films that happen to involve really good clothes. They're not burdened with the need for spectacle and are less likely to underwhelm, because they didn't promise too much in the first place.

(1) Costume designer Patricia Field, who worked on *Emily in Paris*, is responsible for a whole parade of fashion shows including *Confessions of a Shopaholic*, *The Devil Wears Prada*, *Ugly Betty* and *Sex and the City*. Her trademark style is colorful and unabashedly OTT, buttressed by designer brands and pop culture references.

When I was younger I adopted, with my mom's help, a golden lion tamarin at London Zoo. I don't remember the details, but the cost wasn't ruinous to us. In exchange, I got the satisfaction of knowing that a little ginger monkey in Regent's Park slept more comfortably at night.

It was a strange gesture, in hindsight. There is no way our puny contribution paid for the whole upkeep of this monkey. Not with central London prices. Still, at least it was a gesture in the right direction. Like sponsoring a donkey or "buying" a bit of rainforest or a stretch of sea, those who give a small contribution to the tamarins are supporting a good cause, however remotely. The money might not be enough, but it goes to the right place.[1]

At the other end of the spectrum are the truly hollow deeds: "naming a star" and "buying" a bit of the moon. We know these actions are tokenistic because nobody would ever buy them for themselves. They are pure signifiers. You might as well buy a badge saying "I'm thoughtful." Some people even consider these gifts romantic—perhaps because they associate the frozen infinity of space with human love.

As Elon Musk, Jeff Bezos and other avaricious titans compete over rocket launches, owning extraterrestrial property is no longer just in the realm of sci-fi. When these billionaires finally stake out their plots of the Sea of Tranquility, will they be sued by furious people brandishing little certificates off the internet "proving" they already have rights to the rock in question?

If nothing else, the court case would be a depressing reminder of what this furious need to "own" things tells us about ourselves. When confronted with the majesty of the natural world or the night sky, our instinct is to find a way to portion it off and personalize it.

(1) Through Oxfam, for example, you can "send" gifts including goats, pigs and chickens. In reality, this is a marketing tactic and the donations help the charity's projects in a more general sense.

WORDS
ED CUMMING
PHOTO
DAVID SELANDER

CELESTIAL TRANSFER
What's the point of buying a star?

Of all the great fashion faux pas, none have endured quite like socks worn with sandals. Trends come and go—even "ugly sneakers" have had their moment in the spotlight—but our collective distaste for this particular look seems to transcend periods and cultures.

But what is it about socks and sandals that jars so? It's not as if wearing sandals by themselves is particularly controversial (unless you're attending a business meeting or have been summoned to court), and the addition of socks is a practical solution when it's hot and you expect to be walking long distances. It seems we are suffering a hangover from the Victorian era; we've inherited a horror of seeing underwear—that which should be hidden from view—displayed so brazenly in public. Or else it's an irrational response that associates this simple, functional piece of clothing with a part of our bodies that has traditionally been thought of as unclean.

It is true that your feet perspire more than any other part of your body (a remarkable half-pint of sweat a day), but socks are designed to wick that moisture away and keep your feet fresh. They prevent blisters from forming and help regulate the temperature of your feet: something that has benefits for everything from our immune systems to our sexual health— studies have found you are 30% more likely to orgasm when you are wearing socks.

We might do well then to take after ancient cultures, who appear to have had none of our modern hang-ups. From fabric found on sandals discovered in England, we know that Romans were pairing socks and sandals over 2,000 years ago, and the oldest surviving pair of socks, discovered in the Nile valley, has split toes, suggesting they were designed to be worn with a pair of ancient Egyptian flip-flops. They might just have been on to something.

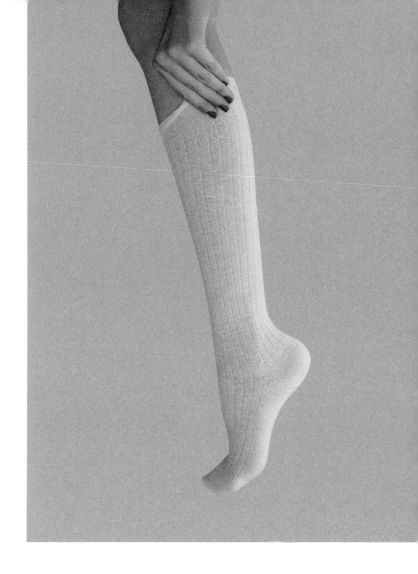

WORDS
GEORGE UPTON
PHOTO
YANA SHEPTOVETSKAYA

Photo: Courtesy of Comme Si

SOCKS AND SANDALS
Rehabilitating a fashion faux pas.

EASY PEASY
The appeal of simple answers.

What if I told you that the biggest problems in your life each had an easy solution? That posing for 20 seconds like a superhero before a big job interview would bag you the role, or that sleeping longer was actually a path to maximum productivity?[1] What if it were that simple?

These questions, and purported answers, are the basis of what journalist Jesse Singal refers to as "Primeworld"—the land of seemingly quick fixes. He critiques this TED Talk–inspired concept that people's behavior is driven, and alterable, by subtle forces. For example, psychologists have found that holding a warm beverage makes people more likely to behave warmly toward others. The logic metastasizes from there: With a nice cup of hot cocoa warming us up, who would remember what the latest international conflict was all about?

The label may be new, but there have always been people looking for quick fixes to complicated problems. Researchers in the 1970s believed their work showed that prosecuting minor offenses such as loitering or jaywalking would lead to people committing fewer violent crimes like robbery or murder. This "broken windows" style of policing, enacted in New York in the 1980s, showed promising initial results. But multiple studies since have shown that there's no clear causal relationship between a lack of order and crime. And broken windows policies also ushered in new problems like stop-and-frisk policing, and the biases that came with it.

In other words, primeworld ideology asks you to set aside concerns about systemic problems. It is your state of mind, rather than the state of the world, that is at fault. If only you could manage to sleep an extra hour, you could be giving a TED talk too.

(1) In one of the most popular TED talks of all time, Amy Cuddy explained that "power posing" led to higher testosterone levels and lower cortisol levels. However, several other researchers have tried —and failed—to replicate the results.

WORDS
SALA ELISE PATTERSON
ARTWORK
MARCUS SCHÄFER

Artwork: Courtesy of Trunk Archive

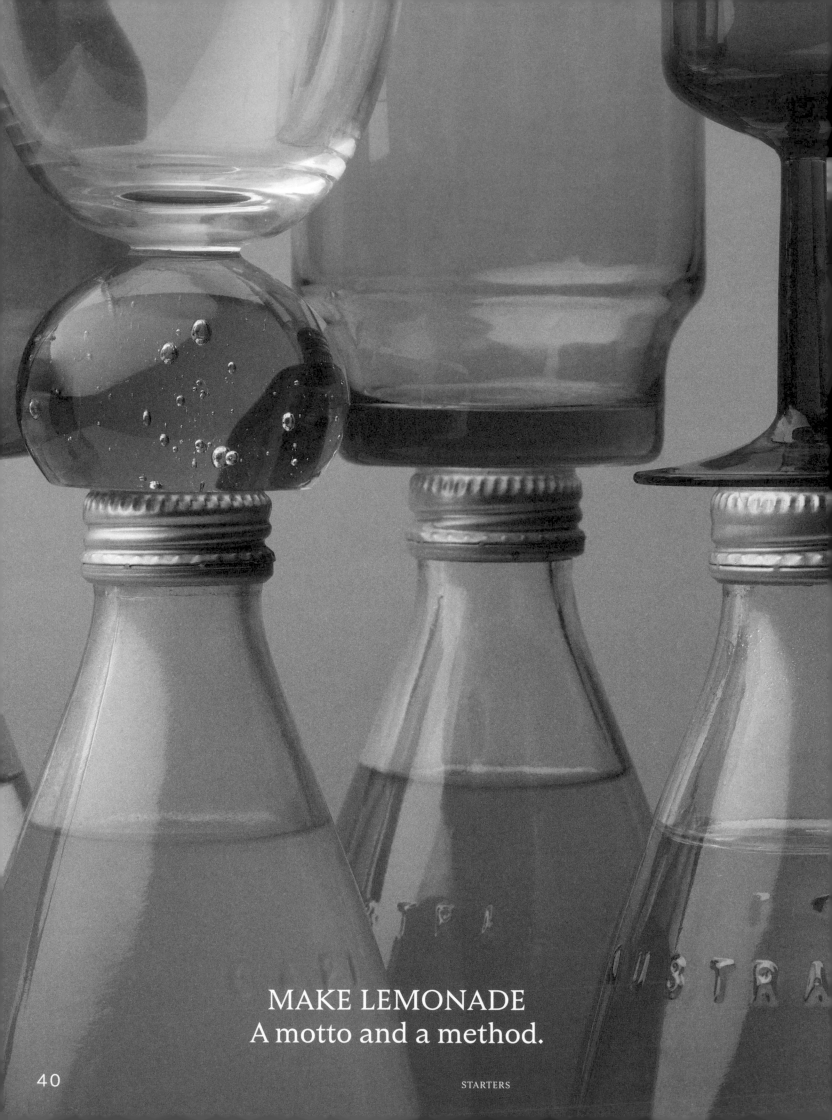

MAKE LEMONADE
A motto and a method.

STARTERS

The proverb "When life gives you lemons, make lemonade" is understood to have been coined by the American writer Elbert Hubbard in 1915. In his obituary of Marshall Pinckney Wilder, one of the most successful vaudeville performers and a favorite of the British royal family, Hubbard wrote that the actor achieved greatness despite the challenges of being born with dwarfism: "He picked up the lemons that fate had sent him and started a lemonade stand."

The phrase would come to be refined and popularized over subsequent decades, embodying a particularly American belief in self-made success. Yet the history of making lemonade goes back a lot further than enterprising American children and their 5¢ stands. Medieval Egyptians drank qatarmizat—lemon juice sweetened with sugar—in the 11th century, and by the 17th century, lemonade had become so popular in Europe that a guild, the Compagnie de Limonadiers, was formed in Paris, monopolizing its production.

With the invention of carbonation techniques at the beginning of the 1900s, fizzy bottled lemon soda became a favorite. But if life does give you literal lemons—or you're just craving the good stuff—lemonade is very easy to make at home. Recipes vary but in its simplest form, lemonade is made from lemon juice, cold water and sugar. Restaurateur Kamal Mouzawak, who is behind the Tawlet restaurants in both Beirut and Paris, suggests kneading the lemons by hand rather than using a squeezer, as they do in the Lebanese town of Batroun. It is, he says, "the best for summer heat."

WORDS
GEORGE UPTON

Left Photograph: Lauren Bamford, Styling: Stephanie Stamatis. Right Photograph: © Estate of Jan Groover. Courtesy of Janet Borden, Inc.

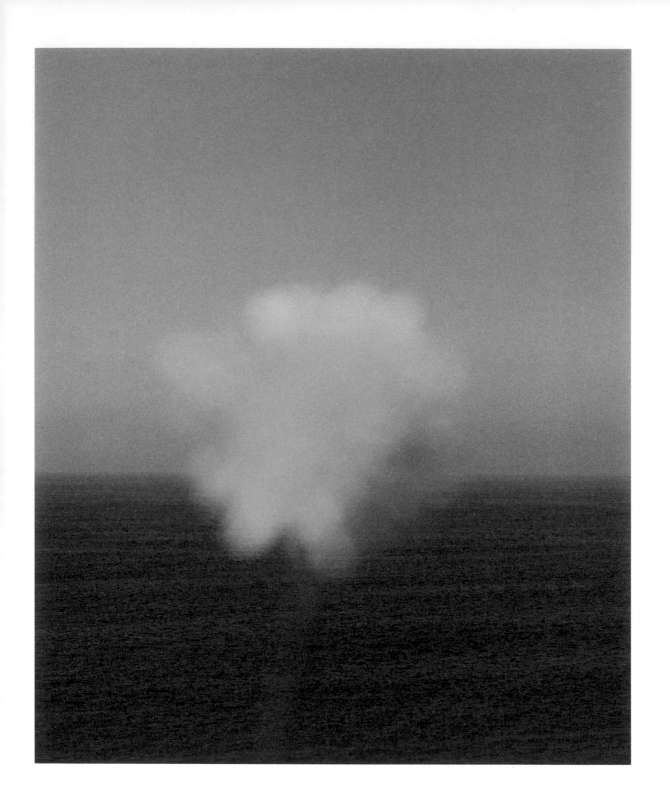

42

NOTHING TO SEE HERE
The allure of slow TV.

WORDS
ASHER ROSS
PHOTO
DENIS BOULZE

The idle, plotless meandering of slow TV flies in the face of every entertainment maxim. And yet, while programs in the genre offer no story to speak of, they manage to captivate us—whether we're watching newly hatched ducklings milling in a pond or the prow of a ship splitting placid waters.

Slow television is largely credited as a Scandinavian phenomenon. Its big moment came in 2009 with the premiere of the Norwegian *Bergensbanen Minute by Minute*—a recording of the seven-hour train journey from the coastal city of Bergen to Oslo, filmed in real time with minimal adornment. Almost all the footage is near-silent, save for station announcements and a steady rumble of train on track. As the hours tick by we see the countryside evolve from pine-trimmed fjords to snowy highlands, and eventually into the gray anticlimax of the capital.

The show became a sensation in its home country, with some 20% of Norwegians tuning in. Later iterations found even larger audiences, winning over viewers worldwide and spawning imitations in country after country. GoPro-equipped amateurs joined the mix, as did nature conservatories that fixed cameras to nests, fish tanks and zoo habitats. By the time the world found itself house- and apartment-bound in spring 2020, one web designer had created a global map where viewers could select slow programming based on location, from Hanoi to Montenegro. There's something for every mood: canoe trips, gardening, knitting parties, firewood being chopped, firewood burning, and offshoot genres like the work of Chinese sensation Li Ziqi, who won over millions with her silent presentation of bucolic Sichuan life.

None of this is supposed to work, at least not according to most theories of narrative entertainment. The story, after all, is the be-all and end-all for human interest. And slow TV, for all its splendors, lacks a story by definition. It offers no tragedies, no tensions, no redemptions to escape into.

In this way, it holds up a mirror to real life, which seldom coalesces into a plot. This is why "reality" television requires so much intervention from production staff. And, as in life, this lack of plot means that our thoughts become the narrative. If the Norwegian countryside seems lonely, it is only our mind that makes it so. If we imagine that a widower lives in the cottage by the river, it is us alone who has penned his story.

Think of a child on a long car drive, watching a drop of rain course slowly down the windshield. The image has no tension on its own, but in her boredom the child might adjust her head to make the droplet follow the center of the road, or wait apprehensively to see if it will combine with another. Slow TV like *Bergensbanen* invites just these types of dazed-out inner narrations, and returns us to a meditative mood where our own speculations and associations take center stage.

In many cases, these thoughts unfurl like daydreams, but slow TV has on occasion led to less abstract tensions. In 2014, the Woods Hole Oceanographic Institute in Massachusetts faced rabid criticism from viewers of its osprey nest cam after a mother bird began neglecting her chicks. Having invested weeks watching the little birds hatch and fledge, fans demanded that staff intervene to save their lives. Experts, of course, advised against it, and the staff refused to cave. The young chicks died, and those who watched it happen were grief-stricken. It was something that happens every day in the natural world, where there is no screenwriter. Merciless, common—but to the viewers, an unbearable story.

OLIVIER KRUG

WORDS
DAPHNÉE DENIS
PHOTO
LUC BRAQUET

On the undersung art of Champagne pairing.

Olivier Krug is the sixth-generation director of the Krug Champagne house. Since its founding in 1843, the house has prided itself on finding new ways to work in an industry governed by its traditions. Most recently, under the watchful eye (and nose) of cellar master Julie Cavil, Krug has started a program pairing its Champagne with one simple ingredient each year, and commissioning chefs to create complementary recipes that elevate it. This year, it's rice.

DAPHNÉE DENIS: Can you tell me about your ancestor Joseph Krug's founding dream: a Champagne cuvée that wouldn't be affected by variations in climate?

OLIVIER KRUG: It is Krug's raison d'être. My ancestor used to work for another Champagne maker and was frustrated by the fact that, to make good Champagne, they had to wait for a good harvest year. On a good year, Champagne houses produce *millésimes*—Champagnes which are primarily made of the same vintage—and the rest of the time, they make Champagnes *sans année,* which combine different years of harvest. They are well made, but never as intense and radiant as Champagnes from great years. So Joseph Krug thought, "I want to create Champagne that is great every single year." No harvest is the same, even from one good year to the next. No wine parcel has the same nuances and taste. He thought it would be interesting to use that variety of styles.

DD: Since 2015, you've paired your Grande Cuvée with a different ingredient every year. Should Champagne always be accompanied by food?

OK: There is no specific time to have Champagne. Of course, having it on its own can be a pure tasting moment. But you can go very far when you add food; it's a dialogue. Krug has always been very close to great chefs, and one day, those chefs told me, "Let's work around ingredients." Eventually, we opened a program worldwide. We have ambassadors, chefs we put on the path of one ingredient: in India, it was onions, in Mexico, peppers. . . . They learn techniques from locals who cook it daily, and then they go home and develop recipes to go with Krug Champagne.

DD: You've paired Krug with onions, peppers and, this year, rice. Why choose such humble ingredients?

OK: It stems from a conversation with the chefs we work with and of course with cellar master Julie Cavil. We present a great dish made from an ingredient that—just like the grapes we use for Champagne—may seem banal, but isn't banal at all once it is transformed. So when we offer a recipe to accompany our Champagne, the pairing itself will make the tasting experience exceptional.

DD: How did you arrive at rice?

OK: Rice is one of the most universal ingredients, and one that is a staple of many types of cuisine around the world. I used to live in Japan, so I know their rice producers well. I remember one conversation I had with chef Hiroyuki Kanda, who is one of our ambassadors now. He came to a tasting with boxes containing different types of soil, and I realized that I never had thought of rice as having a *cru.*

DD: So you found similarities between rice production and Champagne production?

OK: Yes! You may think it's "just" rice, but there is rice from Asia, then rice from Japan, and then rice from different Japanese regions. You could come across a chef who says, "The rice I want is the one from *this* lot, in a small town where there are only two terraces." It's very similar to the way Julie will travel to small valleys across Champagne to locate unique vineyards. *This feature was produced in partnership with Krug.*

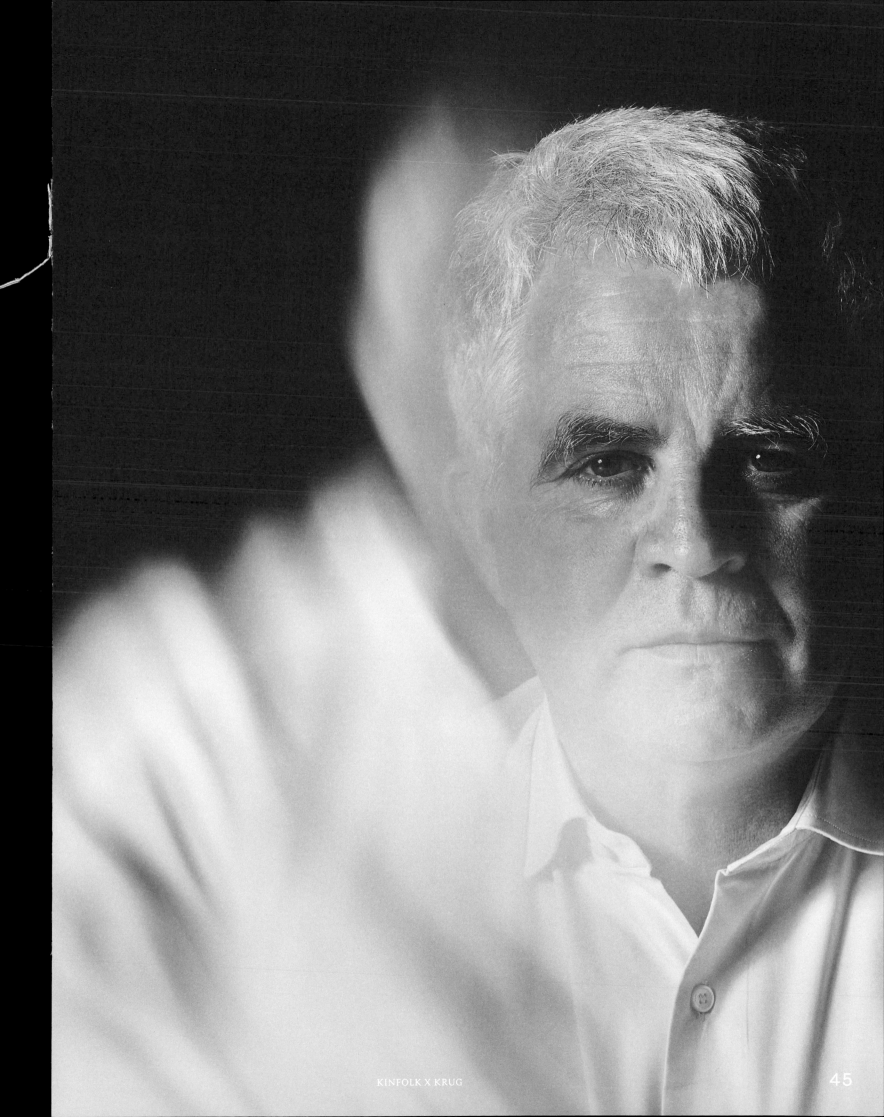

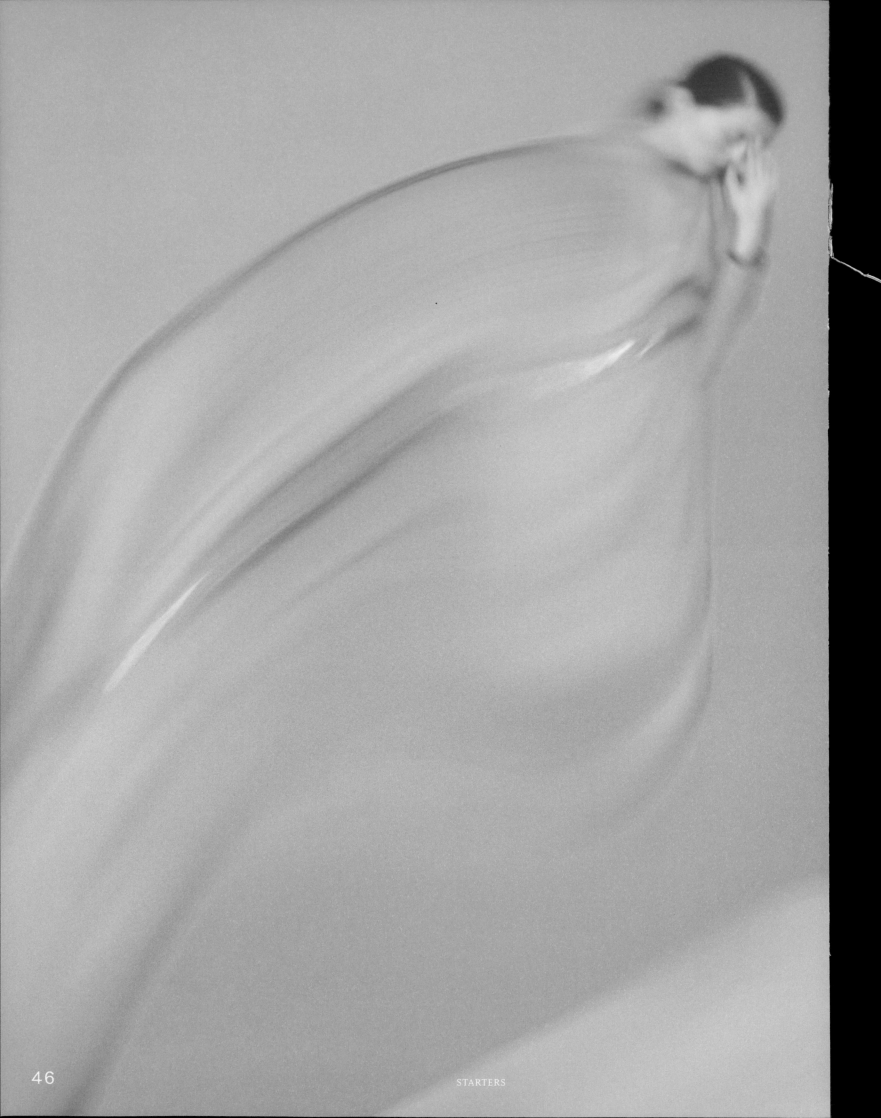

WORDS
GEORGE UPTON
PHOTO
PAUL ROUSTEAU

Four questions about supernatural studies.

Dr. Peter Lamont is a senior lecturer at the University of Edinburgh where he specializes in the history and psychology of magic and the paranormal. It's an area of study that explores not only why people believe in the supernatural but how we all understand and relate to the world around us. Here, he explains why a belief in ghosts (both the spirits of loved ones and more malevolent poltergeists) has been a consistent part of human experience, shaped by changing religious, social and cultural contexts over thousands of years.

GEORGE UPTON: The earliest depiction of a ghost, carved into a clay tablet in ancient Mesopotamia, dates from the 4th century B.C. Why has it been such a constant in human history?
PETER LAMONT: If you believe in God or the existence of a soul or that there's an afterlife—as people have since ancient times—then it doesn't seem so implausible that there might be some communication from the other side. The nature of these interactions, however, and the ways in which they have been interpreted, has changed over time.
GU: What do people say when asked why they believe in ghosts?
PL: They'll often tell you the reason is simply that they're real, that they've seen them. The fact we're asking the question at all suggests we're coming from a position of skepticism. It's like how we wonder why people believe in levitation, but we don't ask why they believe in gravity.

Often when psychologists come to explain why people believe in supernatural phenomena, the explanations they give reflect that skepticism: that it could be about intelligence or education, a desire for greater control of your circumstances, or for religious reasons and the desire for an afterlife. All of these could be true, but they also don't necessarily lead to a belief in ghosts. For those people who do believe in ghosts, their experience is an explanation in itself.
GU: In what ways have people reported experiencing ghosts?
PL: It's inevitable that religious or cultural representations of spirits will shape how people understand their experiences. In Orthodox Christianity, for example, there's a common belief in miracles and spirits, but not in witchcraft or magic. So, the latter might be seen as fraudulent (or perhaps as real but evil) and that would inform how people would view their own experience.

Interestingly, during the Victorian period, many wealthy, educated and sane people start reporting seeing things that couldn't be explained. There are some quite quirky conversations recorded from the time exploring issues around things like why ghosts are often seen with clothes (if the soul survives, would their trousers also survive?). An idea develops that the experience might be real but the ghost isn't—that rather than proving the existence of an afterlife, ghosts are evidence of how we can be deceived by our senses.
GU: Can we apply this open-minded approach to other aspects of our lives?
PL: Studying these extraordinary things definitely requires you to think more critically about everything—not just in terms of logic or evidence but about meaning and context. As a true sceptic, it's not enough to debunk things you don't believe; you have to question everything you think. It's a bit like traveling—you need to encounter different viewpoints to realize how much of the way you see the world you take for granted.

WORDS
SALA ELISE PATTERSON
ARTWORK
MARY ELLEN BARTLEY

Etymology: The word *anecdata* is used to describe information that is presented as a substantiated truth (i.e., data), when it is in fact based on personal experience, speculation or opinion (i.e., anecdote). Or, as the *Longman Dictionary of Contemporary English* briefly defines it, "information based on what someone thinks but cannot prove." It is interesting to note that the designation neither confirms nor denies the accuracy of a piece of evidence; it only speaks to the process that informed its coming into being.

Meaning: The earliest references to anecdata appear in technical and legal documents. The *Oxford English Dictionary* catalogs the first citation in 1989 in the *Michigan Law Review*. The term is thought to have come into more mainstream use a few years later. Economics journalist Paul Solman is on record using it on the *MacNeil/Lehrer NewsHour* in 1992, calling anecdata "the journalist's approach to reality."

Still, references to the word have only really gained in popularity in the past few years. One might attribute that to a rise in use of anecdata in our content-hungry, information-saturated society. It's as if the unrelenting demand for fresh ideas mixed with an infinite supply of information both permits and pressures us to speak beyond our areas of expertise. Today, anecdata fuels everything from dinnertime debate to flimsy academic writing to fake news cycles—and the term is used as a dismissive rebuttal by those policing or poking fun at peddlers of these unreliable ideas.

But anecdata's reputation might be on an upswing if research projects like Anecdata.org succeed. Created by scientists and researchers at MDI Biological Laboratory, a nonprofit biomedical research center based in Maine, the website describes itself as a "free citizen science platform anyone can use to collect observations of our changing world." Its hypothesis is that large amounts of anecdotal evidence can be crowdsourced and analyzed to yield data sets that are as (or even more) rigorous than what emerges from conventional research.

This formalizing of informal information might be anecdata's most interesting moment yet. There is something elitist in the notion that only a narrow set of experts, sources and methods can lead to indisputable truths, just as there is something exciting and democratic about extending that privilege to a broad and plural public.
—

WORD: ANECDATA
Fact, meet fiction.

Artwork: *Thin Poem* by Mary Ellen Bartley

Though often unsatisfying, losing is as much a part of our lives as its more coveted counterparts: winning, gaining and improving. As we age, we lose our youth; as we gain experience, we lose our naivete. In many ways, life is an accumulation of these losses.

Alongside these existential losses are more dreary failures: Loved ones pass, job offers fall through, relationships falter. One way of processing setbacks is to treat them as a springboard to a brighter future. But in his 2021 book *Losers,* Josh Cohen argues against this search for silver linings and toward a new outlook on losing. As a psychoanalyst, Cohen sits with his clients as they come to terms with their losses and failures. It's a necessary intervention: Only through exploring the range of ugly feelings can his clients recognize the possibility of another state of being. To banish this darkness would be to know no light at all.

Cohen's argument is not a pep talk that promises losers that "the only way is up." That way of thinking plays into the same unhelpful binary: By optimistically imagining a win on the horizon, we are still acting out our fear of loss. Instead, salvation lies in humility, which Cohen describes as "the consequence of an awareness that truth doesn't belong to us." Like loss, humility is characterized by an absence: of pride, self-regard, entitlement. This absence humbles us when we lose, and when we win—as Cohen writes, "Humility reminds us of the large portion of arbitrariness that determines any personal success or failure."

In a world without losers, we would still face loss. But in a world without winners, we might finally find relief.

WORDS
NATHAN MA
PHOTO
XIAOPENG YUAN

ON LOSERS
A fresh perspective on failure.

STAR HIRE
The rise of the celebrity creative director.

To cash in on their fame and influence, celebrities can now set their sights a little higher than the usual endorsement deals. The last few years have seen a growing number of would-be brand ambassadors announced with a grandiose title that suggests new levels of authority, that of "creative director."

Brands have been adding celebrities to the creative payroll since at least 2009, when Lindsay Lohan began her disastrous and short-lived stint as "artistic advisor" to the French fashion house of Ungaro. But in 2021, the promotions really piled up: British *Love Island* contestant Molly-Mae Hague parlayed a string of successful collaborations into a creative directorship at PrettyLittleThing; Kendall Jenner took on the role at luxury e-commerce site FWRD; Cardi B joined *Playboy* as its first creative director in residence; Drew Barrymore was brought in by Garnier.

On social media, people often bemoan the fact that these titles have been given to celebrities at the expense of dues-paying creatives who have worked their way up through the industry, as though the appointments were the result of an unjust recruitment process rather than a C-suite strategy. But they're often part of another corporate tradition: title inflation. Title inflation is how your boss gets away with giving you more responsibility, but not more money; it's the reason an astonishing third of Goldman Sachs employees have "vice president" on their business cards. It's also why Instagram users aggregating fashion photography have self-styled themselves as curators, and why YouTubers and all manner of influencers have rebranded as content creators.

It's no coincidence that these roles all have loose definitions to begin with (they can be gate-kept, but not regulated), nor that each connotes a sense of purpose, talent and prestige. For the average person, those associations can be a tool to cultivate a reputation and respect when they're the only currencies at your disposal. But for celebrities, for whom currency is no issue, they also serve to shake the underlying stigma of trading on your image: Spokespeople are in it for the money; creative directors are in it for self-expression. The former are pretty faces; the latter have something to say.

As with economic inflation, the long-term costs of widespread title inflation could ultimately outweigh the initial benefits if left unchecked. Devaluation is part of the deal. The issue isn't that when everyone's a creative director, no one is. It's that when everyone's a creative director, what reason is there to care?

WORDS
ALLYSSIA ALLEYNE
PHOTO
NIK MIRUS

Part 2.
FEATURES
Tiny furniture, gallery chic and audacious fashion.
52 — 112

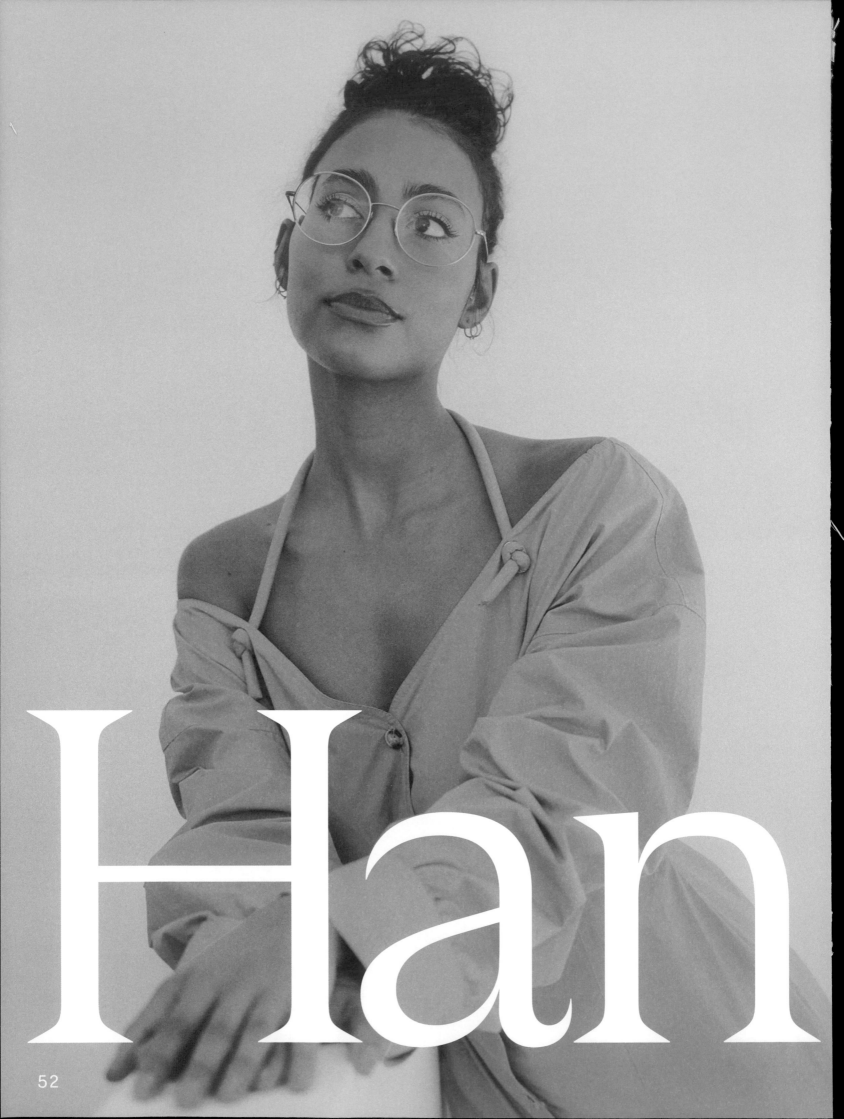

Han

Words
KYLA MARSHELL
Photography
EMMA TRIM
Stylist
JÈSS MONTERDE

nah

THE ART WORLD'S NEXT

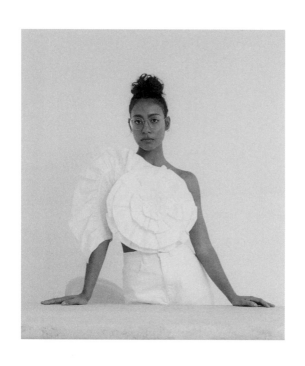

BIG THING IS A GALERIST.

On first approach, Hannah Traore Gallery feels like any other downtown New York arts space. Sunlight pours in through the big glass doors; the air is still; white bouclé-covered settees anchor the room, looking, at first, like art themselves.

But on the walls—the true real estate—is something different: color. *Hues*, the gallery's first show, features artists working with a rainbow's worth of different shades: glittery yellow, electric turquoise and iridescent multicolor patterns. One wall is painted green, another is two-tone—yellow and candy cane red. All works in *Hues* are also by artists of color. It is not a gimmick or a one-off; here, marginalized artists exist at the center.

Traore, 27, grew up in Toronto, the daughter of a white Canadian mother, a fiber artist and collector, and a Malian immigrant father. Art was celebrated in their household; she and her siblings were encouraged to explore their creative interests.[1] To hear the story of how she went from curatorial intern at MoMA in 2018 to gallery owner in just a few years is to wonder what steps you missed. But the short answer is: She took a big swing. Like many people, Traore had a reckoning during the COVID-19 pandemic. After getting laid off from her job at New York's Fotografiska in April 2020, she revisited her dream of opening her own gallery. As a student at Skidmore College in upstate New York, she'd curated ambitious shows, even featuring Mickalene Thomas and Kehinde Wiley in an exhibit she created for her senior thesis.[2]

The unexpected slate of free time gave her the push she needed. "I just wanted to do what I wanted to do," she says. "At a certain point I realized, Why am I suppressing all these ideas? I should be acting on them." During our conversation, the gallery's two spacious rooms are empty save for Traore and her assistant, but so much has already happened here—a launch, panel discussions and several long nights. Traore estimates she worked 100-hour weeks in the run-up to launch.

The way Traore speaks about her vision for the space is confident without being boastful; unselfconsciously excited about what's to come. Her central idea, she explains, was to create a space where she could highlight the work of artists from historically underrepresented groups—including people of color, women and queer artists.

In the art industry, as in many others, prodigy and youth are valued—but more so in artists themselves. Curating, itself a kind of gatekeeping, has its own gatekeepers, with an expectation of dues-paying that Traore somewhat skirted. "I definitely had a good amount of work experience—the proper work experience—to do what I'm doing, but it's still a shock to people," she says. "I see being young as an asset because I'm not as chained down to rules as someone else who has been in the industry for a longer time might be."

(1) Traore's exposure to art as a child included art camps and museums as well as home crafts with her three siblings, darkroom photography and pottery.

(2) Traore's undergraduate thesis explored the work of Malian photographer Malick Sidibé. In 2017, she organized an exhibition that included Sidibé's work and that of artists he influenced, including Kehinde Wiley.

She started by having a series of informational interviews with people from around her industry and, through their counsel, built a team—business consultants, art lawyers, PR agents and mentors, whom she mentions often and by name. They included the New Museum's deputy director Isolde Brielmaier and Toronto art collector Kenneth Montague. "I felt comfortable going on this journey because I knew I had this support," she says. "And I trusted that the support would keep growing."

And she trusted herself. There is clearly an internal drive propelling her forward, something she says comes from her family. "Knowing that my siblings and my parents believed in me made me believe in me." She also felt inclined to prove herself to the doubters of yore, like the arts-disparaging mom of a childhood friend she ran into the last time she was at home. "She made a comment [to my mom] like, 'How embarrassing that all your kids are in the arts.' That's a sentiment that a lot of people have. Doing something that's half art, half business felt like proving to them that I can have a career in the arts that's successful."

" I trusted that the support would keep growing."

Since opening the gallery in January 2022, much of Traore's time has been filled by press: photo shoots and interviews with her about her story. On the one hand, there's an element of this she enjoys. Fashion—in particular, her penchant for bright colors—is important to her. It's part of the reason her first show, the one with which she's introducing this gallery to the world, is called *Hues*.

But on the other hand, this gallery space is not about her—it's about the artists. What matters to Traore is that they have a place to show their work without the pressure to foreground their identity. Over the last several years of a global racial reckoning, there have been many instances of increased representation in the art world, as well as its inevitable byproduct: performative allyship. Or as she puts it, galleries that want to include artists of color for "street cred."

She shared the example of an artist she's working with, James Perkins, whose work includes paintings and installations of striking, large blocks of color. "You would never know that he's a Black artist by seeing his work. He's said to me he feels the reason his work hasn't gotten the push it needs is because of that," Traore says. "But I don't have to prove anything. I don't have to show a Black artist to prove that I'm not racist—I'm Black."

(page 52) Traore wears a top by NANUSHKA.
(previous) She wears a top and trousers by MARA HOFFMAN.
(right) She wears a dress by STELLA MCCARTNEY and jewelry by ANH JEWELRY.

Makeup: Rebecca Alexander. Hair: Ben Skervin

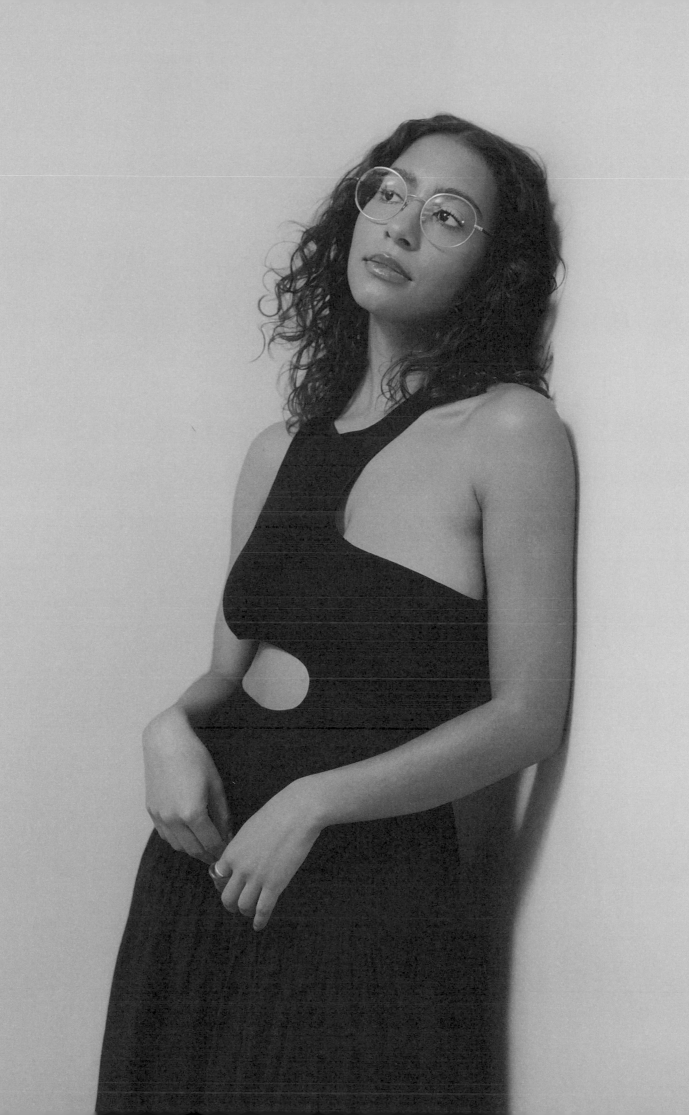

(right) Alongside *Hues*, the gallery is also showing *Mi Casa Su Casa*, a group show organized by Hassan Hajjaj that features the work of emerging artists from Morocco.

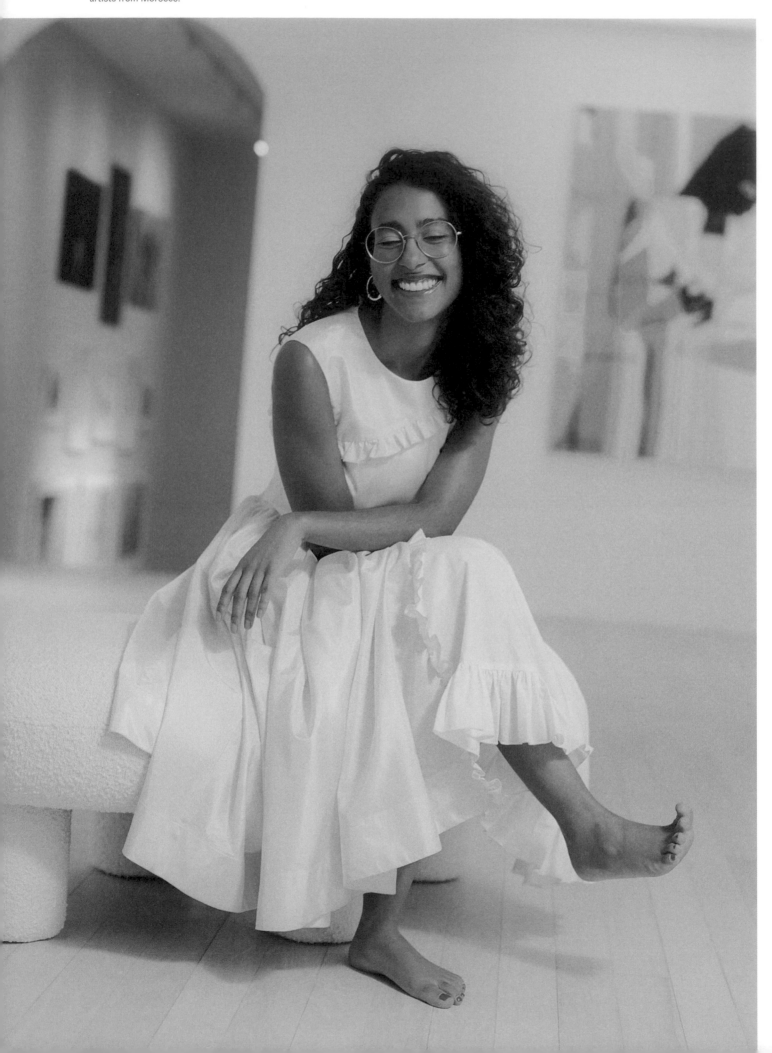

As she's been curating for her own space, she says she's been able to offer her artists, who include Hassan Hajjaj, Murjoni Merriweather, Dan Lam and Wendy Red Star, something that some other gallerists are not always able to provide: understanding.

Beyond the joy of not tokenizing or being tokenized (she rejoiced talking about Brielmaier, her first-ever Black boss: "what a difference it made"), being a gallerist who implicitly understands her artists also offers a competitive edge. Curation extends beyond putting pictures up on the wall. In many cases, she's collaborating with artists as they make the work, offering perspective and guidance. One such piece in *Hues* is "*dhund* (translation: fog)" by Pakistani sculptor Misha Japanwala. It's a bright blue casting of the artist's shoulders and breasts. In not having an agenda, Traore said, she can "give the artist more autonomy in the work." I had never considered that curators participate in the creation of their artists' work. But in this case, for an artist for whom showing her breasts is a real subversion in her culture, trusting the curator—how she'll display, contextualize and represent the work—is vital. After our meeting, Traore wrote to clarify a comment she'd made about the piece with a quote from the artist herself—another instance of advocacy in action.

Traore also wants to challenge what a gallery is and what can be in it. "A lot of the time in the art world we like to make sure that our artists are only artists," she says. "And I think that's ridiculous, because people are complicated and have talents in many different fields." Upcoming exhibitions include the first gallery show for Camila Falquez, traditionally a commercial photographer, and a hybrid show where a sculptor will also be showing her fashion collection. This boundary-crossing is already in evidence. As well as showing art by Hassan Hajjaj in the current exhibition, the gallery currently welcomes visitors to relax on chairs that he designed.

Being the boss does mean making certain concessions, one of which is limited time to explore her own art practice. She was an art

(above) Traore wears a dress and shoes by PRADA and jewelry by ANH JEWELRY.
(right) She wears a top by MARA HOFFMAN.

minor in college, with an interest in pottery and photography. "It's definitely taken a back seat since I started working on the gallery, and since college," she says. "One thing I have done in my house is bookbinding, which I really love. If I'm stressed and I make time for myself to make art, that stress goes way down."

After all the help she received, Traore is keen to become a mentor and a role model in her own right. "I would love to be someone who people look to, because there were a lot of amazing Black women who I looked to," she says. Though she can rattle off a dozen or so Black women gallerists in New York City, in an ideal world, that number would be higher, that influence more established. For all the aspiring young gallerists, she has three key tips: "Ask for as much advice as possible. Do what you can—you don't have to open a huge space on the Lower East Side. And trust yourself."

It's that trust—true belief in the work she's doing—that unites her many ideas and the art throughout the space. Every few moments, she mentions yet another show she's mounting—the year is already blocked out, filled to the rafters with possibility. "I absolutely love that when someone comes to me and says, 'We want to do this,' I don't have to ask anybody. It's between me and me."

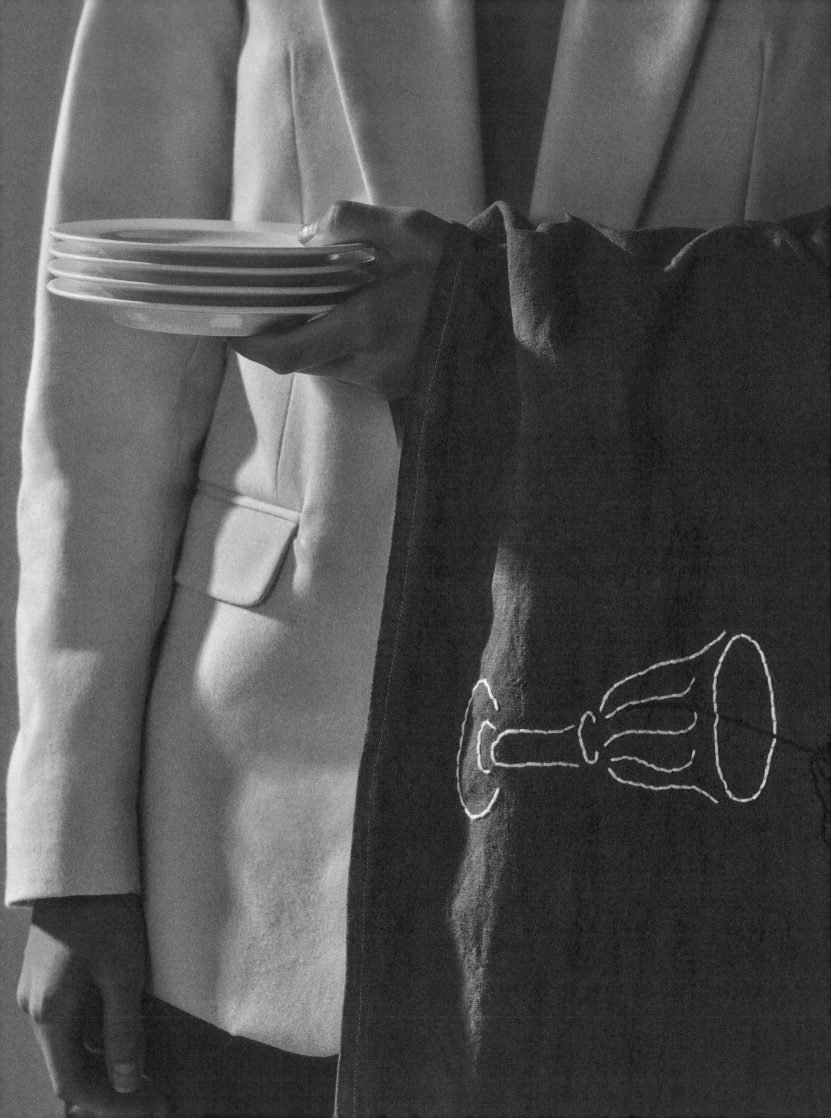

A place setting
stitched for
every season.

63 AN UNMOVABLE
 FEAST

Textile Design
SARAH ESPEUTE
Photography
LAUREN BAMFORD

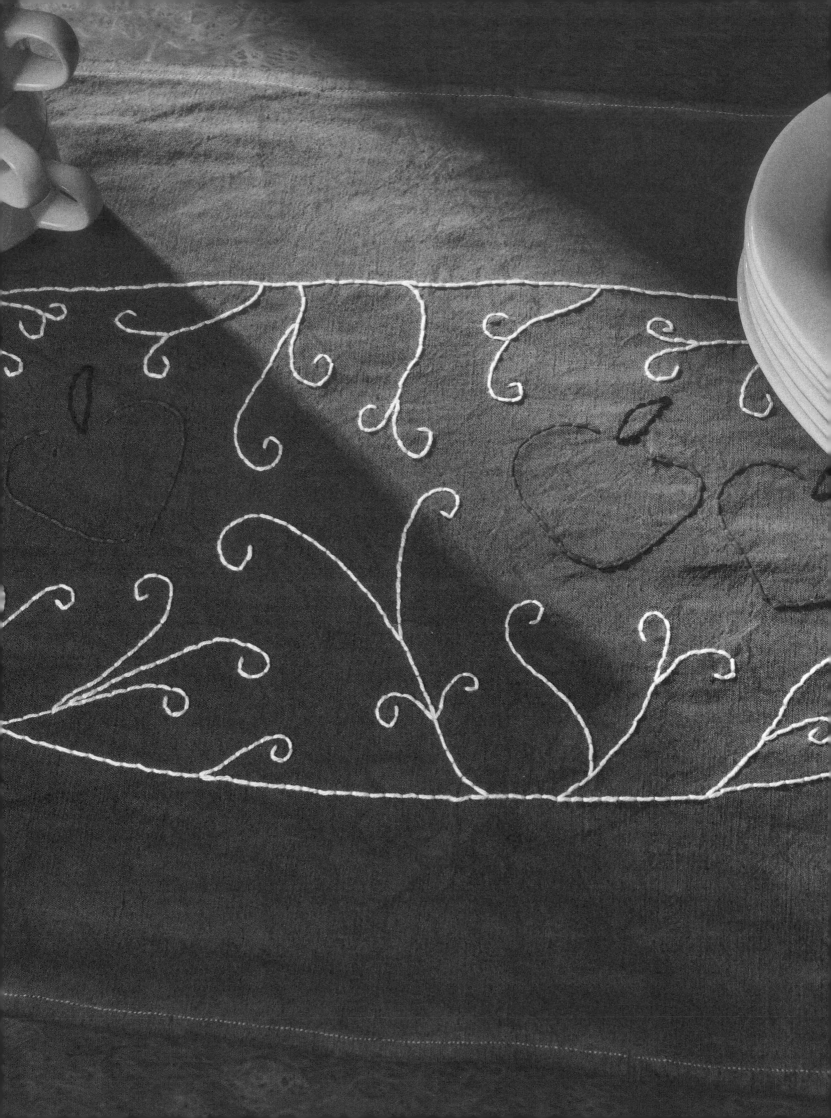

(all) *Kinfolk* commissioned French designer SARAH ESPEUTE to create these embroidered tablecloths inspired by the seasons.

Set Design
STEPHANIE STAMATIS

Q&A:
SARAH ESPEUTE
Words by Harriet Fitch Little

HFL: What was the inspiration behind this collaboration with *Kinfolk*?

SE: I wanted to create a series of embroideries that were illustrative and colorful, with an offbeat energy. Each piece evokes a season and a table story related to it: "Spring" features freshly cut mountain flowers; "Summer" a sunny lunch; "Autumn" the harvest of grapes and "Winter" a rustic dinner.

HFL: You often incorporate trompe l'oeil details into your designs—why?

SE: I find that trompe l'oeil brings both an aesthetic and fun atmosphere to an interior. There is a shift between the second and third dimensions—reality and the illustrated—that I find very interesting.

HFL: Why do you think tablescaping is so popular at the moment?

SE: It's a moment of conviviality and pleasure! It awakens a beautiful moment—the feeling of sharing, and the joy of receiving. I think it's also a form of expression that reveals one's personality, one's tastes—an art of living.

HFL: What's dinner like at your home in Marseille?

SE: I cook rather simple and unpretentious family food, mainly Mediterranean recipes. But I like it to be generous and beautifully presented in all sorts of old dishes, large and small. There's a lot of washing up, but it's so much more enjoyable.

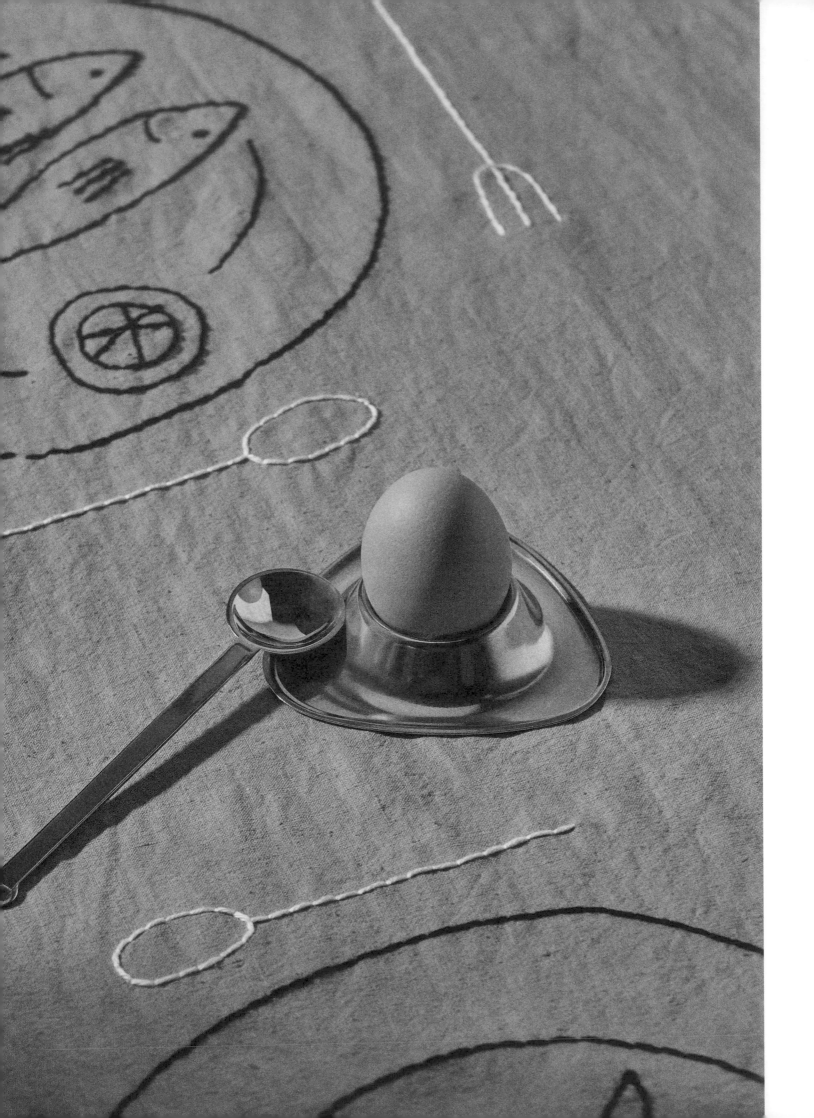

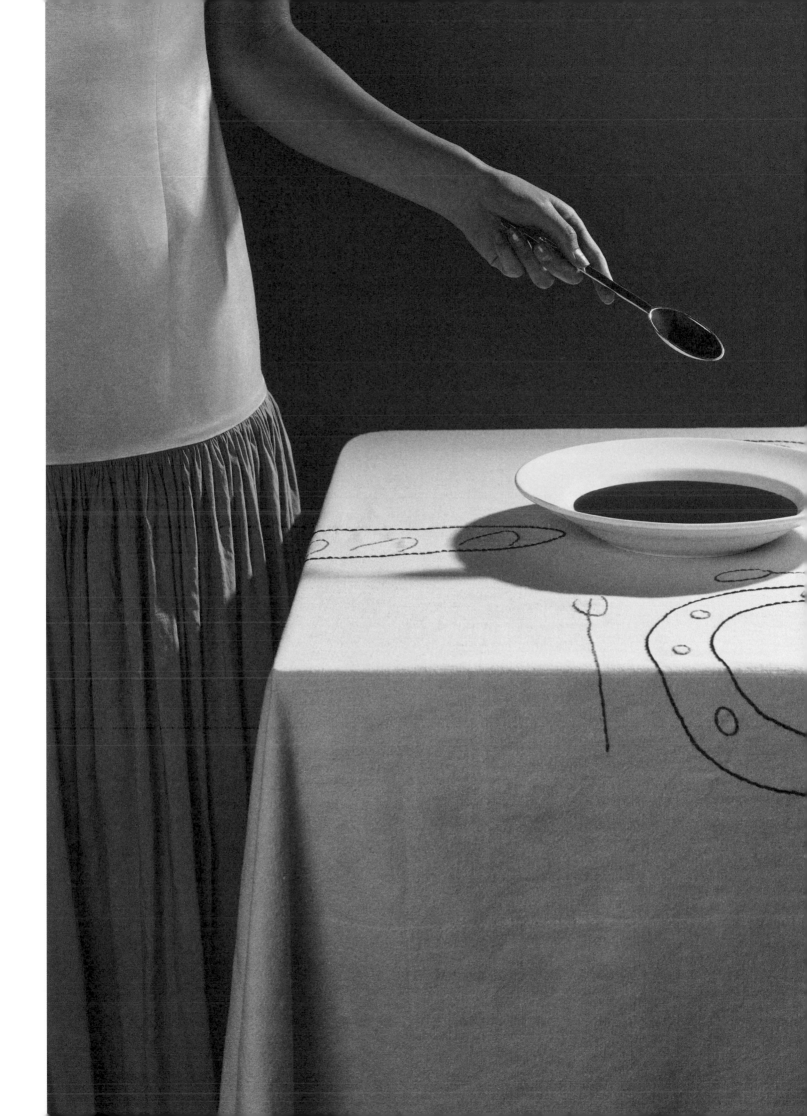

Photography
DENNIS WEBER

Michelle ELIE:

AN AUDIENCE WITH AN AUDACIOUS DRESSER.

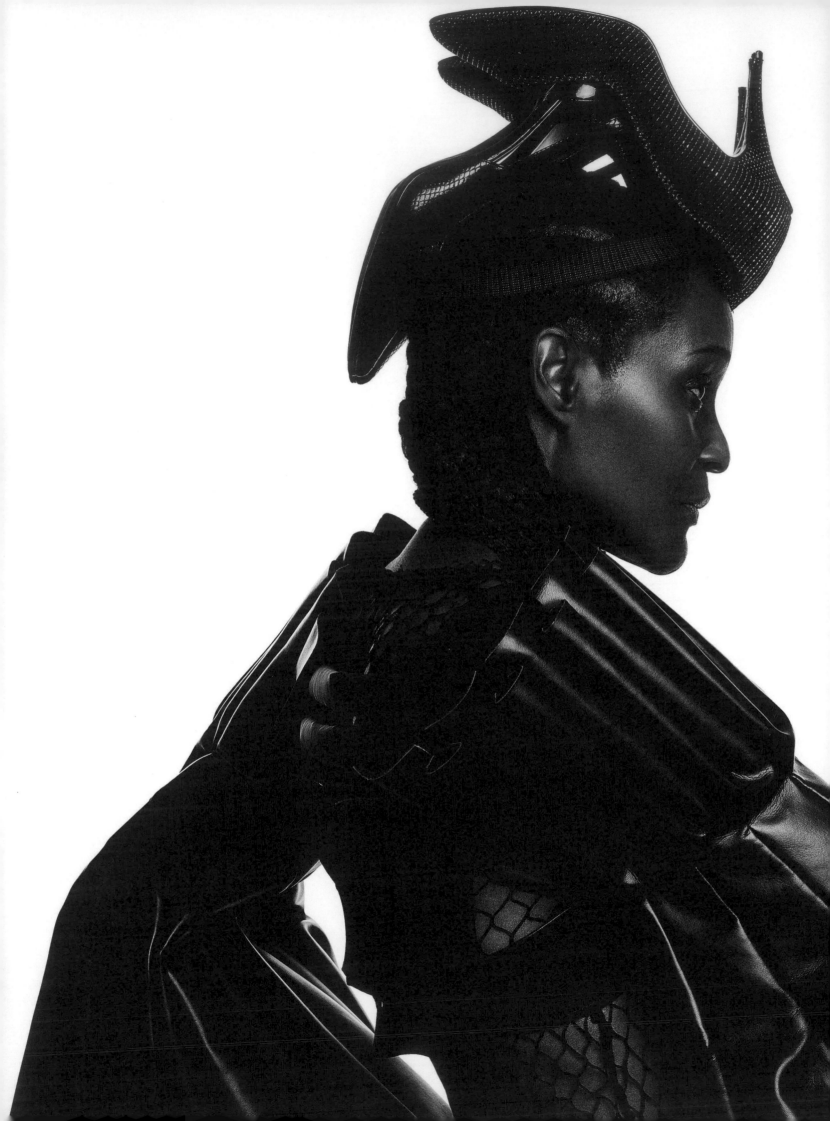

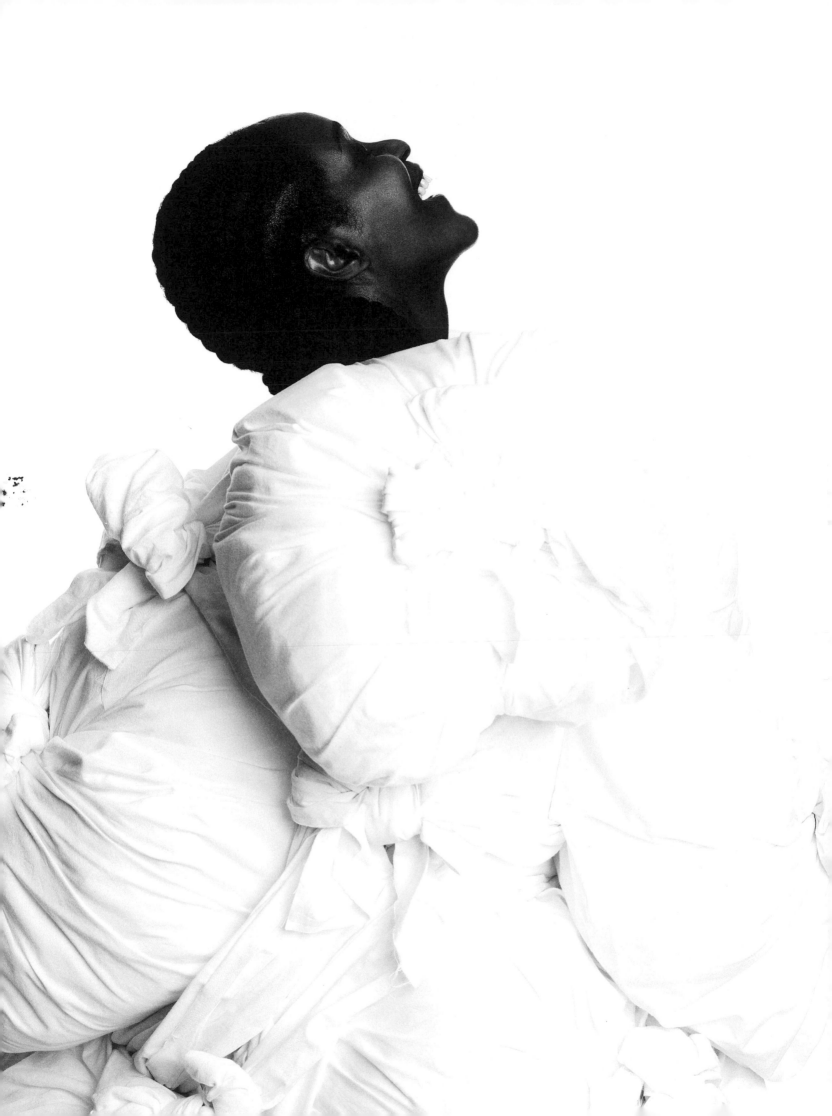

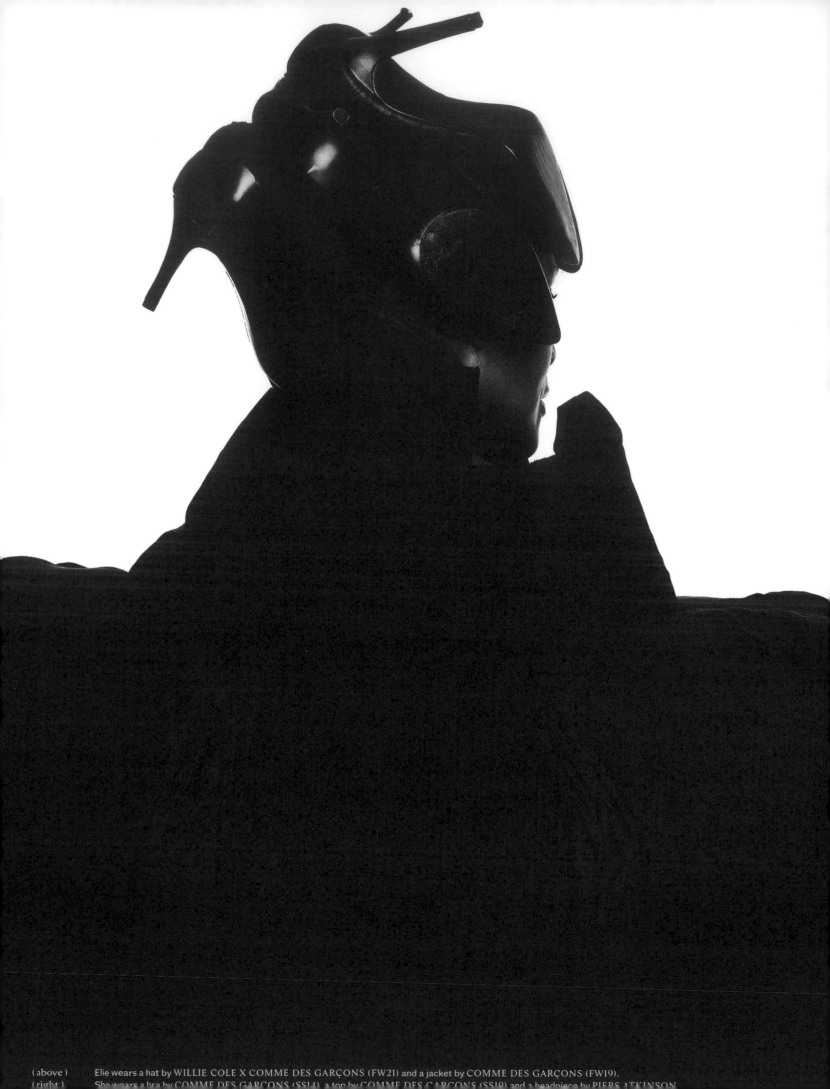

(above) Elie wears a hat by WILLIE COLE X COMME DES GARÇONS (FW21) and a jacket by COMME DES GARÇONS (FW19).
(right) She wears a bra by COMME DES GARÇONS (SS14), a top by COMME DES GARÇONS (SS19) and a headpiece by PIERS ATKINSON.

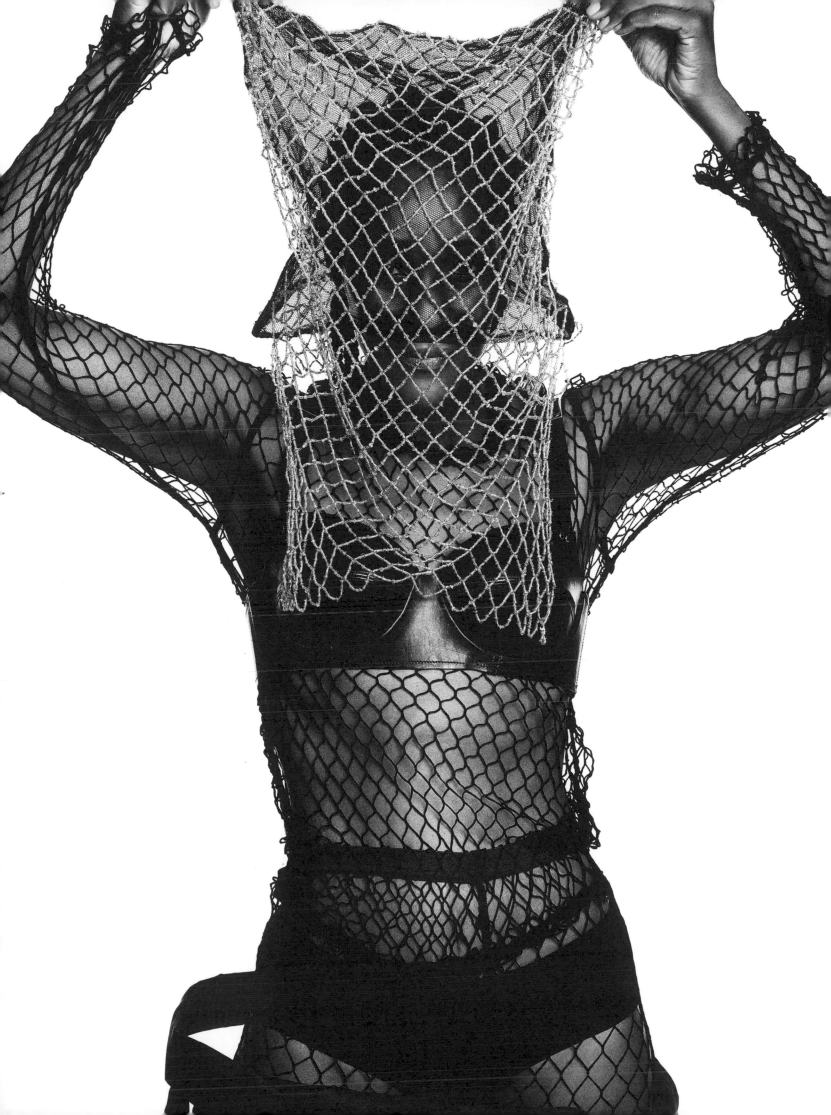

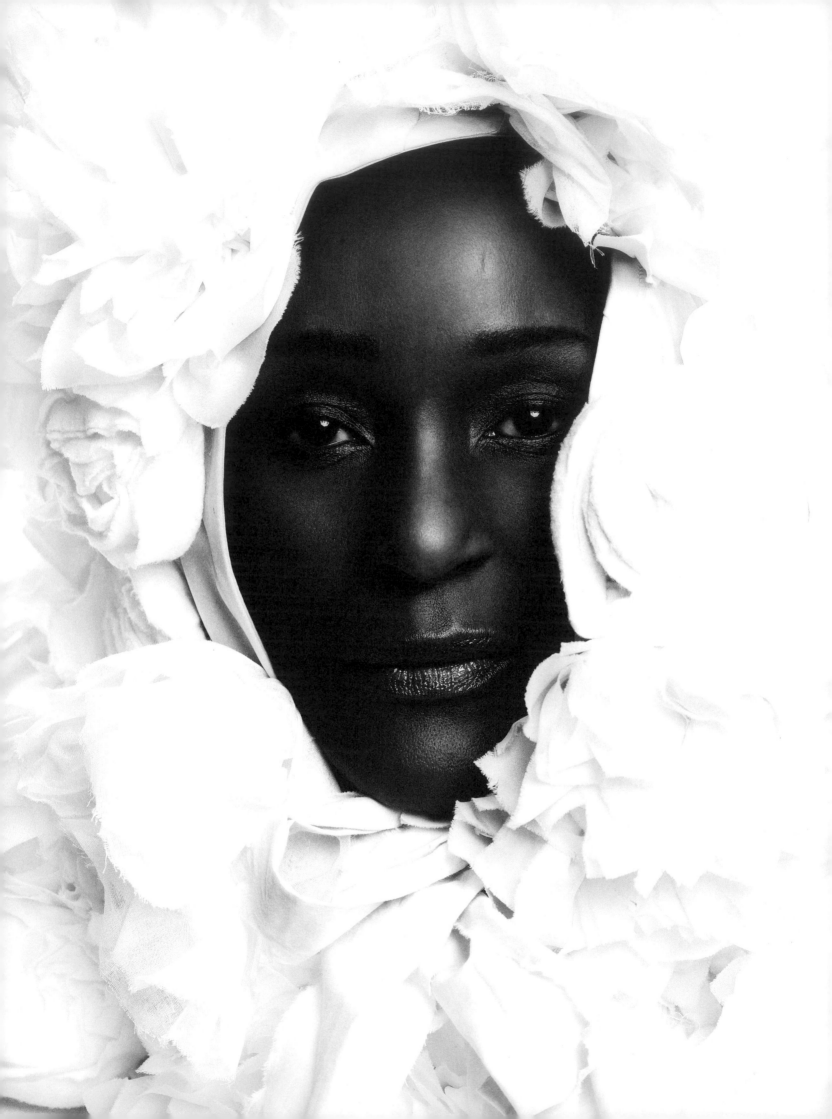

RJ: That's real commitment. It almost goes into the realm of art performance or living sculpture.

ME: Once you put on certain pieces from Comme that restrict you, you become a performer.[1] The minute you go out on the street, people look at you. "Who is the strange person here?" You get either adoration or rejection. You're ready for everything. People take pictures of you without asking; they think you're a freak show. I went to Paris, and they went click click click.

RJ: Do you see your clothes as a conversation? Or perhaps an opening gambit where you can't control the response?

ME: That's the beauty of Comme. [Kawakubo] opens conversations. It's like when you go into an exhibition. Whether you like it or not, it's a conversation. The fact that you like it is a conversation. If you don't like it, that's an even more interesting conversation because you have to understand why. We only like things we see within ourselves. We dislike things we don't understand. I prefer disliking. I'm always interested to see how far I can push myself and what clothes can do for me. Why am I so fascinated by the most difficult ones?

RJ: Other than Comme des Garçons, Yohji Yamamoto and Vivienne Westwood—whom I know you also love—which designers do you currently admire for their strength of vision?

ME: I would not miss a Valentino show. I love Pierpaolo [Piccioli]. *Love*. He makes me want to wear Valentino couture. But I have to afford it. I *will* buy a Pierpaolo Valentino cape. That's something I am saving for: I don't care if it's my last wish, I will buy one. Talking about last pieces, I always think about what I would want to be buried in.

RJ: Have you got that planned out already?

ME: Definitely. I was in charge of dressing my mom when she passed away. I have to put it in my will that they dress me up. I don't want to be cremated, that's for sure. My last exit has to be a dress. I haven't found it yet. But I have an idea. The [Comme des Garçons] White Drama collection. Oh! With flowers and flowers and flowers. I always dreamed Rei made that as a burial dress.

RJ: It's one of the strange things about clothes: They outlive their owners. What do you imagine happening to your own collection?

ME: I would want [my family] to continue the collection and eventually exhibit it in Haiti. That's my big wish. I want to bring something back to my roots, to where I was born. I want kids who are interested in fashion to visit and say, "Wow, she was Haitian; wow, I could do that." Just like, as a kid, I used to watch all the flights in the sky. I imagined Europe, I imagined Paris, I imagined New York. I would want to bring [that] back, to give that. Even if it's just to one or two people, that's enough.

(1) Elie takes a starring role in *Fashion Babylon* (2022), a documentary by filmmaker Gianluca Matarrese that lovingly charts the lives, dreams and crises of fashion world insiders. According to Matarrese, the documentary's title alludes to the "Babylonian chaos of illusion and self-delusion" inherent in the fashion world.

"By the time I'm 90, I think I'm going to be severely abstract."

(left) Elie wears a dress by COMME DES GARÇONS (SS12).

If everyone's a critic, is anyone?

ESSAY:
CRITICAL MASS

Words
HETTIE O'BRIEN

If criticism is a service industry, who is it serving? Judging by a number of recent articles, the answer is nobody. Cultural critics live in an "unrepresentative internet bubble," Yair Rosenberg wrote in a January edition of his newsletter for *The Atlantic*. "The contemporary reader is unhappy" because critics are "lying to him," according to a recent essay by the editors of the literary magazine *N+1*. The dominant mode of criticism today is the "hatchet job" marked by "scornful hauteur," Richard Joseph concluded earlier this year in the *Los Angeles Review of Books*.

According to these accounts, critics are either desperate click-seekers or isolated internet users who have become inured from the cultural preferences of ordinary people. To Joseph, the worst traits of criticism resemble Amazon Marketplace: "The market logic of the contemporary

These arguments identify a certain dishonesty in contemporary reviews and a lack of good faith among reviewers. Part of this diagnosis has to do with the shrinking of editorial budgets of traditional media, which has been accompanied by a simultaneous explosion in the number of opportunities to express one's opinions in writing.[2] Speaking recently at a panel event hosted by the National Book Critics Circle, the literary critic and *New Yorker* staff writer Parul Sehgal identified how the breadth of critical opinion on social media "puts pressure on the reviews to stand out ... on the critic to either have [their review] anoint or destroy" a work.

There is also the simple fact that negative reviews are more fun to read, and therefore make a bigger splash on the internet. Larissa Pham, a literary critic and author of the essay collection

" People love reading something negative—seeing someone getting taken down. It's very exciting."

book review, like the rest of journalism today, is the logic of virality: clicks equal revenue," he writes.[1] Before everything was available to read online, people might have turned to their regular newspaper or magazine to figure out which books were worth reading or exhibitions worth visiting. Now, the field of discourse has expanded and the attention of consumers is limited, so critics must ensure their reviews stand out among the competition, engineering their snarkiest sentences to later do the rounds on social media. The editors of *N+1*, on the other hand, identify the problem as one of skewed incentives: The critic is "a freelancer, jumping from gig to gig," they write. One review is always an audition for another. The rewards of honesty here are slim, so we shouldn't be surprised if the reviewer's inflationary praise and "tepid verbiage" seem contrived as fluff for a dust jacket.

Pop Song, tells me, "People love reading something negative—seeing someone getting taken down. Someone who is popular, a little mainstream, mass market. It's very exciting." But really good criticism should do something more than just lambast, she believes. In an essay for *The Nation*, Pham identified the great gulf that lay between two recent viral reviews: the ad hominem barbs that the critic Lauren Oyler laid on Jia Tolentino in her review of *Trick Mirror* (Oyler questioned whether Tolentino had ever met an ugly woman) and Parul Seghal's quietly

(1) Joseph identifies middlebrow authors as the most likely to be subject to a hatchet job. "It has a goal, and that goal is specifically to skewer commercially successful authors for aspiring to elite literary modes," he writes.

(2) Not all reviews are written. On TikTok, content creators have used the #booktok tag to share short, snappy reviews of what they're reading. Several book retailers, including Barnes & Noble, have a recommendations section dedicated to books promoted by these influencers.

devastating skewering of Kristen Roupenian's *You Know You Want This* (a "dull, needy book," in Seghal's words). Where the former took a dig at the author, the latter left such personal speculation out of it . Both reviews were negative, but Seghal's was "generative," Pham wrote; it evaluated whether the book had succeeded according to the terms the author had set for it.[3] "Interpretation is a gift, because it requires such care to read something closely. That's an act of generosity," Pham tells me. "You have to approach a project on its own merits and what it's trying to do."

Yet a lot of criticism does not do this. Part of the reason people like reading spicy, negative reviews is because it makes a change from dull reviews that merely act as publicity for the book or exhibition in question. The diminished status of criticism in publications that were once the

" The journalists had their reviews already written out. They just went back on the train and filled in the blanks."

gatekeepers of cultural opinion has produced many short reviews of this sort, which are too brief for substantial interpretation and too tame to be critical. The number of people who have the privilege of being paid to read an author's work or attend an exhibition or eat in a restaurant and then write about this experience in a newspaper or a magazine is shrinking.[4] Those who find themselves in this position therefore have a responsibility to do a good job of it—to engage with a work sincerely, to grapple with the ideas of the person who made the work, to read around the subject.

(3) Kristen Roupenian, the author of *Cat Person*, spoke in subsequent interviews about feeling that the acclaim of her first story had led to unrealistic expectations for her book. "Loads of people congratulated me on the story going viral but I didn't celebrate it. It was just scary," she told *The Independent.*

(4) Criticism feels fun and fair only when an industry is thriving. During the pandemic, when the restaurant industry was all but shut down, critics became understandably unwilling to write negative articles. As Sam Sifton, *The New York Times*' food editor, predicted in 2020: "There's going to be, I imagine, a drumbeat of boosterism and cheerleading."

Despite this, it can seem as though some critics are phoning it in. "I remember going down to see the Turner Prize in Margate. The press person told us that when all the newspaper journalists came down for the opening, they had their reviews already written out. And they just went back on the train and filled in the blanks," Zarina Muhammad, a British writer and art critic, tells me. "No wonder their reviews end up regurgitating press releases." In 2016, Muhammad founded the White Pube with Gabrielle de la Puente. The arts criticism and curation platform has since become known for its irreverent reviews and memes about the art world, published through its website and Instagram. It was born from a sense of frustration that Muhammad and de la Puente shared toward contemporary arts criticism: the "white people, white walls and white wine" that dominated the industry, as Muhammad has previously described it.[5]

In 2016, Muhammad visited an exhibition in London that de la Puente had recommended. After the exhibition, she caught a bus and found a copy of the free *Evening Standard* newspaper on a seat. Inside was a review of the show that she had just seen. "I sat on the bus, secretly furious. How was that a review? It had just described what was in the room and given it three stars—no justification," Muhammad says. When she arrived at the studio she shared with de la Puente, she "slapped down the newspaper on the table, and that was our conversation for the day. We spoke about how weird it was that as art students we didn't really read art criticism. We didn't read contemporary writing about our field of study. How odd is that?"

Six years after first buying the domain name for the White Pube, the work that de la Puente and Muhammad are most proud of is the grants they award to working-class writers and critics. Every month, the White Pube gives £500 ($650) to a new writer, with no strings attached. "It doesn't help that writing is quite a middle-class thing. I'm middle class. I wouldn't be a critic if I wasn't," Muhammad says. "This is such a bizarre way to make a living—it's so precarious . . . and unrewarding. I think a lot of it comes down to access."

I sometimes wonder why anyone would want to read what someone else has written about a book, when they could have the experience of reading it (and blasting it on Goodreads)

themselves.[6] Then I remember that the best pieces of criticism are works in their own right—writing that pays careful attention to the work of others, vindicating the attention we pay both to that work and to our own lives. "When I think of criticism, I think of interpretation. When I finish a book and I have questions, the first thing I look for is reviews," Pham says. "At its best, a review allows you to look at something in a new way or shines a light on something that might be ambiguous or highlights the beauty of that ambiguity. Ideally, you're always trying to give someone more ways of looking at something."

(5) The White Pube's founders are also keen to break down traditional boundaries of what gets reviewed and what doesn't. The site often publishes video game reviews written by de la Puente. As she explains in one blog post: "I used to be an art critic but suddenly exhibitions were locked away. Games were there in my bedroom with me, ready."

(6) Authors have a love-hate relationship with Goodreads, the world's largest online book community. One issue is review bombing—a coordinated attack on a book's star rating by a group of people who object to its message or, in some cases, want to extort the author by demanding payment to stop the trolling.

At work with *Giancarlo Valle.*

Gi
anc

arlo

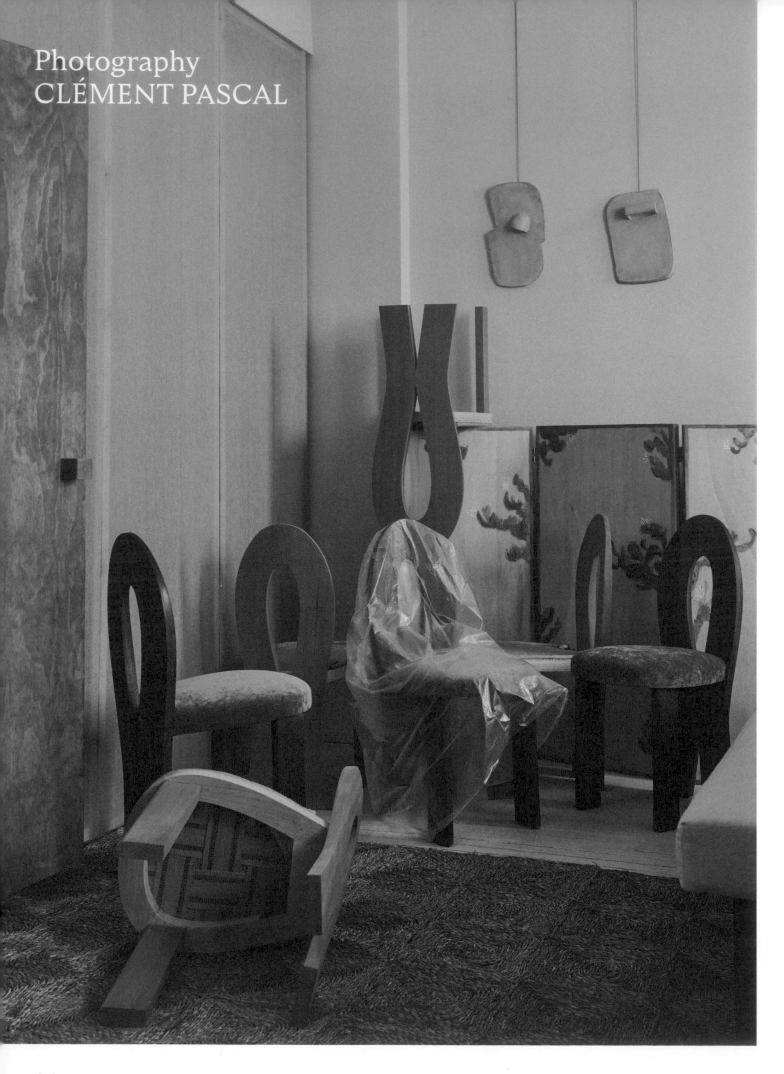

Photography
CLÉMENT PASCAL

There are many worlds within the walls of Giancarlo Valle's interior design studio in New York City's Chinatown. Dollhouse-like maquettes are scattered throughout the room, fitted with tiny, curved sofas and coffee tables, pocket-sized lamps and vases, and painted screens and works of art no bigger than a postcard. These meticulously rendered miniatures represent details from Valle's works in progress. A model for a home in rural Connecticut includes minute reproductions of the client's extensive collection of architect-designed furniture that Valle is incorporating into the overall scheme. Nearby, sitting on a shelf between unpacked boxes, is another exquisitely detailed room representation with tiny clay icons sprinkled across the ceiling. This represents a project on pause, but Valle keeps the model on display for inspiration.

Valle, who has come from dropping his kids off at school when we meet, surveys the studio, where four members of his staff have begun to settle in for the day. Boxes and maquettes stretch toward the ceiling. "We're sort of mid-move," he explains, gesturing to a set of stacked shelves at the back of the room—a carryover from the studio's former, smaller space just down Canal Street. "We keep uncovering things we'd forgotten about." A Smile chair—one of his first and more famous designs—is perched on one of the upper shelves. Made of shearling and suede, the chair is defined by a wide, cradle-like seat in the shape of a smile. On the studio's walls are taped images of furniture and interiors; inspiration for ongoing projects. The space is full, yet feels open and cohesive, a reflection of Valle's distinctive style.

Valle opened his eponymous design studio in 2016, fresh from positions at top-tier architecture firms including SHoP and Snøhetta. Early, high-profile projects, like a hotel in Tulum, a residence in Singapore and a studio for artist Marilyn Minter, showcased his holistic approach to design, one that combines architectural elements, custom furnishings and decor.[1] Soon, other big-name clients began to reach out, including the model Martha Hunt and Hollywood entrepreneur Kevin Wendle.[2] Still, Valle is modest: Seated at a long table in the new conference room of his studio, he speaks rarely of himself, and more of the collective work of his team.

"I feel like with a lot of these things it's a reaction to personal experiences and where you came from," he says of his style, which is characterized by soft curves, clean wooden furniture and sparing use of bold, rich colors. Symbols of these design sensibilities are peppered throughout the room—a low, tile-topped coffee table sits before a green sofa with a scalloped back; an ornamental glass light fixture hangs overhead.

(1) Valle's design can be surprisingly playful. For Minter's studio, he designed a wall installation featuring a jumble of large rectangular boxes that conceal coat closets.

(2) Hunt was inspired to hand over the design of her New York apartment to Valle after a visit to his nearby studio. "I first went in for chairs, and it evolved from there," she told *Architectural Digest* in 2021.

Growing up between San Francisco, where he was born, Caracas, Chicago and Guatemala City, Valle was introduced to a variety of cultures and aesthetic sensibilities during his formative years. An academic background in architecture, which he studied at the graduate level at Princeton University, has informed his technique. "A big part of [my work] is my questioning of the boundaries of architecture. . . . I look back at a lot of the people that I respect and there were no boundaries there," he says. "It was very fluid. They were designing furniture and cities and buildings and houses."[3]

While Valle has left his days of building design behind, he applies some of the same skills to interiors and his own furniture creations. Wanting to remove the silos that architects and interior designers often find themselves in, Valle aims to merge both disciplines. In addition to sourcing decor and making bespoke furnishings, he reconstructed a staircase for a Manhattan townhouse and inserted ultra-thick interior walls into a Greenwich Village loft. For his own home in Brooklyn, he gutted and redesigned the kitchen, constructed bookshelves and built custom closets and drawers.

> "With a lot of the people that I respect, there were no boundaries. They were designing furniture and cities and buildings and houses."

Part of Valle's approach is his somewhat idiosyncratic use of maquettes, the small-scale mock-ups of projects he is working on. "There's something you can't fake with a model in the way you can with a computer, and I like that the model in and of itself is an editing tool," he explains. "There's a structural element which is actually an architectural concept: If you can't build it in the model, you can't build it in reality." The miniatures are made of wood and clay, a material Valle prefers because it's quick to mold and has a simplistic quality. "There's a sort of sketch-like [quality]," he says of clay. "We look at the model and think, *Can we make the physical thing not look like clay, but have the simplicity of it?*"

Any given project will go through both digital and physical renderings, a multi-draft process that allows for careful editing of a space. "We're not tied to any medium per se," says Valle. "Being able to move from three dimensions to two dimensions to sketching to illustration, that all has to be very, very fluid. You have to jump between them to really understand what the limits of an idea are or where you can extend it."

(3) The furniture and objects that Valle collects often come from fringe movements, moments in history when designers were transitioning between styles, or the designs people made at the beginning or end of their career.

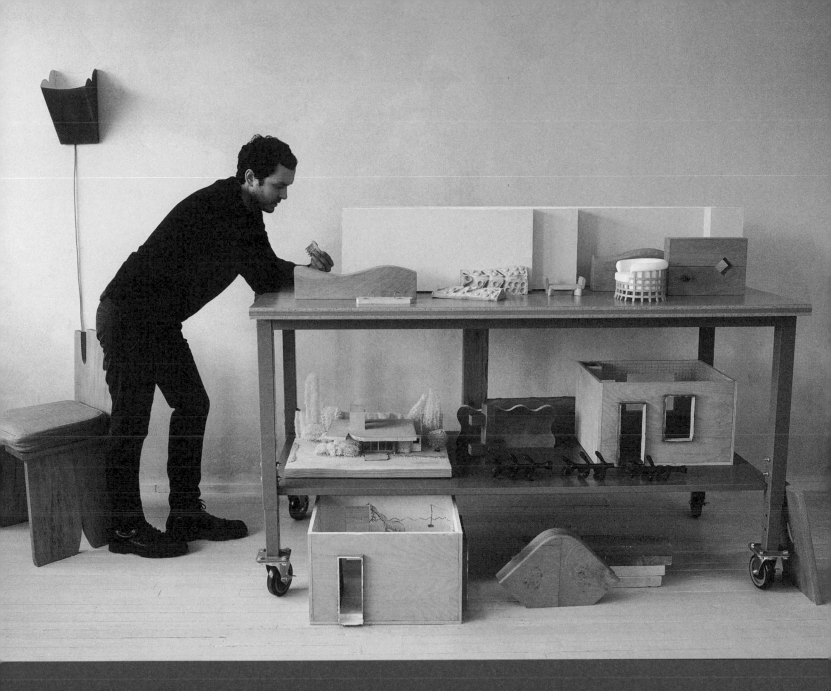

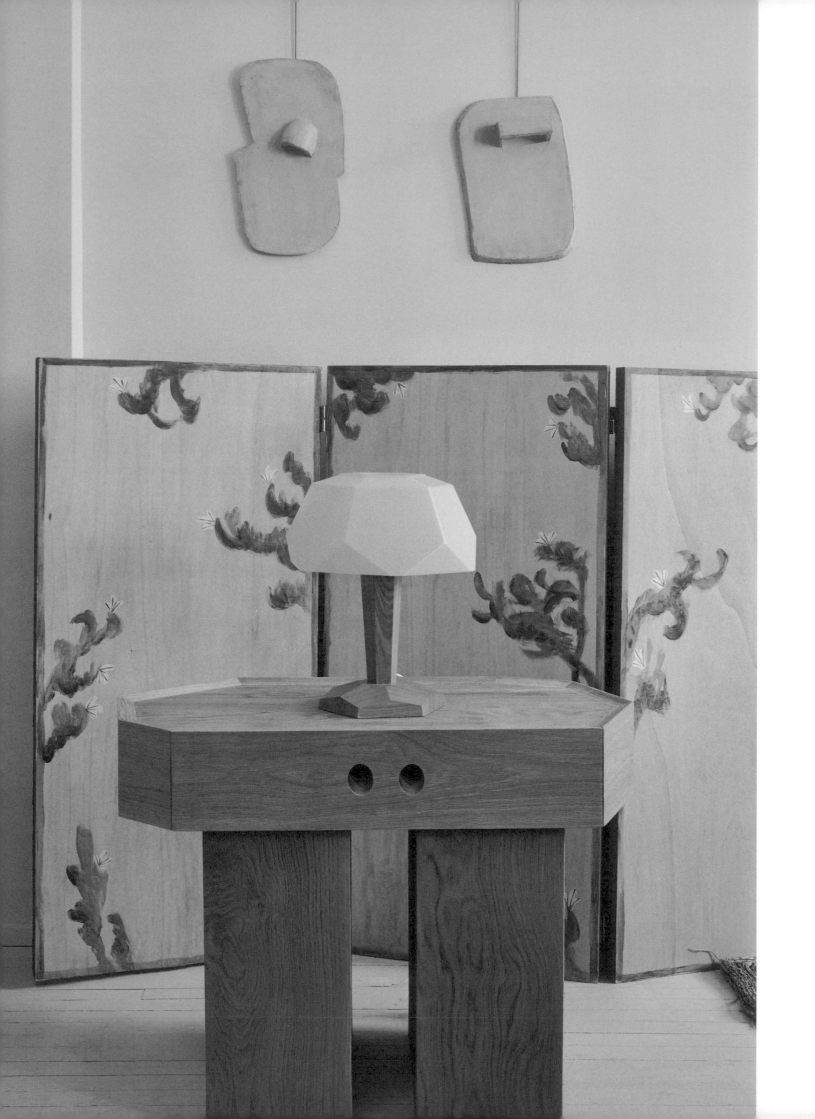

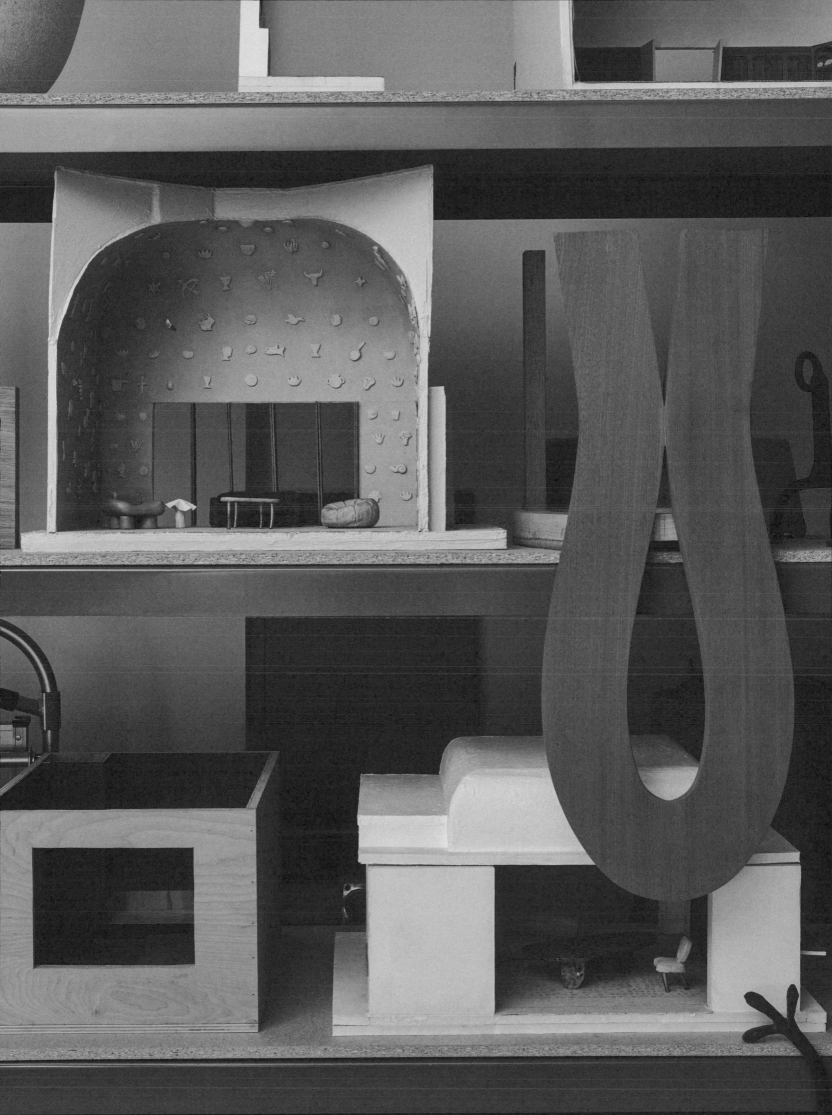

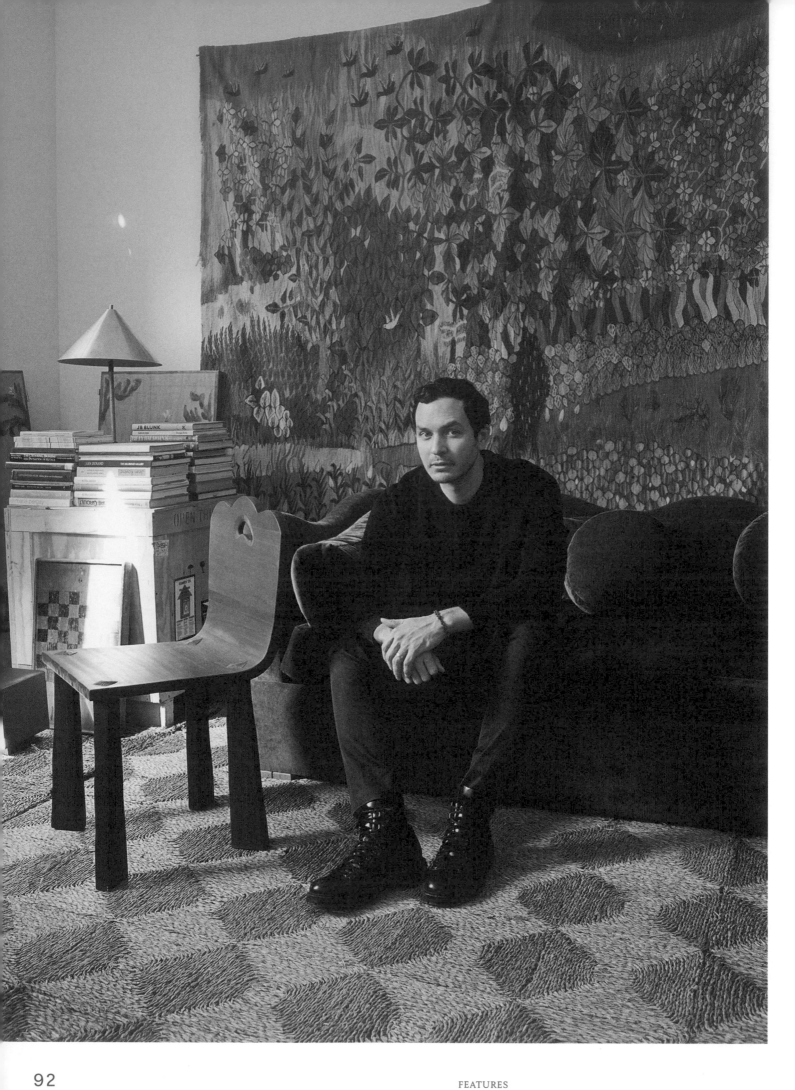

Valle's layered use of mediums in the creative process is evident in the finished designs. You get the sense that these spaces are meant to be lived in: A far cry from the sterile computer renderings of a real estate listing, his work is tactile and has a warmth within it. "That's where we invest a lot of time and energy, trying to make that balance look effortless," he explains. "We're working in a way where we can control a lot because we make a lot [of bespoke furniture].[4] It's just a personal approach that allows the space to be very harmonious, but also not too serious. It can't be serious."

While Valle is especially well-known for his own bespoke furnishings, he will work with master artisans on certain touches—handwoven textiles, perhaps, or custom ceramics. Valle has commissioned artists like Natalie Weinberger to create stoneware tiles for tabletops, and Matt Merkell Hess to create custom ceramic tiles and a fireplace. "We don't know where we're going sometimes," he says of these partnerships. "It's not like we're sketching something and asking them to reproduce it. It's more: Here are the variables, which way do we go? That's really exciting, to be able to improvise and not feel tied down."

When asked which upcoming ventures he is most excited about, Valle names three home interiors projects—the one in rural Connecticut, another in Minneapolis, and the last in Toronto. Though each structure is vastly different architecturally, Valle is unfazed. "I actually like the challenge of very different types of projects. We're always trying to stitch them together in a way that feels cohesive, but they are quite varied," he explains. There is an increased interest, it seems, in Valle's particular niche: design that looks beyond fragmented elements of space and at the structure as a whole. Valle understands, on an intuitive level, that this is part of his appeal. "People that come to us now are looking for an experience," he says. "They want the whole thing. It's great that we're now able to really look at those projects through that lens."

(4) At the beginning of his career, Valle's furniture was all bespoke. Some items are now available for purchase, although often with a lead time of three months.

Inside the London apartment uniting Greek mythology,

Home Tour:
GERGEI ERDEI

Words
JOHN OVANS
Photography
ALIXE LAY

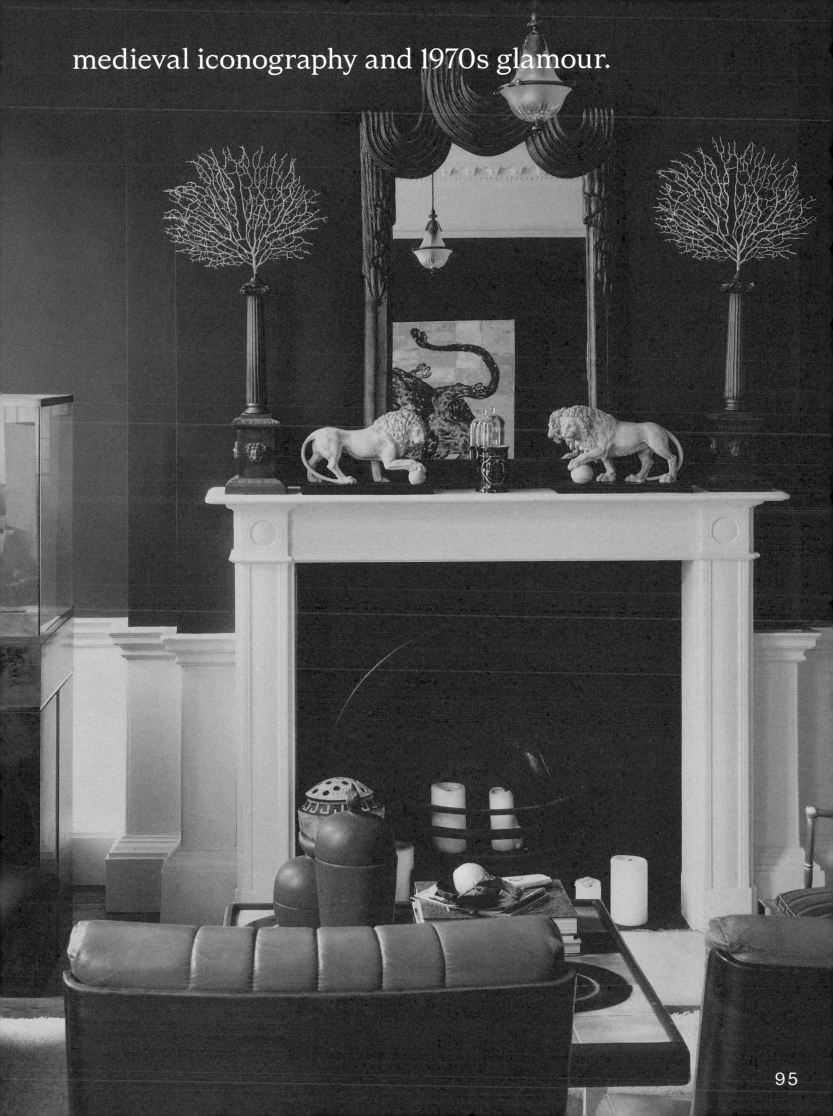

medieval iconography and 1970s glamour.

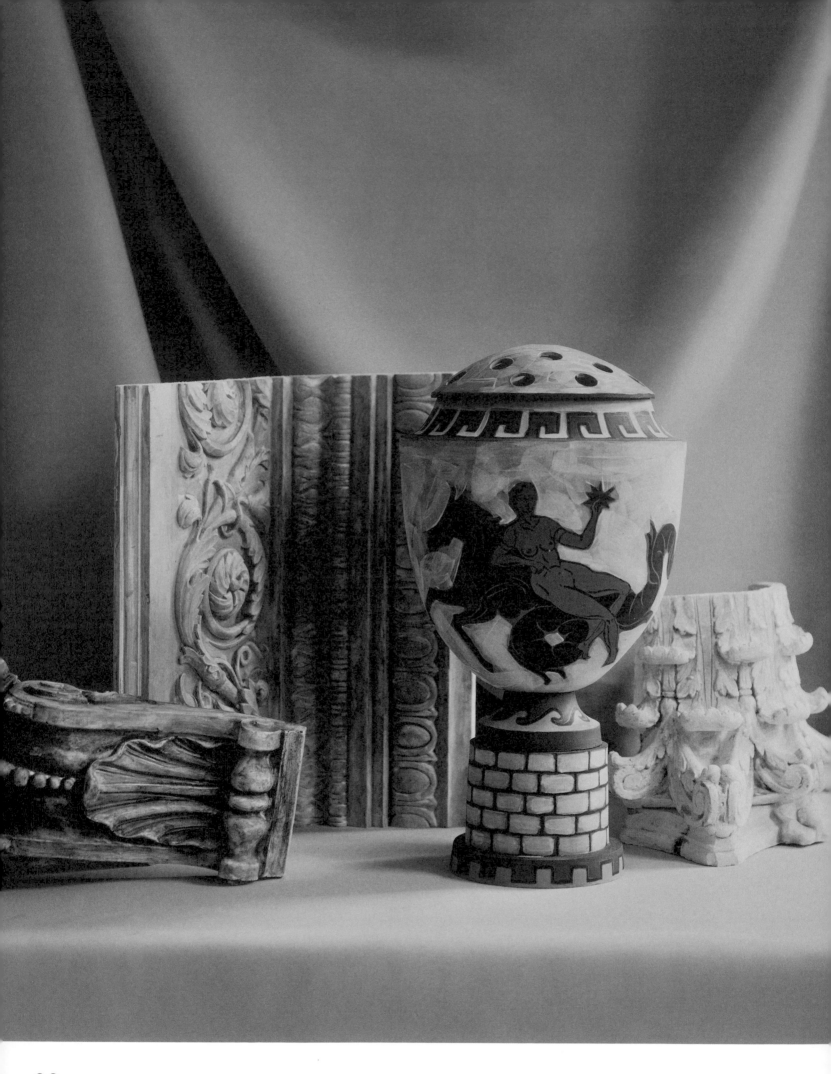

Lamb's Conduit Street is fiercely protective of its independence. The partly pedestrianized street in London's Bloomsbury is lined with characterful Georgian buildings home to independent boutiques and restaurants; when Starbucks tried to open, residents blocked the move. Charles Dickens was once a local, and W. B. Yeats attended séances here. The area also inspired the setting for Virginia Woolf's *Jacob's Room*.

Another storyteller who has made his home here is Gergei Erdei, the former Gucci designer whose eponymous interiors brand was founded in 2019 and is now stocked by retailers including Matches and Selfridges. His wildly adorned homeware draws from an endlessly intriguing pool of references, from medieval creatures and Greek mythology to zodiacs and celestial patterns. One placemat features a Roman dog, lazily stretching within a border of bursting blue sunrays, while his cushions feature prints of marble floors from ancient Pompeii. His current collection was inspired by the bold geometric prints of designers like David Hicks and André Arbus. Like a good story you want to hear again and again, his work is warm, lived-in and more than a little eclectic.

Erdei's home fits the same description. The apartment is situated in exactly the kind of building he dreamed of living in when he was growing up in his native Hungary: an early 18th-century townhouse with enormous windows and high ceilings. Deep terra-cotta walls provide an unassuming backdrop for his unusual furnishings: an '80s chair in polished nickel replete with horned ram motifs; an energetic painting of leopards brawling—painted by Erdei and inspired by a Roman mosaic; a vast antique display cabinet. But his apartment is not quite the overstuffed maximalist explosion you might expect as an extension of his products, which he explains was a conscious decision to keep the mood a bit

calmer for the occasions that he works here. Having only moved in six months ago, he acknowledges that he's "missing all those items that have memories connected to them. Bits that make a home a home, so that's the next step."

This reverence for the imagination is shared by several other young interior designers who have moved to the UK from overseas. There's the colorful, entertaining aesthetic of Swedish decorator Beata Heuman, and the sumptuous, decorative patterns and prints of Milan-born Marti-

(above)
The storage boxes in Erdei's apartment are marbled, in keeping with the theme of antiquity.

na Mondadori Sartogo. If Britain is a nation known for its eccentricity, then it's no surprise that it should be a home—both spiritually and literally—to like-minded designers, each with their own take on modern maximalism. And it can be no coincidence that the rise of this aesthetic has come during

the sensory deprivation of the pandemic, when our homes became our whole worlds.

"I feel British people are curious and not scared to experiment, therefore British-based designers are also braver because they have an open-minded audience," says Erdei, who first moved to London for his master's in womenswear at the London College of Fashion before accepting the role at Gucci. "If we look back to the interiors of British stately homes we can see how eccentrically they are filled with mix-and-match objects—from Grand Tour souvenirs through to chinoiserie collectibles," he says. "But we don't even have to think about anything opulent. We can just think about the average British home in the '50s when the crazy floral wallpapers were big and they sometimes paired them with patterned carpets. There was a lot going on."

The current trend for maximalism is sometimes dubbed "cluttercore," although this is misleading given that—done "right"—it converges with minimalism at the point of careful curation. Detail is important to Erdei—right down to the literal cherry on top. "The photo shoot we did for [the most recent] collection, I wanted to go towards a jet-set lifestyle in Palm Beach in the '60s and '70s.... I was searching for this cocktail cherry that is a typical element of a '60s motel buffet dinner," he says. "Usually when I design, it's almost like creating a film set. I'm listening to the right music that puts me in the mood; I'm trying to imagine a full interior but also the people who live there—what they are wearing, what kind of life they have. It's nailing those references."

This attention to the small details has always made all the difference to Erdei; for him, it's essential to making a home. "Your home is there when you wake up and start your day, it obviously matters—like what sort of plates you're eating from. When I was a student I couldn't afford nice things.

(left) This terra-cotta urn was made in collaboration with ceramicist Giuseppe Parrinello.
(overleaf) Erdei hopes that his home will eventually become a shoppable showroom.

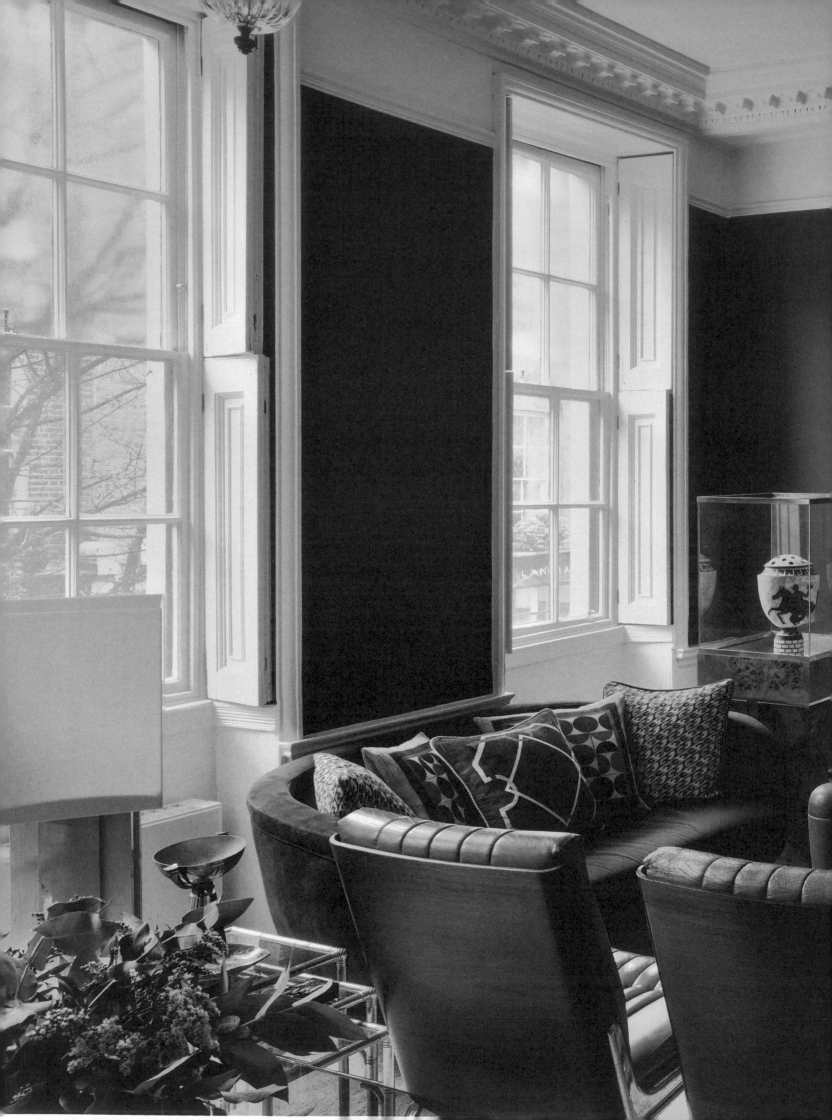

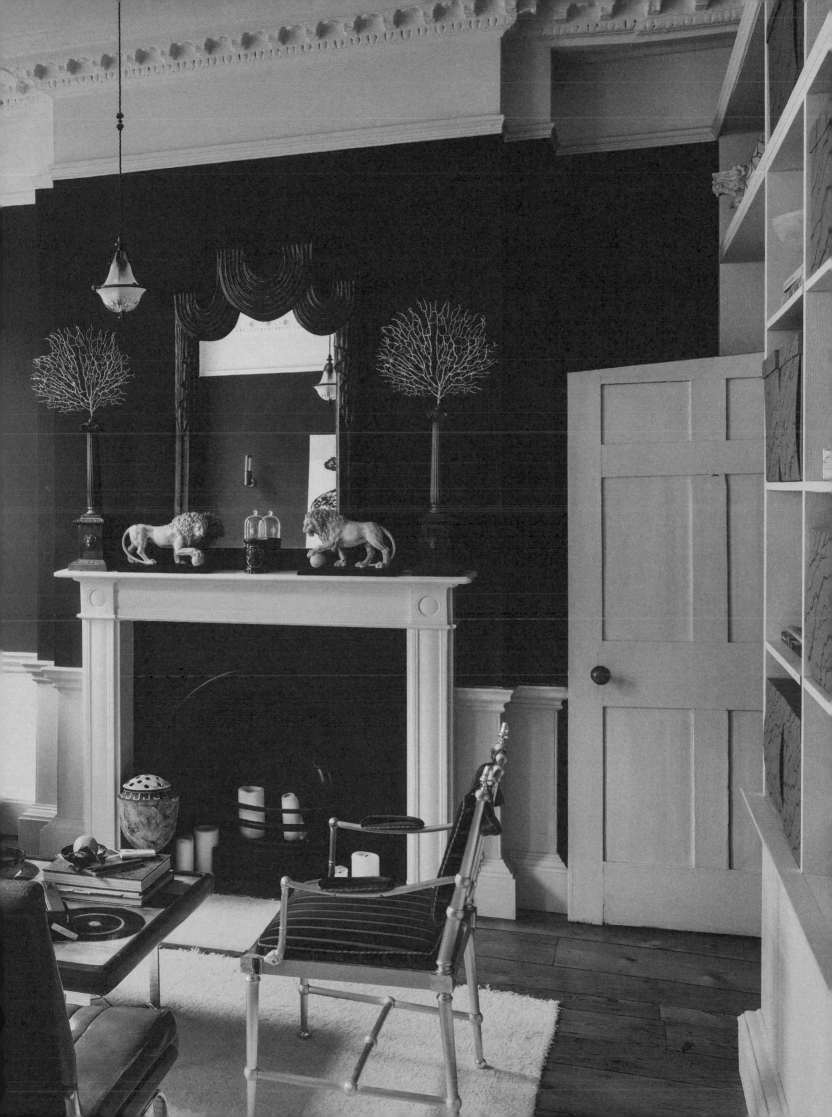

And it was such a pain for me to eat from plain horrible IKEA plates. I went to vintage markets and grabbed some £1 plates with big pink roses. What you surround yourself with is so important because it reflects on your mood."

The idea that your home should be deeply personal, as opposed to a white orderly cube, remains at the heart of Erdei's brand. "It's interesting to know the person behind the product, their visual development, everything that they've gone through. Now when there are so many brands without any story, or any designers behind them, just products, products, products, I think it's really nice to have something a bit unique, and more personal."

Eventually, he would like to take the relationship with his customers even further with a new platform on his site that allows them to "shop" his home for curated pieces. Throughout our conversation, Erdei rattles off the names of the many vintage and antique markets at which he is a regular magpie, and it's quite apparent he loves the hunt. There's another advantage as well: "I don't like to get bored by objects, so I like to have things going out and coming in." He references designer Jasper Conran, who recently emptied his grand estate via auction.[1] Bidders were able to see photos of some 430-plus objects in situ and take a virtual tour of Christie's King Street gallery, styled by Conran himself. "You could see all these pieces

that he had collected throughout his life and how the objects were styled in his home," says Erdei. "It's even more personal when it's coming from a space that is closer to everyday life, or an actual home." Beyond that, he'd like to open a boutique hotel: a whole lifestyle captured in one building.

Erdei feels that as a designer you should "put yourself into every small part" of a project. "You should really tell a story with everything." If his first home is anything to go by, his own unfurling story will be ambitious, unusual and never dull.

(1) Conran sold the contents of his six-bedroom apartment inside New Wardour Castle in 2021, explaining that he traveled too much to make good use of it.

UNDER THE

SUN

(left) Saliou wears a shirt and shorts by PRADA and sandals by LEMAIRE.
(below) Anna wears a top by ARKET and trousers by GAUCHÈRE.

(below) Anna wears a swimsuit by ERES and sits on a towel by HAY.

(opposite) Top Left: Anna wears a swimsuit by ERES. Top Right: Saliou wears a top by RALPH LAUREN. Bottom Left: Saliou wears swim shorts by VILEBREQUIN.
Bottom Right: Anna wears a swimsuit by ERES and lies on a towel by HAY.

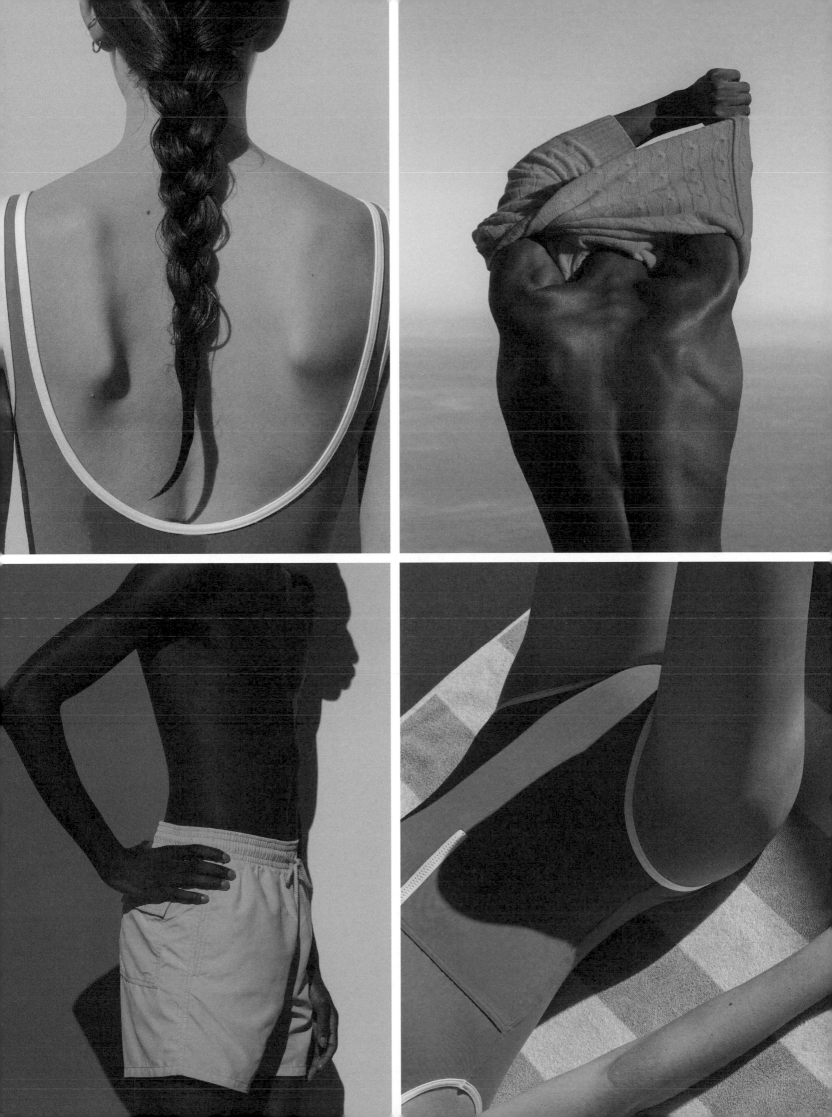

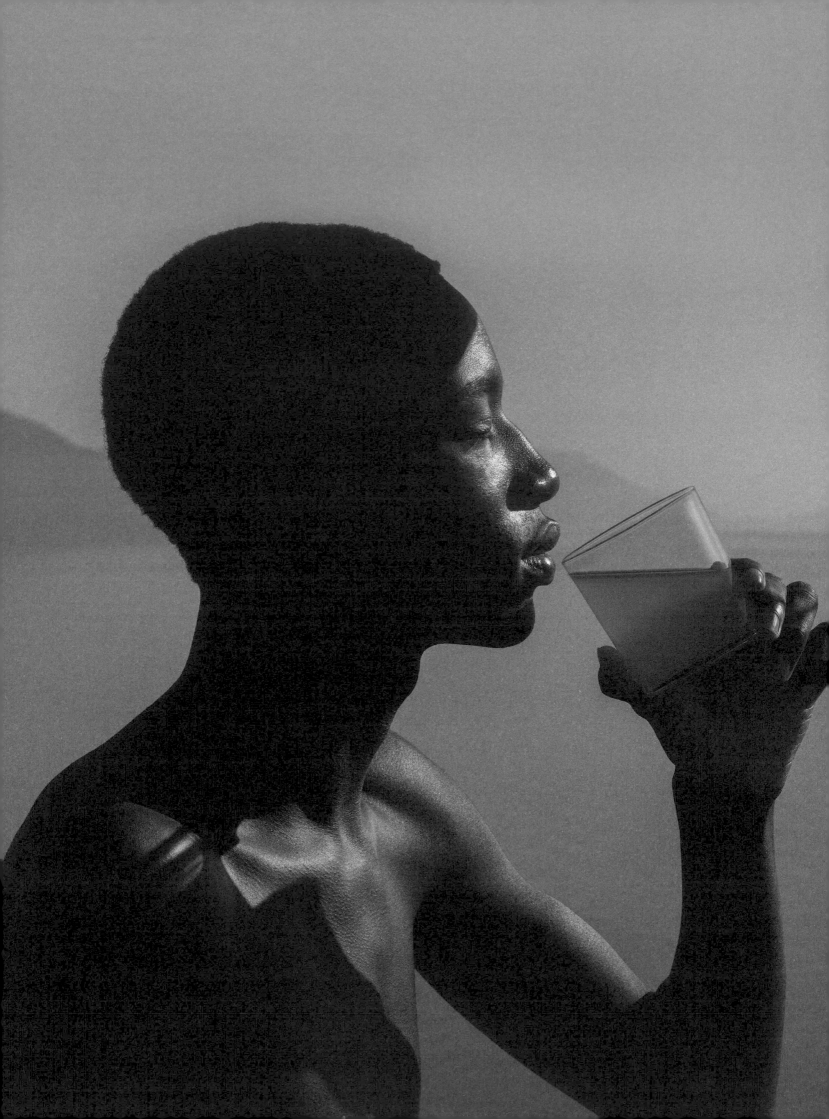

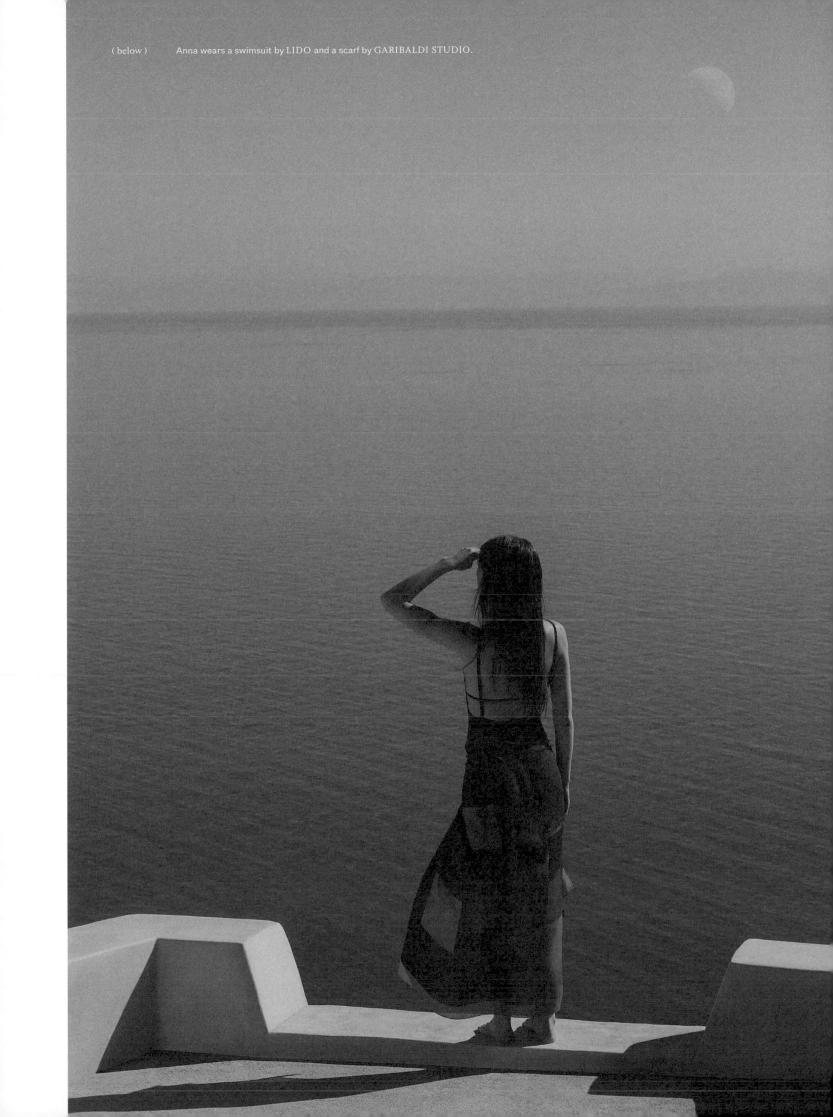

(below) Anna wears a swimsuit by LIDO and a scarf by GARIBALDI STUDIO.

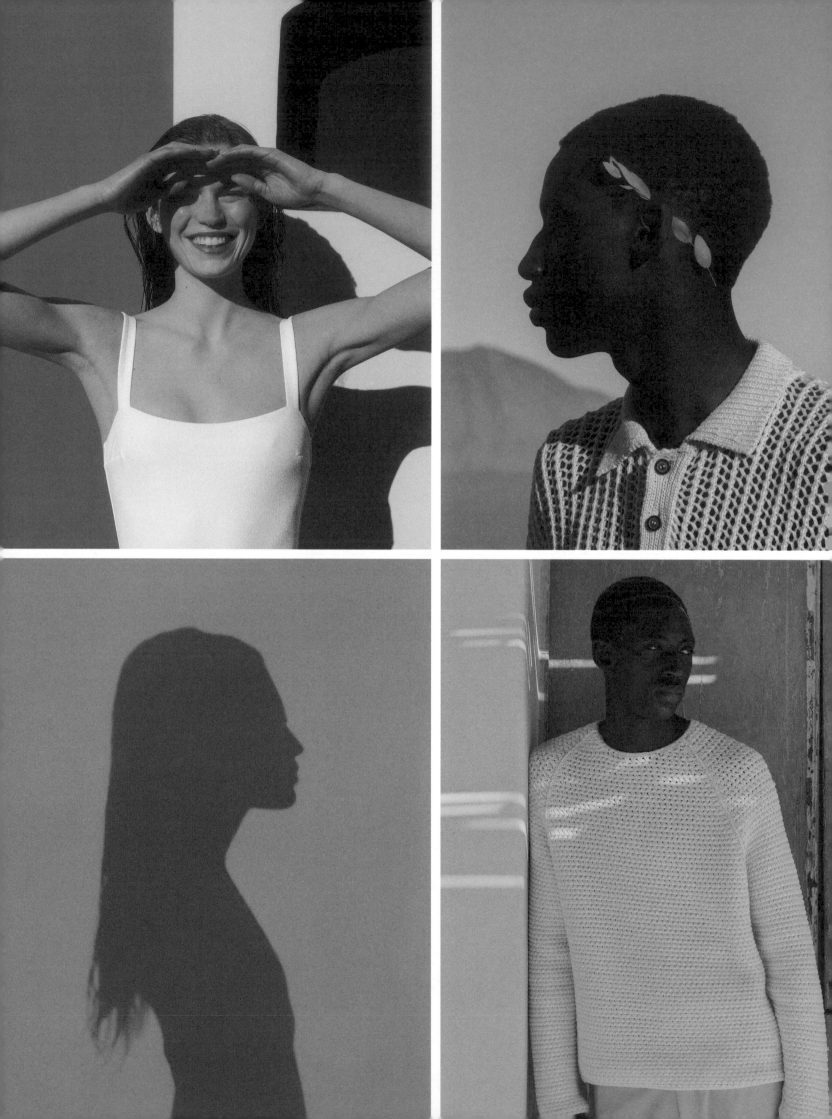

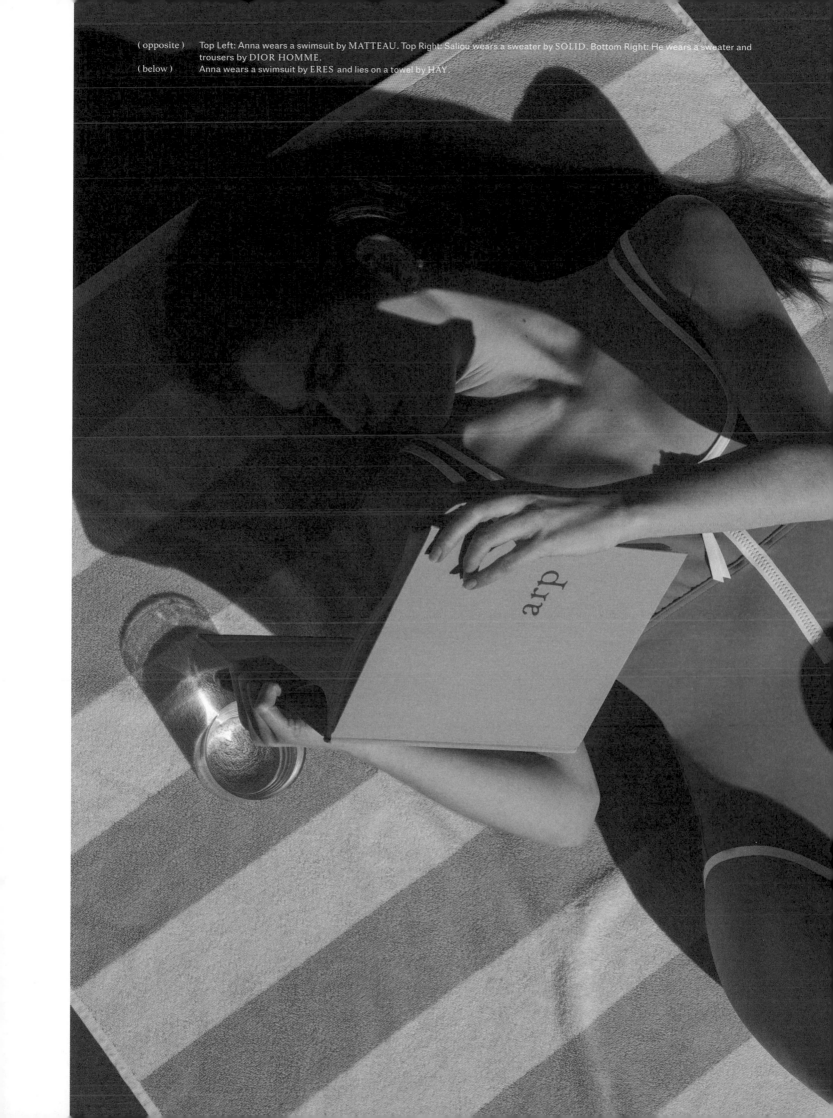

(opposite) Top Left: Anna wears a swimsuit by MATTEAU. Top Right: Saliou wears a sweater by SOLID. Bottom Right: He wears a sweater and trousers by DIOR HOMME.
(below) Anna wears a swimsuit by ERES and lies on a towel by HAY.

arp

Hair & Makeup
HELENA HENRION
Models
ANNA PALGEN & SALIOU DIAGNE
Location
ALICUDI, ITALY

Part 3.
THE WEATHER
Sun seekers, forecasters and René Magritte.
114 — 176

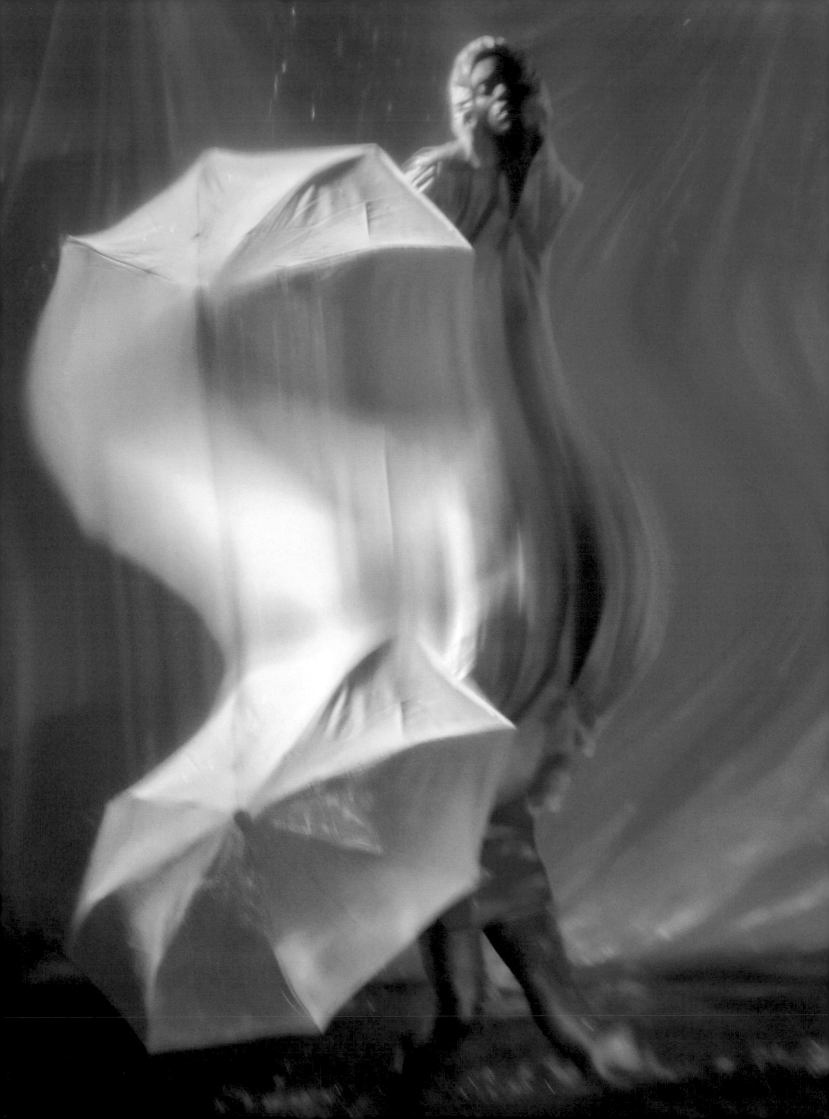

Drip Drop

(RAIN)

CHAPTER ONE
A splash of color for summer showers.
Photography PAUL ROUSTEAU Styling GIULIA QUERENGHI

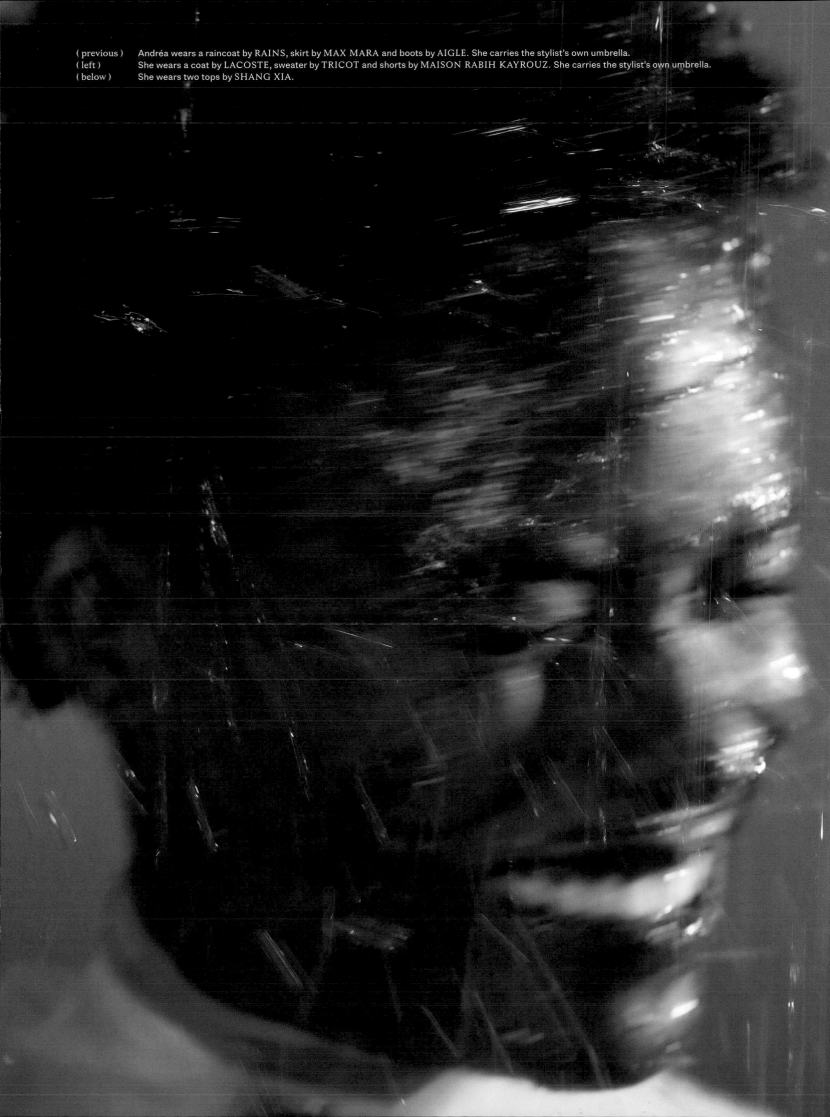

(previous) Andréa wears a raincoat by RAINS, skirt by MAX MARA and boots by AIGLE. She carries the stylist's own umbrella.
(left) She wears a coat by LACOSTE, sweater by TRICOT and shorts by MAISON RABIH KAYROUZ. She carries the stylist's own umbrella.
(below) She wears two tops by SHANG XIA.

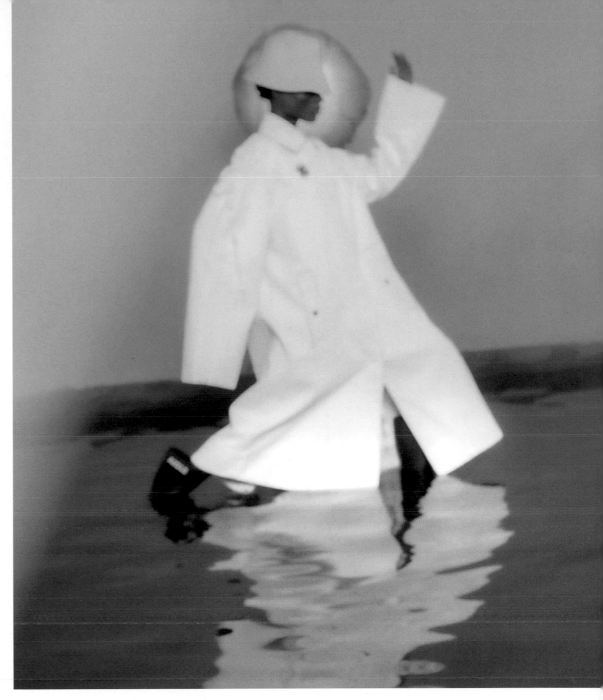

(above) She wears an outfit by HERMÈS.

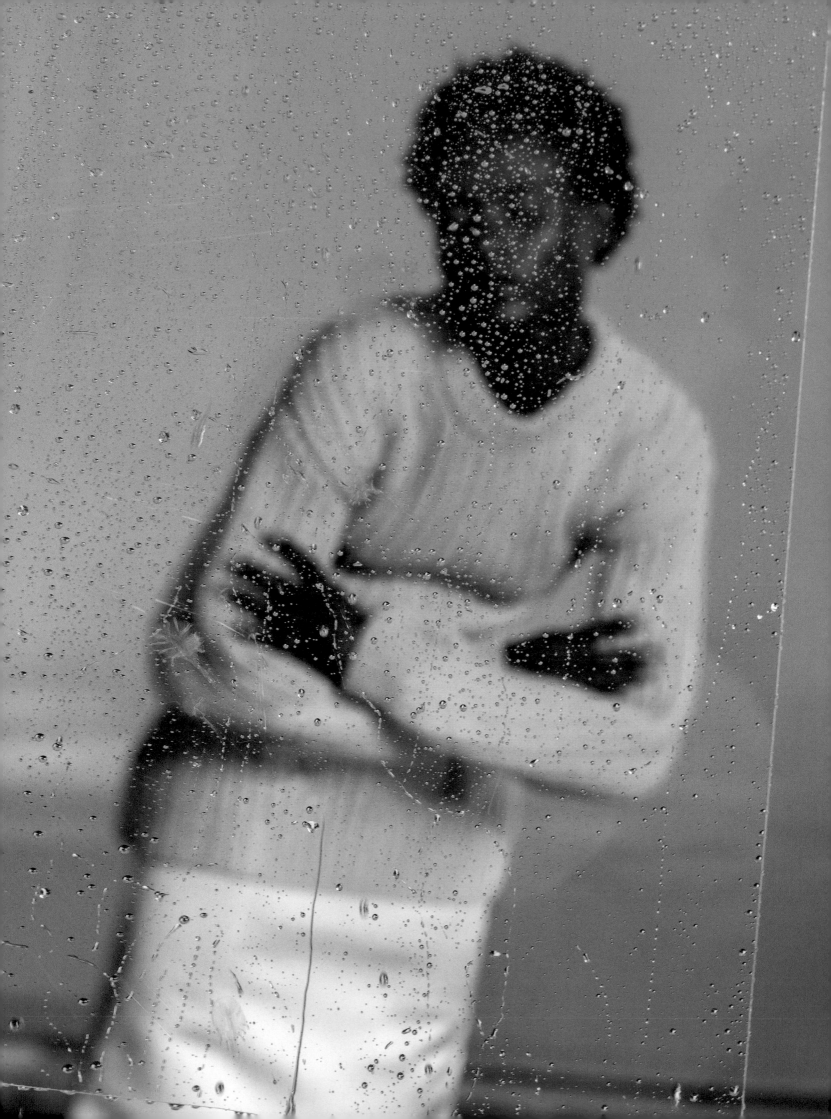

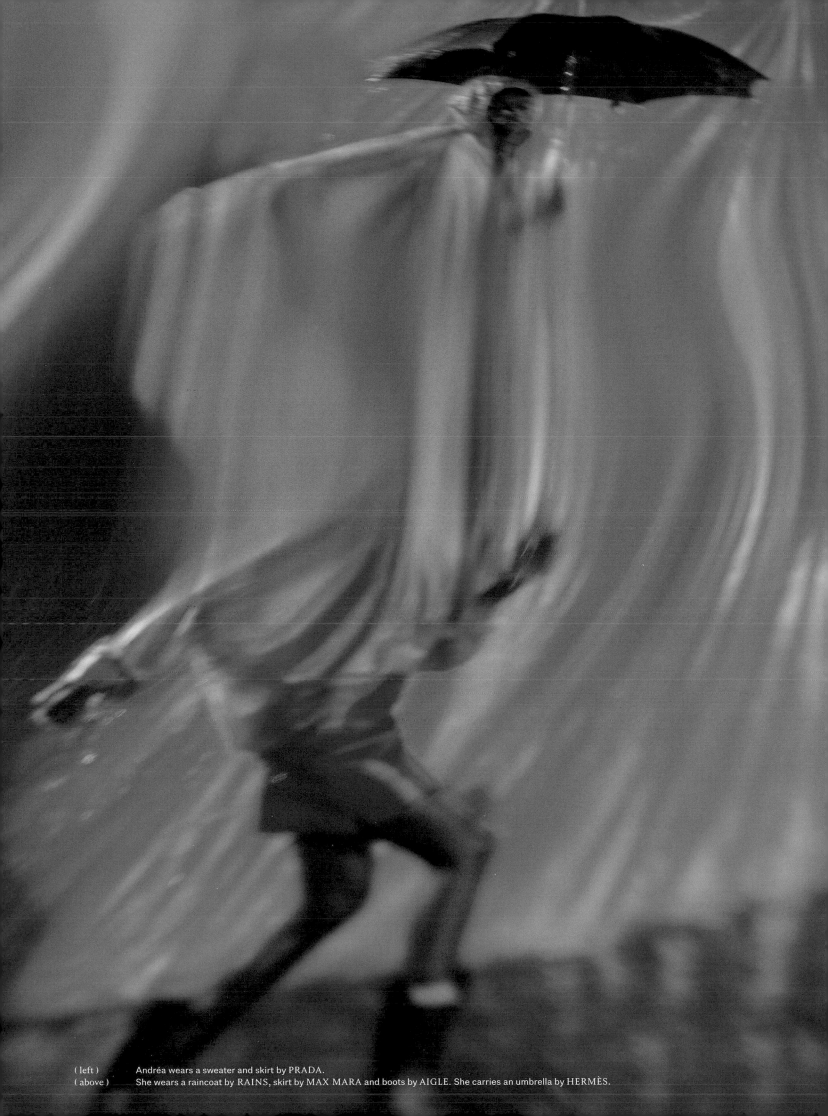

(left) Andréa wears a sweater and skirt by PRADA.
(above) She wears a raincoat by RAINS, skirt by MAX MARA and boots by AIGLE. She carries an umbrella by HERMÈS.

(below) Andréa wears a dress by MM6 MAISON MARGIELA and a hat by MAISON MICHEL.
(right) She wears two tops by SHANG XIA.

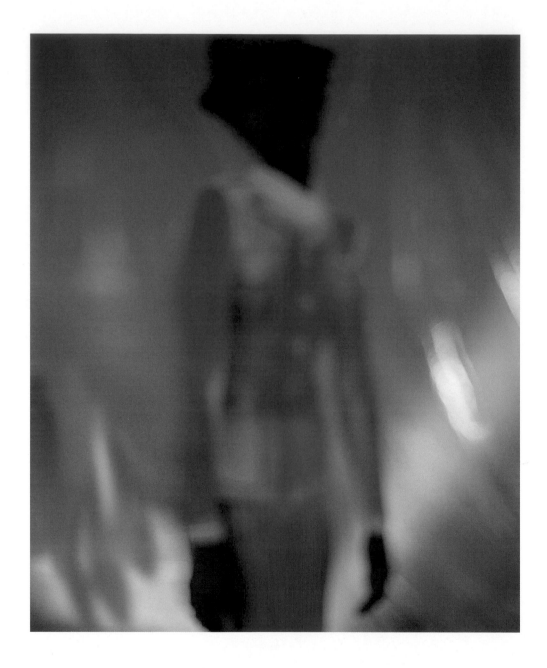

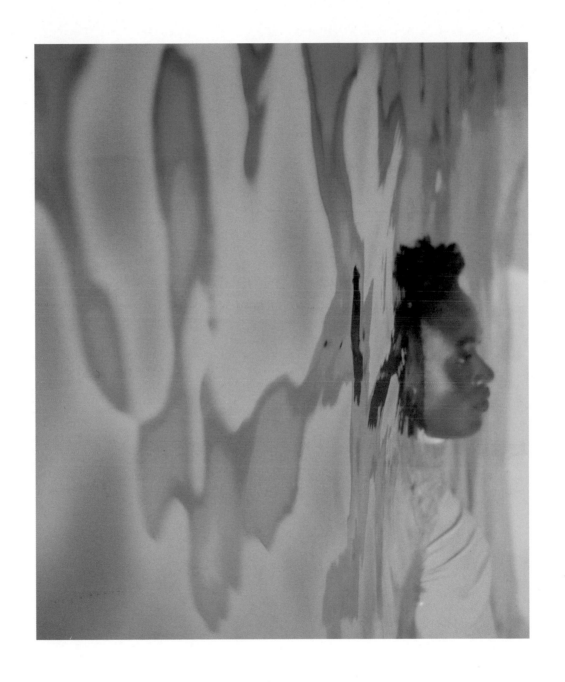

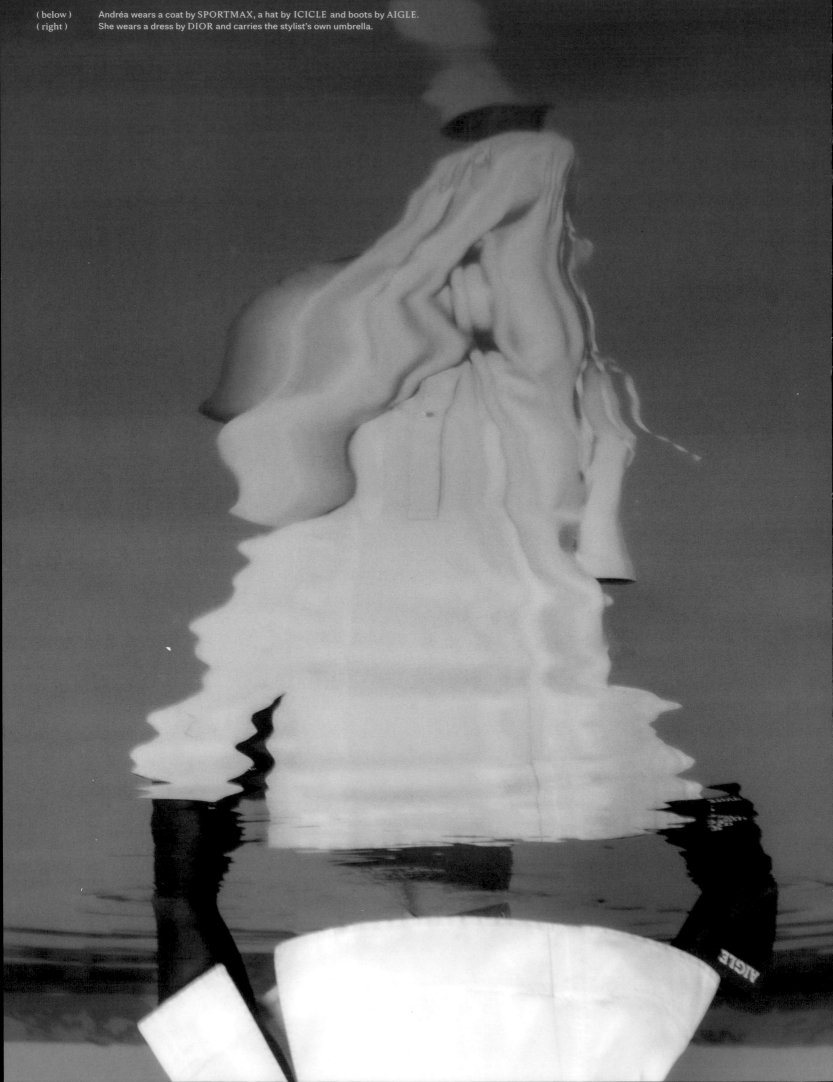

(below) Andréa wears a coat by SPORTMAX, a hat by ICICLE and boots by AIGLE.
(right) She wears a dress by DIOR and carries the stylist's own umbrella.

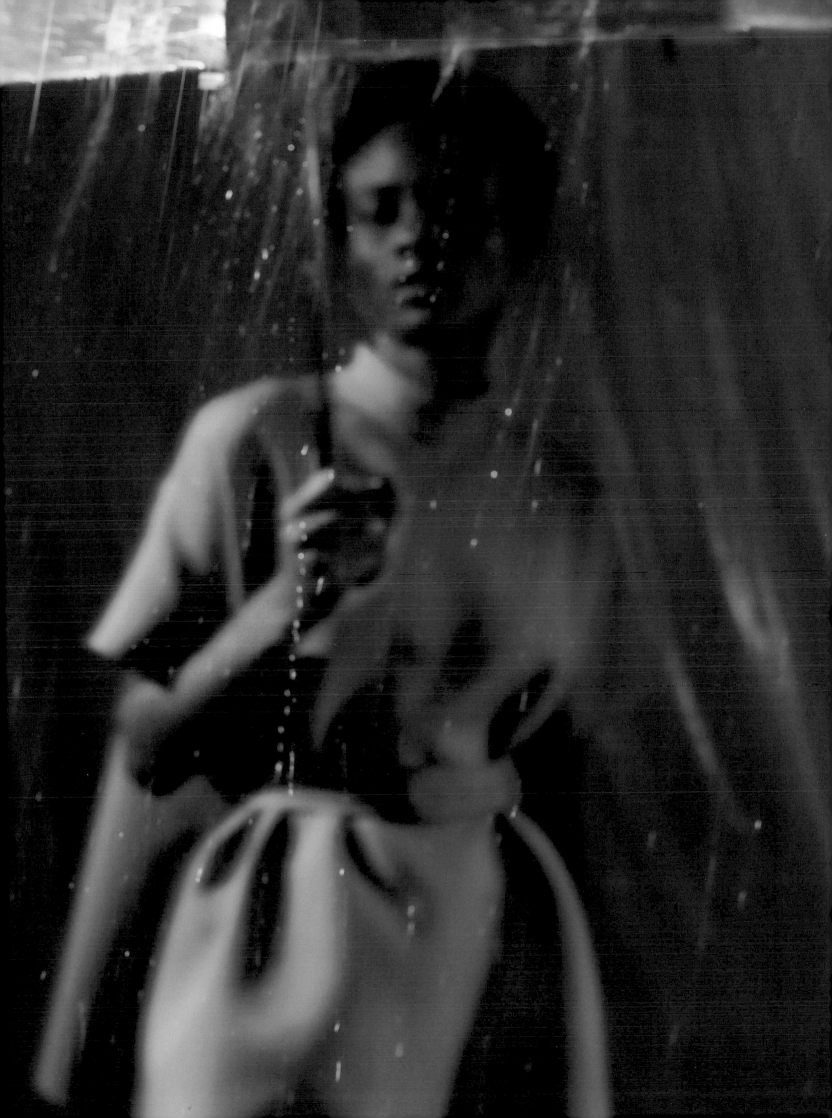

(left) Andréa wears a jacket and skirt by DRIES VAN NOTEN and sneakers by ACNE STUDIOS.
(below) She wears a jacket by MONCLER X DINGYUN ZHANG.

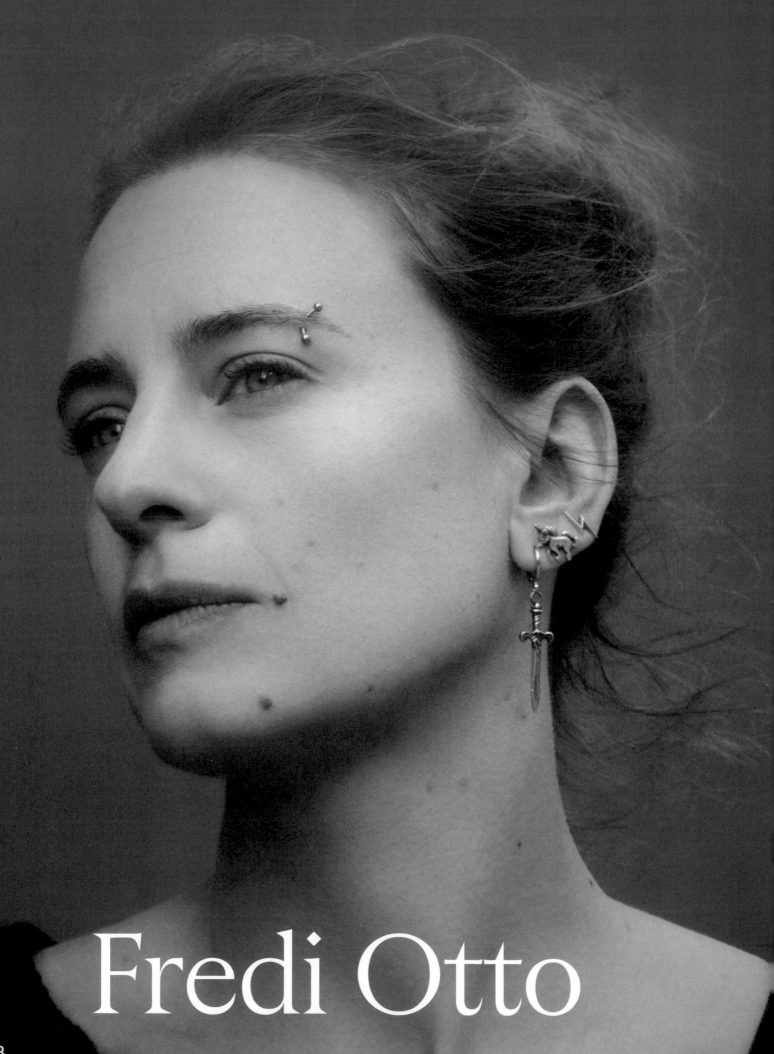

Fredi Otto

CHAPTER TWO
One scientist's mission to prove the link between extreme weather and climate change.
Words HETTIE O'BRIEN Photos MARSÝ HILD ÞÓRSDÓTTIR

(EXTREMES)

Friederike Otto, known to most people as Fredi, is a German scientist renowned for studying the effects of climate change on the weather. From her base at Imperial College London, she leads World Weather Attribution—a resource that can prove, within a matter of days, whether a storm, flood, heat wave or drought was caused by the climate crisis. Not so long ago, people used the malignancy of nature or the whims of gods to explain why the weather careened between dangerous extremes. We now know these extremes are often caused by climate change—but until Otto's research, it took scientists months or even years to gather the evidence that would definitively prove the link.

When I meet Otto at a café close to her home, not far from the banks of the River Thames, the sky is finally calm. In the preceding days, Storm Eunice had dragged the roofs from buildings and toppled trees across Britain. Otto tells me in her characteristically frank manner that, contrary to popular perception, the storm was not caused by climate change. "If you measured the wind speed of the recent storm, there was no evidence that climate change

[made it] worse," she says. Otto is frustrated by the tendency to blame every extreme weather event on our planetary crisis, in part because it leads to world-weary apocalypticism that obscures the capacity those in wealthy countries have to change course.

In her book, *Angry Weather*, Otto describes what she calls a "new way of doing climate science": one that is not confined to specialist journals or reports, but instead equips activists and policymakers with the evidence needed to dispel myths and pin responsibility on those who have "profited most from not acting on climate change earlier." *Angry Weather* is propelled by a stark cadence and urgent conviction that humans aren't condemned to forever suffer the effects of volatile weather, our homes repeatedly flooded as the seas rise. Instead, Otto believes that adapting to this uncanny new climate is an entirely possible—albeit political—choice. The feeling you get when you listen to her speak is not a sense of quickening dread about our shifting, malevolent weather, but optimism about the possibility of tangible action.

HETTIE O'BRIEN: On a basic level, how does climate change affect the weather?

FRIEDERIKE OTTO: There are essentially two ways. One is the warming effect. Because you have global greenhouse gases in the atmosphere, it gets warmer. A warmer atmosphere can also hold more water vapor, which needs to escape as rain. So across the world, we see more heavy rainfall. But then there is a second effect, which I call the "dynamic effect." Because we have changed the composition of the atmosphere, this affects atmospheric circulation. So that means that how weather systems develop, how they move and where they move works together with the warming effect. If you have fewer low-pressure systems bringing rain in the winter in an area like southern Africa, for example, which is really dependent on getting rain in the winter, it increases the risk of several-year droughts quite dramatically. These things may sound mundane, but they can have extreme consequences.

HO: You're known for pioneering "attribution research." Can you explain what that means?

FO: Every time there is an extreme weather event, journalists and policymakers immediately ask: What's the role of climate change? With World Weather Attribution, we try to provide the scientific evidence as soon as possible—ideally within days, while the public discourse is still happening. Before this project, it was only people with political opinions or incentives who would give their opinions about a weather event being linked to climate change. So we thought, we really need to change this.

HO: I can see huge political implications for the research you're doing. It could, for example, be used as evidence for the harm particular industries have had on the atmosphere.

FO: That's not an accident. It's definitely been part of the thinking behind doing this. We wanted to really put the causes and facts together to build a causal chain between individual emitters of greenhouse gases—which can be countries or companies—to global temperatures and actual concrete damages. Of course, it's important to understand how much climate change affects the weather in order to build resilience and adapt to climate change. But this research is also important for questions of responsibility, and ultimately of retribution and compensation.

HO: Do you think scientists have a responsibility to make their political views clear and to persuade others of them?

FO: We always have this idea that science is neutral or objective. But that's never been true. Science is testable hypotheses and transparent assumptions. That's how science produces facts—by having an idea, testing it over and over again, and at some point it becomes a fact. But the questions scientists ask are never apolitical. Because science is the people who do science, and those people ask questions that are of interest to them and

> " The questions scientists ask are never apolitical."

(right)
In 2021, Otto was recognized as
one of the world's most influential
scientists on the *TIME100* list for her co-
founding of World Weather Attribution.

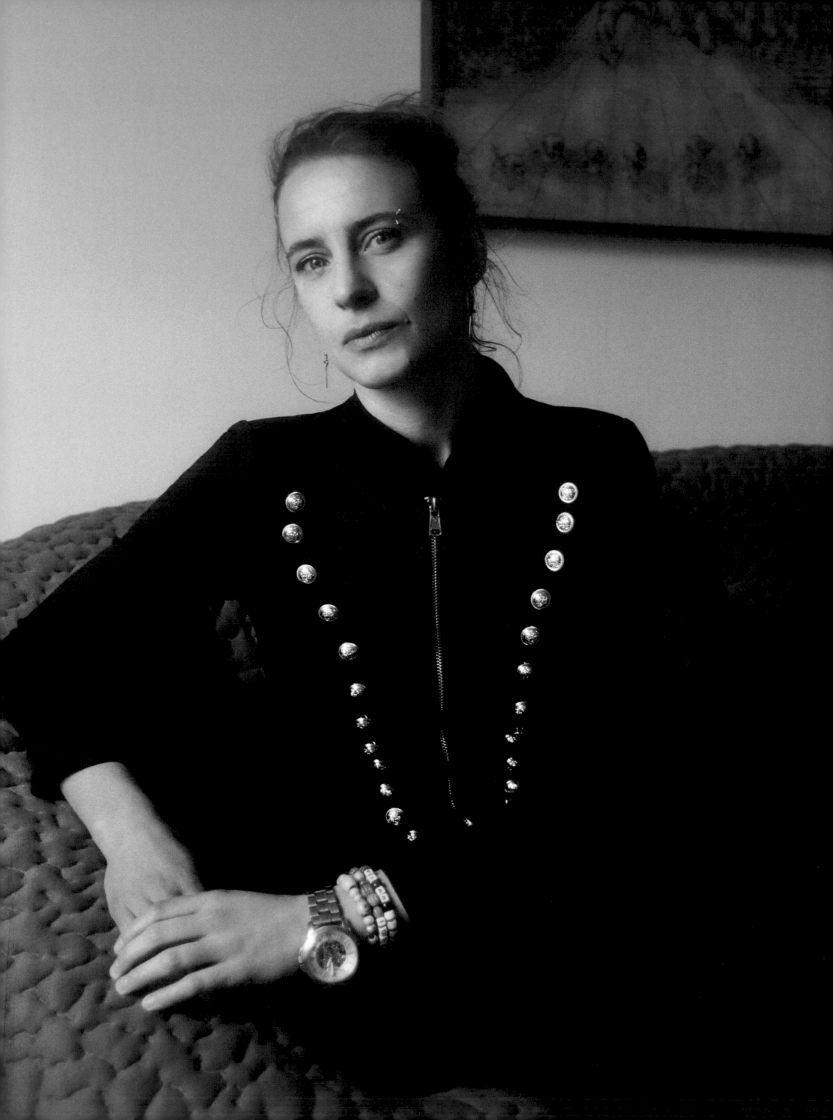

are shaped by their values. So I think it's quite dangerous to believe that science is neutral. For me, it's important that the science I'm doing is actually of practical relevance to the questions we have in society.

HO: How are you able to attribute a specific weather event to climate change so quickly?

FO: It took us nine days to prove that the Canadian heat wave last summer was linked to climate change. We first look at the observational data to find out what aspects of the weather have led to the impact of the extreme event—what we call the "event definition." For a heat wave, it might be that hospital admissions drastically increased after three days of heat, so we'd take those three days and use this period to define the extreme event. And then we would ask: What kind of event is this in the world we live in today? Is it a one-in-100-year event, or a one-in-10-year event? To answer this, we'd look at observational data and statistical climate models. Then we would ask what kind of event this would be in a world without climate change—removing the greenhouse gases and aerosols that we know have been put in the atmosphere since the industrial revolution. The volume of greenhouse gases that have been emitted since the industrial revolution is very well documented and measured, as we have reports of how much coal and oil and gas have been dug out and burned.

HO: There must be parts of the world where observational data isn't so freely available.

FO: Oh yes. We have a very good picture [of data] when it comes to coun tries like the UK. I'm just starting a new project with colleagues in the Kenyan Met Office to find out about heat waves. When you look at the official records, no heat wave in Kenya has ever happened. But that is not the case. And many countries sell their weather data to the highest bidder, rather than making it publicly available.

HO: Are some weather events particularly indicative of the effects of climate change?

FO: For heat waves, climate change is an absolute game-changer. Heat waves have become several orders of magnitude more likely: not just twice as likely, but hundreds of thousands of times more likely. Heat waves are where we see the fingerprint of climate change most strongly. They are also by far the deadliest extreme events in Europe. But of course what turns a weather event into a disaster depends on the vulnerability of the society. So if you have a highly vulnerable population that is only adapted to a small range of possible weather conditions, and you change that even slightly, this can lead to catastrophe. Even if the climate change effect is not big in absolute terms, it can be really dramatic because of peoples' vulnerability.

HO: It seems there is a perception problem when it comes to thinking about the effects of climate change on the weather. We've always had extreme weather events and it's really tricky to disentangle what has always been the case from what is new, alarming and scary.

FO: That's why we do this work: to disentangle these drivers of disaster. Because you can't feel it. You have to actually look at the data. Events that might have been really damaging in the past might not be so damaging now because populations have adapted. But this is also true the other way round. If we have lots and lots of people who have built houses on floodplains or are living in informal settlements, weather events that have happened before are suddenly a lot more damaging now because of our increased vulnerability or exposure to them. That has nothing to do with climate change.

HO: There is a disorienting sense of scale in thinking about all this. We talk about abstract, one-degree rises in average global temperatures, alongside sudden bursts of catastrophe, such as the floods in Germany last year.

FO: Yes. It's also very difficult to communicate this. Climate change played a role in the floods in Germany, for example, but even without climate change these floods would have been an absolute disaster. A lot of the damage was due to people living on floodplains, and the geography of the area features lots of small rivers that flooded easily and quickly. And there was little information about how to evacuate. There are lots of layers in how we portray the effects of climate change on the weather. On the one hand, you want to communicate that climate change is already costing lives. But of course, climate change is also not behind everything bad that is happening.

HO: This is something you've written about before. Why do you believe it's dangerous to blame all extreme weather events on climate change?

FO: It's not helpful. During Storm Eunice, for example, someone on Twitter found a paper that showed that if you had a high degree of warming, you could have an increase in wind strength. They used that paper to say, "Look here, this storm is all caused

"Yes, climate change is a really big problem. But we have a lot of agency to deal with it."

(left)
Otto is the author of *Angry Weather*, in which she lays out how recent weather disasters can be definitively linked to climate change.

by climate change." That's not helping anyone at all.

HO: There is a catastrophe mentality.

FO: Catastrophizing about doom is psychologically easier than seeing that we're part of one of the most privileged societies in the world, so if anyone has the agency to change things, it's us. Precisely because of this, it's really important to remember that for a lot of these weather events, it's not that we suddenly face weather that is in its nature completely different from what we had in the past. It's just a bit more intense, and a bit more likely. It is something we could adapt to. As people get worried, it's even more important to remember that we have the capacity to deal with extreme weather. We can redesign our cities so they have a lot more green spaces; we can insulate homes. We don't need magic for that. We know what to do.

HO: Speaking of magic, it seems that storms, floods and hurricanes are often treated as a tragic force of nature. During Hurricane Harvey in 2017, for example, America's Environmental Protection Agency condemned climate scientists for trying to "politicize an ongoing tragedy."[1]

FO: Like an act of God.

HO: That must really annoy you.

FO: It's very frustrating. It's wrong. Even if climate change isn't playing a role, we can still do a lot to make people less vulnerable to extreme weather. We don't have to have such unequal societies that half of the population are unable to afford insurance, or have to live in flood-prone areas. All of these problems that lead to events becoming tragic are actually completely in our hands to change.

HO: We've seen record heat waves over the last few summers. What might the weather look like in 10 or 15 years?

FO: Heat waves will become pretty normal. It's likely that we will see something like what happened in Canada last summer, where the previous record was broken by 5 degrees Celsius. We might see a one-in-1,000-year heat wave occur. We also will see more heavy rainfall. But many of the changes will be comparably small. The question of whether we will be able to deal with them in 10 years' time is the same question of whether we're able to deal with them today.

HO: Does the subject you're working on ever leave you feeling hopeless?

FO: What I find most depressing is how everything is portrayed as black and white: *It's climate change, we're doomed, the world is going to end*. That's not the case. Yes, climate change is a really big problem. But we have a lot of agency to deal with it. We still haven't changed the public discourse. Even if we were to ignore climate change, the things we have to do to our cities, for example, would make life better and healthier in general. So why are we still not doing them? That, to me, is the biggest source of frustration.

(1) Attribution is important because our brains prioritize immediacy: A leaky pipe at home may feel more urgent than a marginal increase in ocean surface temperature hundreds of miles away, for example. But, as Otto wrote in a guest essay for *The New York Times* in 2021, "when your home is in Houston, an increase of a few degrees in ocean surface temperature turns a distant problem into an immediate catastrophe, as when rain from a storm like Hurricane Harvey deluges your home for days upon days."

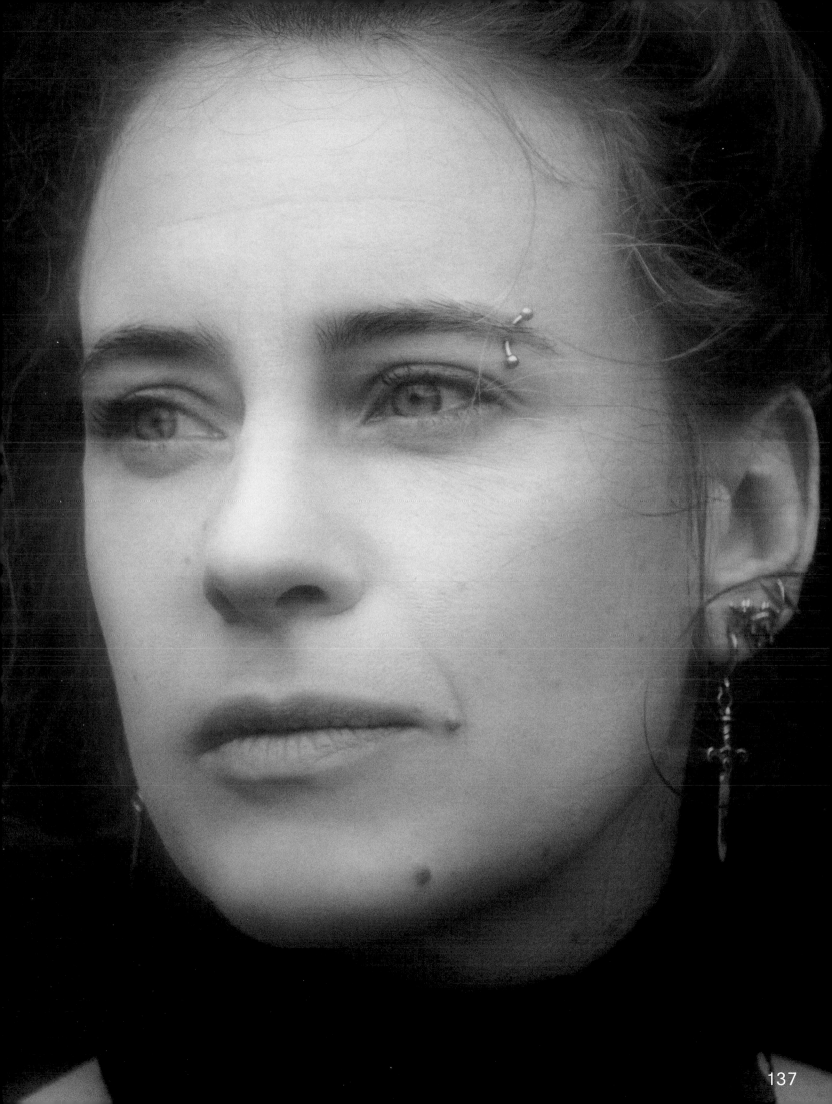

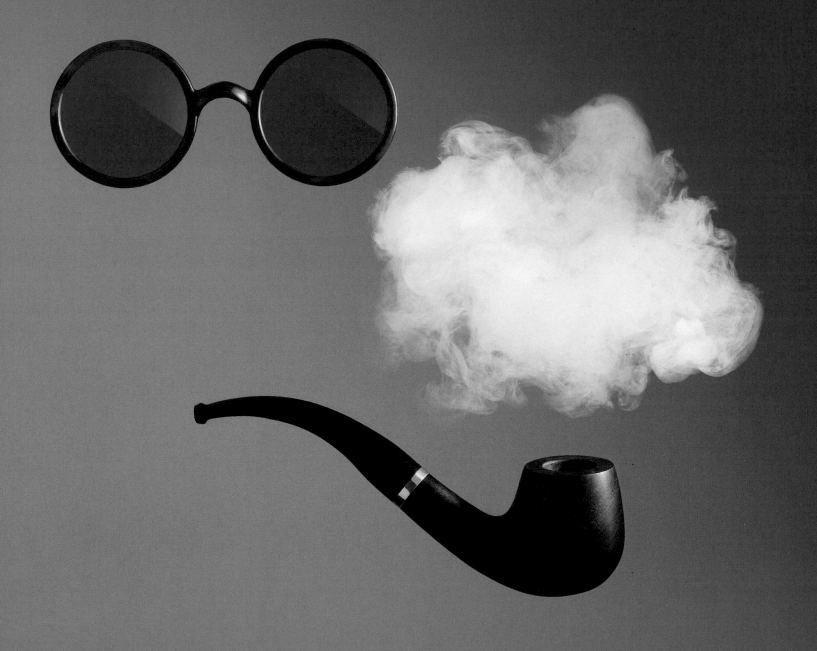

CHAPTER THREE
Compositions inspired by the
iconic clouds—and surrealist sensibilities—of René Magritte.
Photos AARON TILLEY Set Design SANDY SUFFIELD

The False Mirror

(CLOUDS)

(all) Clouds, pipes, bowler hats and apples: René Magritte's paintings placed such familiar items into surreal, cinematic scenarios, his body of work posing questions about the nature of representation and reality. Set designer Sandy Suffield created the clouds in this feature using dry ice and warm water.

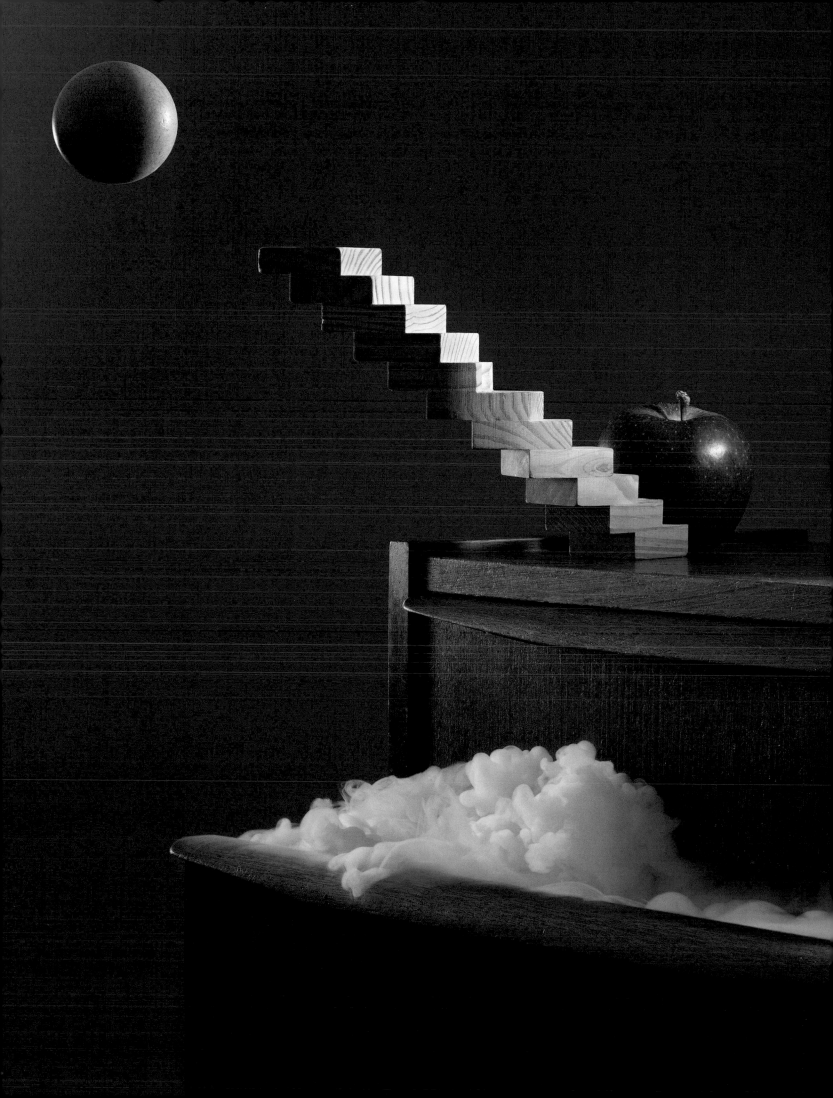

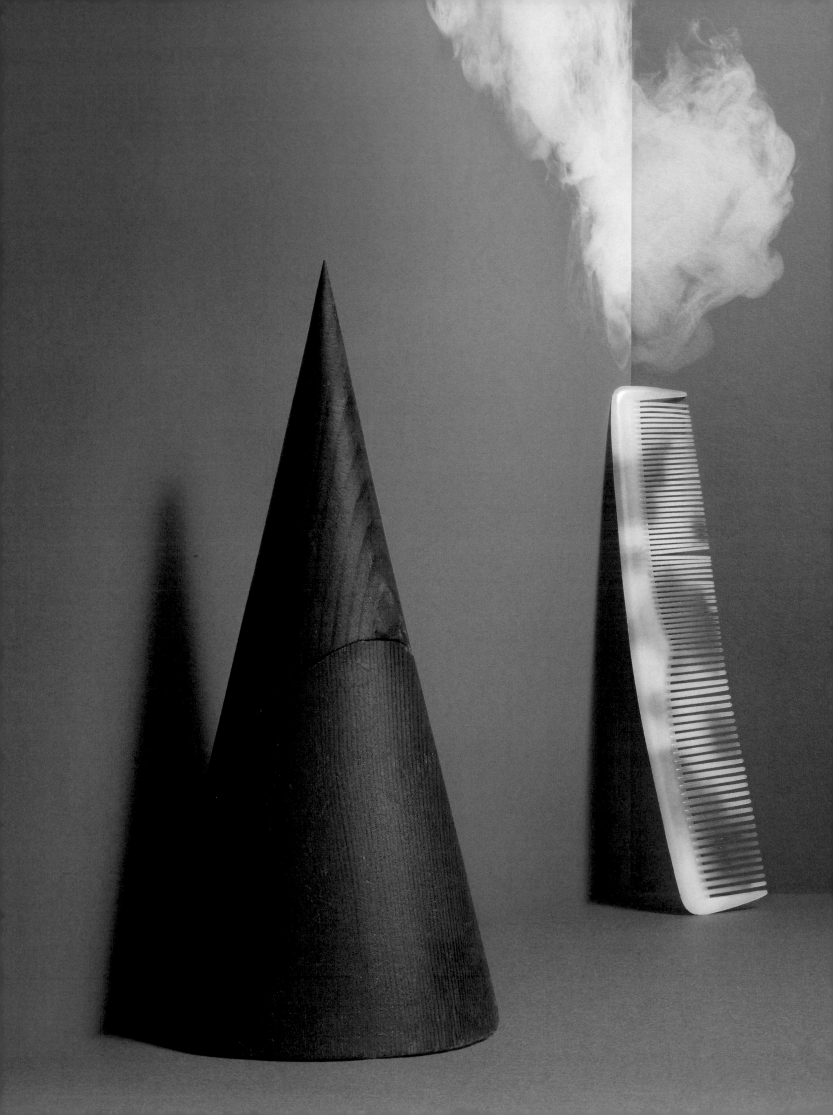

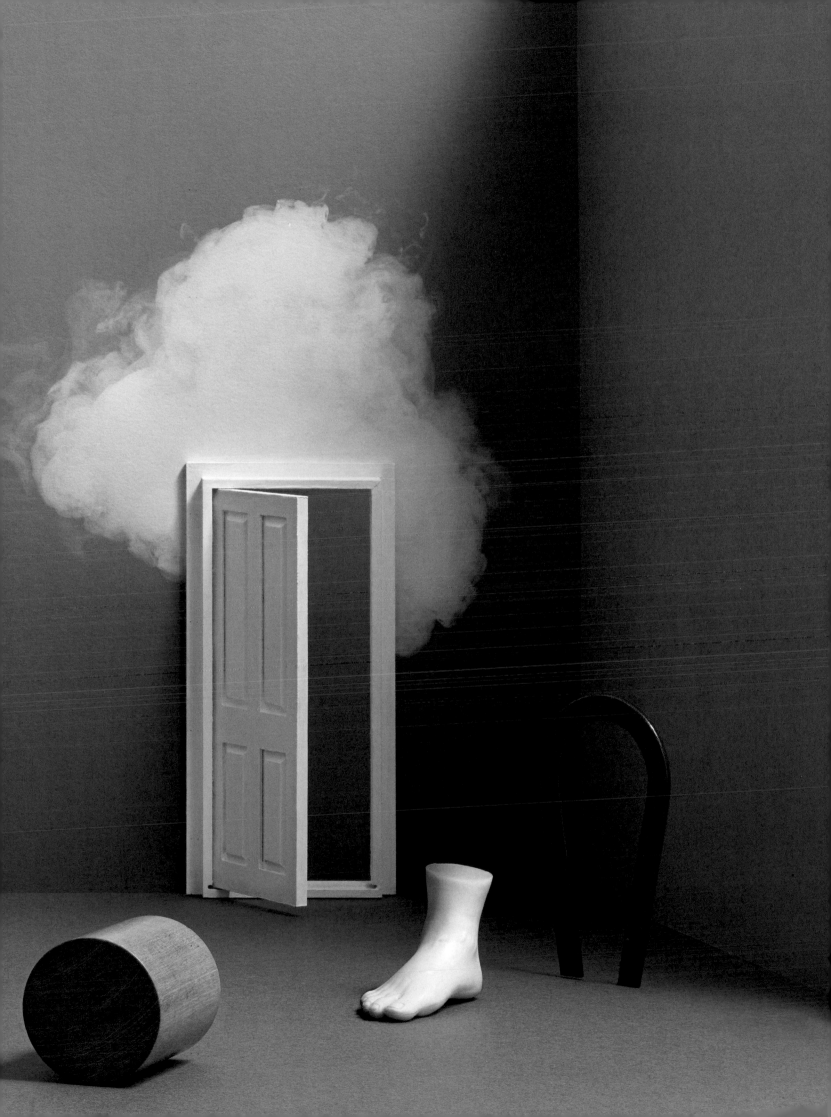

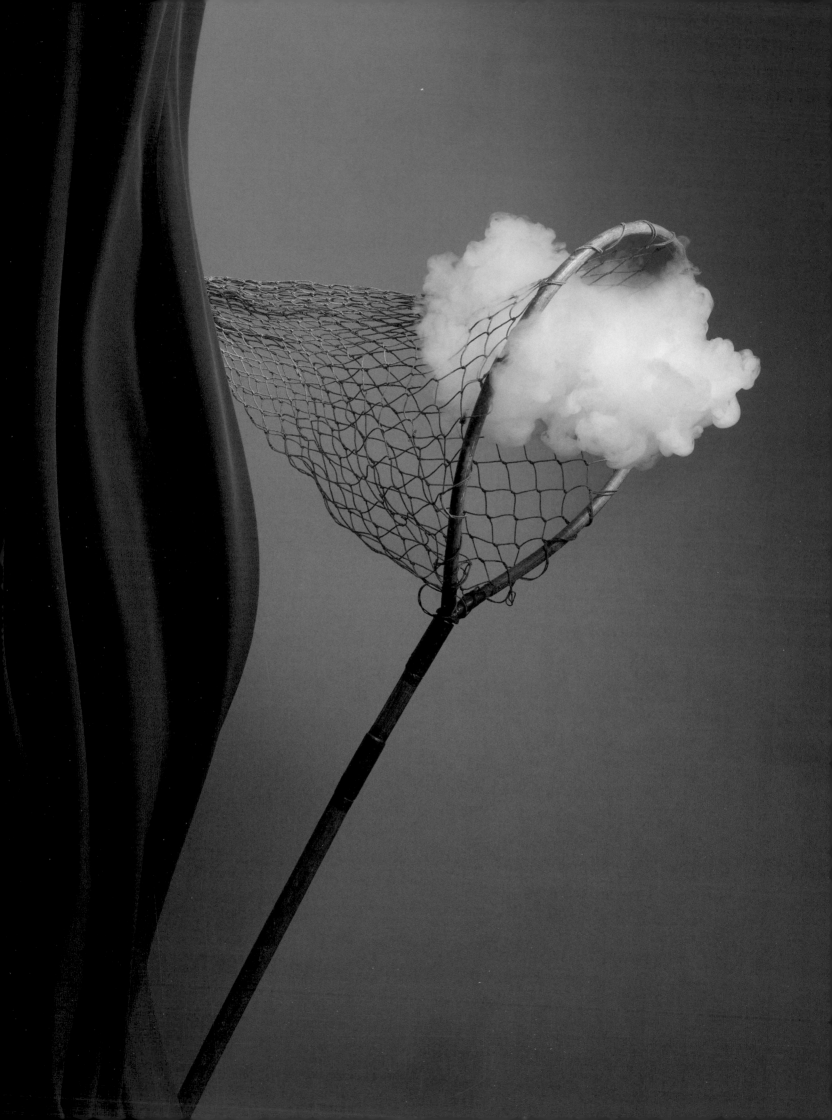

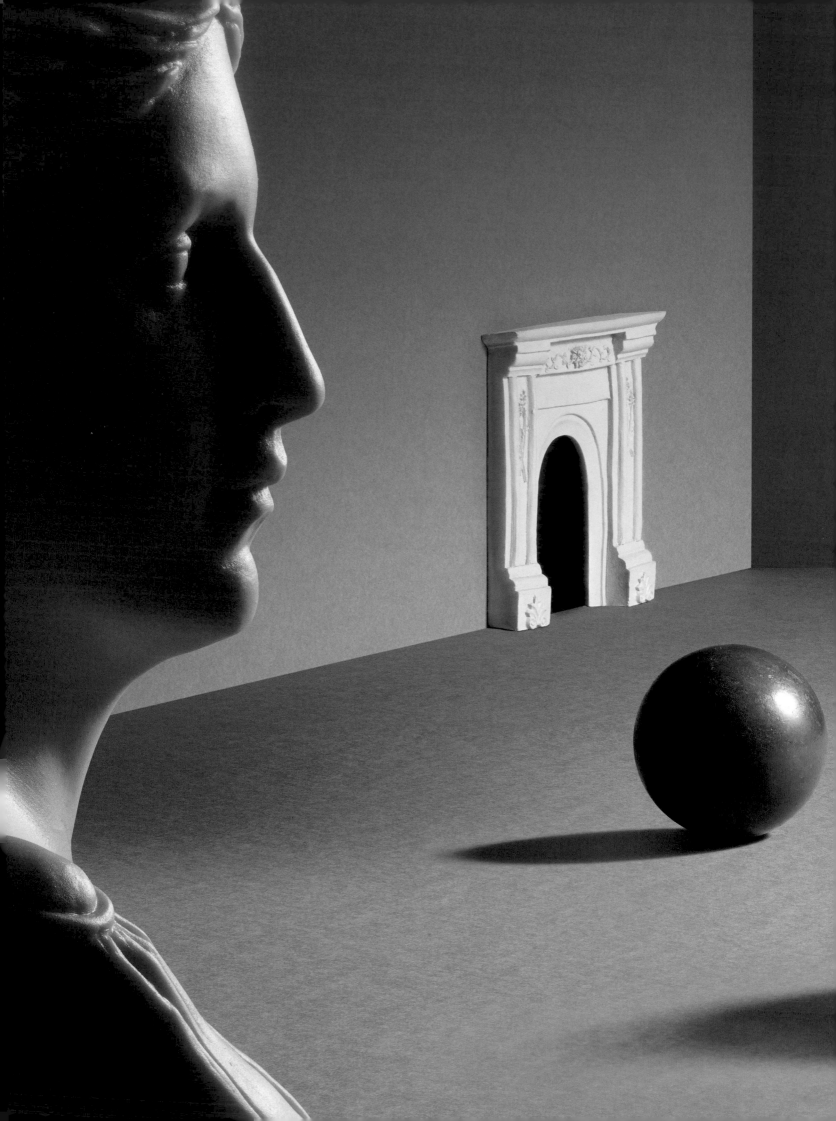

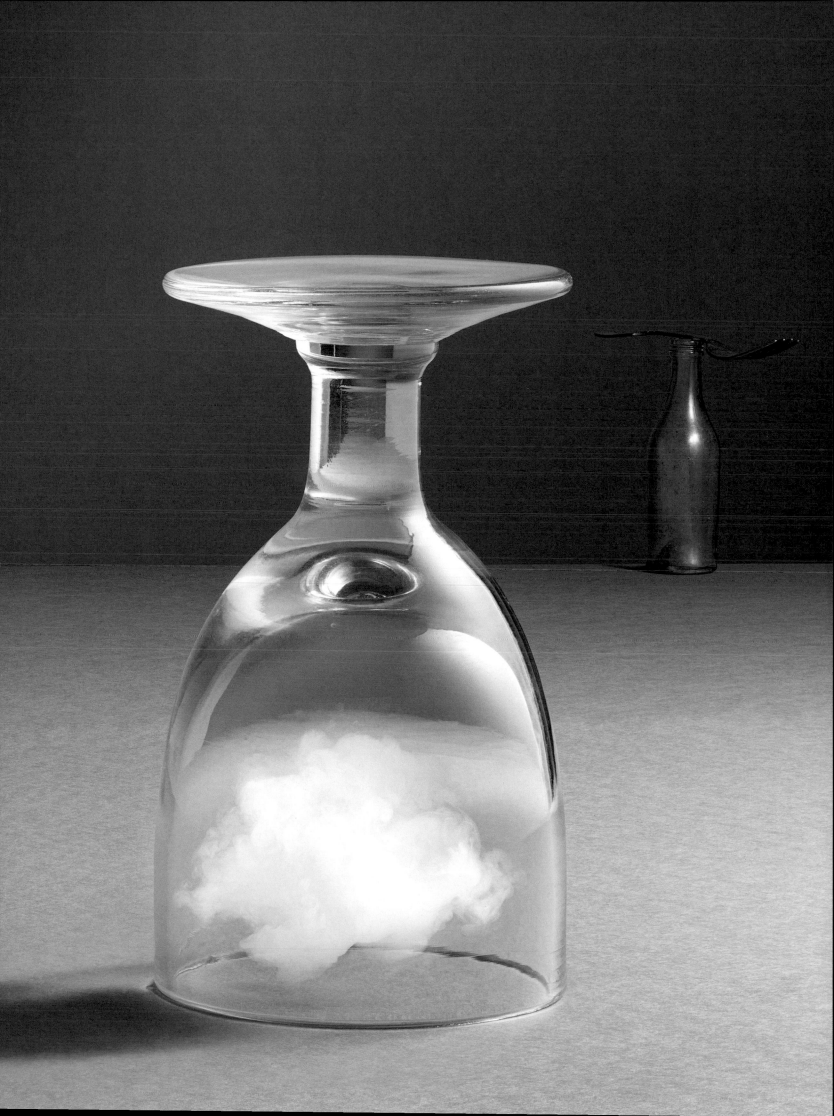

(WIND)

Swept Away

CHAPTER FOUR
A short history of wild weather on-screen.
Words CAITLIN QUINLAN

In our everyday lives, the weather is a mostly banal consideration. In movies, it is traditionally wild. There are the disaster flicks: catastrophes such as *The Day After Tomorrow*, tawdry B-movie horror-comedies like *Sharknado*, wherein a tornado filled with sharks terrorizes Los Angeles, and emotionally heightened dramas like *The Impossible* about a family surviving a tsunami. They are designed to shock and entertain us, hovering on the edge of totally implausible and borderline possible—perhaps, in some twisted way, we watch these movies to prepare ourselves for apocalyptic doom?

On film, weather has the power to transport us, often literally.[1] In *The Wizard of Oz*, the 1939 adaptation of L. Frank Baum's fantasy novel, the aptly named Dorothy Gale gets caught in a tornado that transports her and her dog, Toto, to the Land of Oz. The upheaval of the house with Dorothy and Toto inside causes the death of the Wicked Witch of the East when it crashes down in Oz and sets the story's wondrous journey in motion. The realm-shifting tornado even triggers the film's move from sepia tones to Technicolor.[2]

Or take a similarly witchy tale, *The Witches of Eastwick* (adapted from John Updike's novel), in which Cher, Susan Sarandon and Michelle Pfeiffer discover they have hidden powers when they conjure a brutal thunderstorm to put an end to a tedious school ceremony. Unbeknownst to them, the storm has also brought with it the devil in the form of Jack Nicholson. The town is turned upside down when all three women are irrevocably seduced by him and move into his lavish mansion—a plot development that not only exposes Eastwick's puritanical side but also threatens the sanctity of the women's bond.

Then there's *Groundhog Day*'s weatherman Phil Connors, trapped in a time loop after a blizzard strikes Punxsutawney, and Ariel in *The Little Mermaid*, besotted with a man knocked overboard during a storm at sea. Worlds changed by freak weather events have a fantastical quality to them that is moderated by the familiarity of the weather

(1) This is a global trope. In the Korean romantic comedy *Crash Landing on You*, a wealthy South Korean businesswoman is swept up in a sudden storm and lands on the North Korean side of the DMZ, where she meets (and falls in love with) an army captain.

(2) Technicolor involved a different color process than today's movies. The extremely vibrant but relatively uniform palette in *The Wizard of Oz* is the result of filming the same scene through various colored filters on different strips of film, which are then used to print colors onto the final reel.

in its daily, less striking forms. It is not totally alien or paranormal, even if the changes it provokes are. "I'll give you a winter prediction," says Bill Murray's Connors, shortly before his world is turned upside down. "It's gonna be cold, it's gonna be gray, and it's gonna last you for the rest of your life."[3]

It's not surprising that extreme weather appears so frequently in movies. Whether storms, blizzards or tornadoes, these events have a striking visual quality that makes them exciting on-screen and their obvious drama does a lot of narrative heavy lifting. They've been used since the very earliest stories too—think of biblical floods and rainfall, or stormy shipwrecks in Greek tragedies.[4] These things aside, when we assess these films through a contemporary lens—one that is cognizant of the current global climate crisis—it is interesting to consider the role weather has played in expressing severity and threat even at a time when climate discussions were not as prevalent as they are today. It's hard to watch the storm in *The Witches of Eastwick* without worrying about Cher's ramshackle home on a wooden pier flooding in the rising sea levels or falling into the waves below.

"Worlds changed by freak weather events have a fantastical quality to them that is moderated by the familiarity of the weather."

More subtle weather patterns can provide a narrative device or set the mood in their own way. Spike Lee's 1989 drama, *Do the Right Thing*, explores racial tensions and gentrification in a Brooklyn neighborhood during a long, hot summer, with animosity growing as the heat wave intensifies. Playwright Tennessee Williams was also fond of using hot weather as a tool to escalate

(3) The weather is a main character in *Groundhog Day* thanks to the presence of Punxsutawney Phil, a famous groundhog who people believe can predict when winter will end. If Phil can see his shadow, winter will continue for another six weeks. If he can't, spring will arrive early. "Phil" has been casting his predictions since 1886.

(4) In the Bible, God is often shown acting through the weather. Among his acts: He causes the storm that shipwrecks Jonah and another that kills Job's family, sets hailstorms on the Amorite army and causes a years-long drought that only ends with prayer.

antagonism or signal destruction, and the film adaptations followed suit. Think of a sweat-soaked Marlon Brando flaunting his body to Vivien Leigh in Elia Kazan's *A Streetcar Named Desire*, catalyzing the dangerous lust between them. Leigh's Blanche is at the mercy of the heat, her mental state declining in the humid atmosphere.[5] It makes an interesting comparison to Stanley Kubrick's adaptation of Stephen King's *The Shining*, where Jack Torrance succumbs to insanity in the snow-laden isolation of the Colorado Rockies. The pressure of these climates—opposite and yet similarly effective—brings bold characters to their knees. These articulations of weather, both big and seemingly small, reveal the complex relationships between people and climate in ways that may have been overlooked at the time.

Paula Willoquet-Maricondi, author of *Framing the World: Explorations in Ecocriticism and Film*, thinks that wild weather on-screen has generally failed to inspire audiences to think about climate issues. In the book, she writes that film viewers can feel protected "from the causes and implications of the drama enacted on screen" when environmental issues are presented as improbable fantasy. She explains further over Zoom that "there's a lot of exploration about the efficacy of films to bring awareness and engagement and action on the part of viewers. Then the question becomes, Is awareness enough to motivate people to participate in one way or another to take action? The views on that are mixed."

But when we watch films today that were made several decades ago, before climate change was part of the public consciousness, we may find ourselves interpreting the wild weather they depict differently. "As a viewer, I am influenced by my current condition," Willoquet-Maricondi says. "Now that we have this awareness and are under this threat from weather events that are unpredictable and violent, do we look at these weather events differently in these films, regardless of how they were meant at the time that the film was made?"

Once a dramatic and fun storytelling device, now the weather on film has a new role to play in drawing attention to the climate crisis in a more realistic way. Albert, the British Academy of Film and Television Arts–backed sustainability organization, provides training and support for broadcasters and movie producers to center the importance of positive environmental action. One initiative in particular, Planet Placement, encourages the makers of film and television to include environmentally focused plot lines, character traits or other subtle nods to climate issues within narratives. To guide others, Albert highlights examples from existing works along with any successful results; when Cousin Greg's grandfather Ewan in HBO's *Succession* wrote Greenpeace into his will, for example, it led to a real-world surge in people wanting to do the same. Other case studies include everything from the use of "climate change" as a sexual safe word in *The Morning Show* to references to the Great Smog of London in *The Crown*.[6]

Albert's director, Carys Taylor, explains that "Planet Placement is the phrase that we have attributed to this area because it's about weaving climate issues into all kinds of content and meeting audiences where they are... without beating it round anyone's head."

"The advertising industry pours a lot of money into understanding what's going to shift and nudge people to do things differently," she says. "We need to replicate the same." Albert's work focuses more heavily on representing solutions rather than climate fatalism—it's not about terrifying people into inaction but easing them into positive change.

It's still unclear whether a cinematic flood or heat wave could be an effective way to change attitudes about environmental issues, but Albert's upcoming research into tangible behavior shifts as a potential result of Planet Placement could be hugely insightful. On-screen, weather can transform fictional worlds. Who knows—perhaps our viewing habits will prove capable of transforming reality.

(5) Many works of art contain an element of pathetic fallacy—a literary device whereby nature appears to reflect the emotions of characters. Common examples of pathetic fallacy include sudden downpours when a person is sad and rainbows at moments of heightened romance.

(6) Planet Placement's writers' guide emphasizes that climate change doesn't need to dominate the script. "Maybe it's your character borrowing an outfit from a friend rather than buying a new one.... It doesn't have to take center stage or be an entire story about climate change. The important thing is just to reference the environment in a way that doesn't disrupt your story."

Whip Up a Storm

(STORMS)

CHAPTER FIVE
Cozy recipes for inclement weather.
Recipes ANISSA HELOU Photography LAUREN BAMFORD
Set Design STEPHANIE STAMATIS

GADO GADO
Indonesian Vegetable and Egg Salad

When I visited Indonesia, I arrived when it was still Ramadan, a time when street vendors seem to be everywhere, selling all kinds of snacks and dishes to those who want to break their fast but don't have the time to cook at home. I stopped at one food cart in Banda Aceh that had gado gado (*gado* means "mix" and *gado gado* means "mixes," because this salad is made of so many different ingredients). The vendor had arranged his different ingredients in mounds inside the cart and had a wide mortar to one side, which he used to grind batch after batch of the peanut seasoning for the salad. You can have gado gado as a snack or it can be a full vegetarian meal. This version is served with a peanut-based dressing, but on some islands, the dressing is also made with coconut cream. Serves two to four.

For the dressing
2 cups (10 ounces) raw peanuts
6 fresh mild red chilies, trimmed
1 fresh bird's-eye chili, trimmed
¼ teaspoon shrimp paste (terasi)
1 tablespoon seedless tamarind paste, diluted with 2 tablespoons water
2 tablespoons grated palm sugar
Sea salt

For the salad
2 medium potatoes, boiled, peeled and cut into medium-thin rounds
2 hard-boiled eggs, peeled and cut into wedges
5 ounces cauliflower florets, cooked al dente
5 ounces cabbage, finely shredded and blanched
5 ounces yard-long beans, cut into medium pieces, cooked al dente
1 small cucumber, peeled and thinly sliced
5 ounces tempeh, sliced into 4 portions, shallow-fried in vegetable oil

Preheat the oven to 450°F.
Make the dressing: Spread the peanuts on a nonstick baking sheet. Toast in the oven for seven to eight minutes, or until golden brown. Let cool, then process in a food processor until finely chopped. Transfer to a medium bowl.
Put the red chilies, bird's-eye chili, and shrimp paste in the food processor and process until you have a fine paste. Add to the peanuts. Strain the diluted tamarind paste into a small bowl and add to the peanuts and chili paste. Add the palm sugar and 2/3 cup water. Season with salt to taste. Mix well. Taste and adjust the seasoning if necessary.
Arrange the salad ingredients on a serving platter, leaving enough space for the bowl in which you will serve the dressing. Place the bowl with the dressing on the platter and serve immediately.

GULAI KAMBING ACEH
Aceh-Style Goat Curry

This goat curry, a speciality of Banda Aceh, is normally simmered over a charcoal fire for hours until the meat falls off the bone and the sauce is completely concentrated. It is usually accompanied by rice but you can easily serve it with very good bread to mop up the sauce. Serves four to six.

For the spice paste
3 tablespoons unsweetened shredded coconut
2 tablespoons coriander seeds
2 teaspoons white peppercorns
½ teaspoon fennel seeds
1 tablespoon white poppy seeds (kas-kas)
1 whole nutmeg, grated
½ teaspoon ground cumin
2 inches fresh ginger
2 inches fresh turmeric
1¼ inches fresh galangal
4 shallots (3½ ounces)
2 cloves garlic
1 fresh red chili, trimmed
4 candlenuts, macadamia nuts or cashews
Sea salt

For the meat
2¼ pounds goat meat, preferably on the bone, cut into medium chunks
Juice of 2 limes or 1 lemon

For the curry
¼ cup vegetable oil
4 shallots (3½ ounces), halved and cut into thin wedges
2 fresh curry leaves
3 tablespoons mild chili powder, mixed with 1 tablespoon water
2-inch cinnamon stick
2 star anise
4 whole cloves
2 green cardamom pods, smashed
4 stalks lemongrass, white part only, smashed
2½ cups coconut cream
Sea salt

To serve
Plain jasmine rice or good bread

Make the spice paste: Put the shredded coconut, coriander seeds, white peppercorns, fennel seeds, white poppy seeds and nutmeg in a nonstick skillet and place over medium heat. Toast, stirring all the time, until fragrant. Add the ground cumin and stir for a few seconds. Transfer to a food processor. Wipe the pan clean and put the fresh ginger, turmeric and galangal in it and toast until lightly golden. Add the galangal to the food processor, then peel the ginger and turmeric and add to the food processor. Add the shallots, garlic, chili, nuts, and salt to taste and process until you have a fine paste.
Put the goat meat in a bowl and add the lime or lemon juice. Mix well, then rub the spice paste into the meat. Let marinate for at least two hours, or preferably overnight, in the refrigerator.
Now it's time to make the curry: Heat the vegetable oil in a large pot over medium heat. Add the shallots and cook, stirring occasionally, until lightly golden. Stir in the curry leaves and chili paste. Add the marinated goat, cinnamon, star anise, cloves, cardamom and lemongrass and cook, stirring regularly, until the goat is lightly browned. Reduce the heat to medium-low, cover, and cook for a few minutes, or until the meat browns a little more. Add the coconut cream and salt to taste and mix well. Reduce the heat to low and let simmer for 45 minutes, stirring regularly to make sure the sauce is not sticking, or until the sauce is thick and some of the oil has risen to the surface. Taste and adjust the seasoning if necessary. Serve hot with rice or good bread.

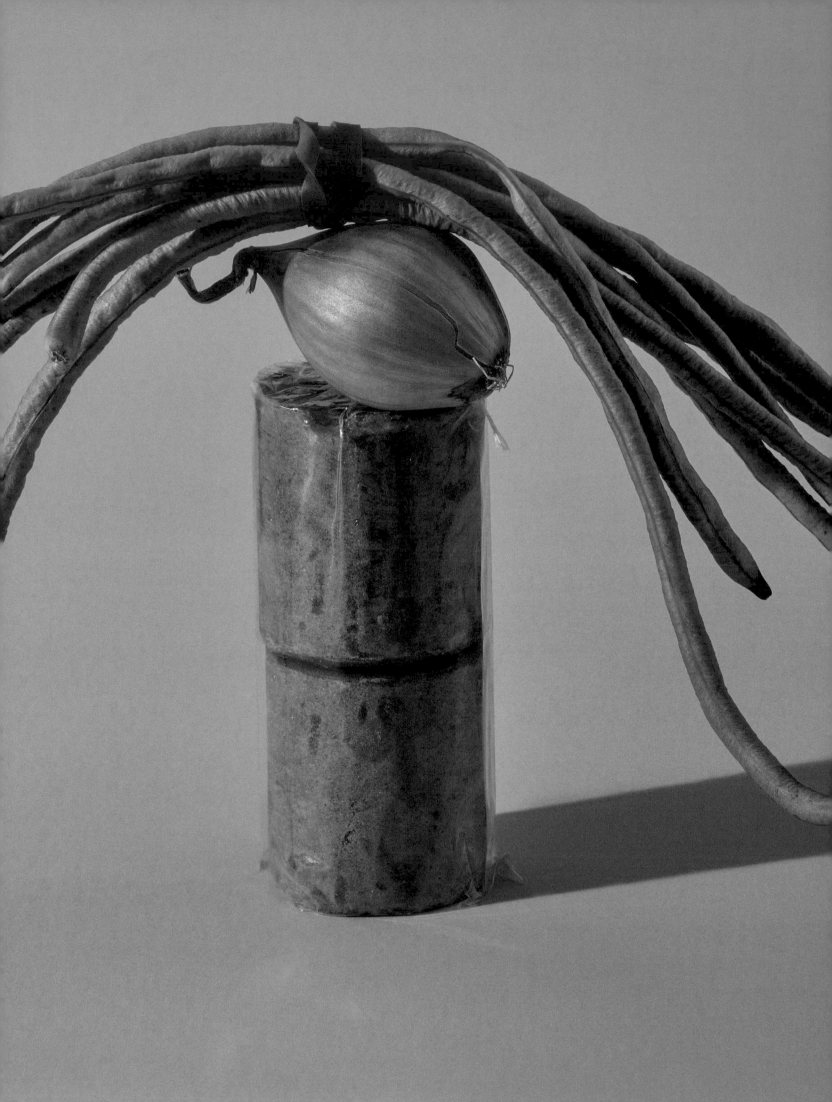

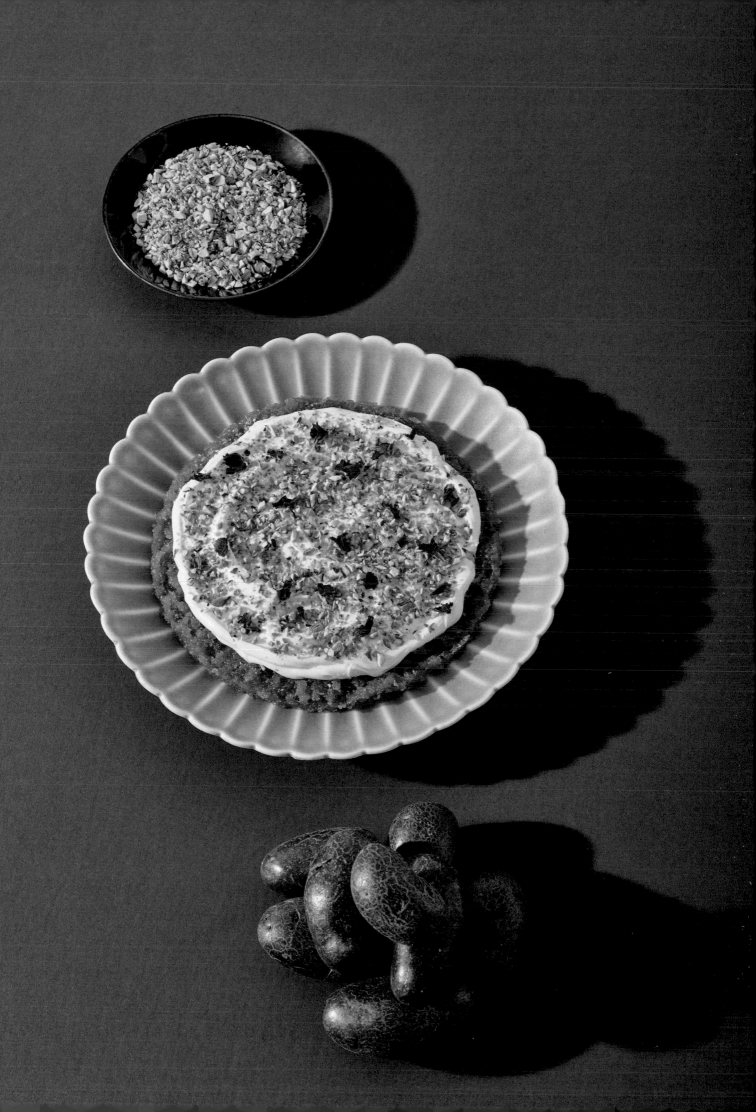

P.159
AYSH EL-SARAYA
Bread of the Seraglio

The word seraglio means both "harem" and "sultan's palace." Depending on how you read it, you can consider this dish, of Turkish origin, either a cheap dessert served to concubines or one fit for kings. I would opt for the latter despite the modest basic ingredient of stale bread. As a matter of fact, most Arabs consider aysh el-saraya a luxurious dessert because of the sinful amount of clotted cream covering the sweetened bread base. It is often eaten as a treat in between meals rather than as a dessert—Arabs usually finish their meals with fresh fruit and only serve sweets at celebratory meals. Serves four to six.

One 8-inch round loaf of bread (about 14 ounces),
 around 1 day old
1¼ cups organic cane sugar
1 teaspoon lemon juice
1 teaspoon orange blossom water
1 tablespoon rose water
1¼ cups Lebanese clotted cream (ashtah) or English
 clotted cream
2 tablespoons coarsely chopped pistachios,
 for garnish

Trim off and discard the crust of the bread, or reserve it for making breadcrumbs. Tear the bread into rough 1-inch pieces.

In a medium saucepan, combine 3½ tablespoons water, the sugar and the lemon juice. Bring to a boil over medium heat and cook, stirring constantly so that the sugar does not recrystallize in places, until the syrup has caramelized to a golden-brown color, about 15 minutes; be careful not to burn it. In the meantime, bring about a cup of water to a boil. Gradually add ¾ cup of the boiling water to the golden-brown syrup, stirring with a long-handled wooden spoon—the syrup will splutter when you add the water, so make sure you do this very slowly and cautiously. Remove from the heat and add the orange blossom and rose waters.

Add the bread to the caramelized syrup and return to a medium heat, pressing down on the bread with the back of the spoon to help it soak up the syrup. Keep mashing it, until it has absorbed all the syrup and is quite mushy, about five to 10 minutes.

Spread the bread in an even layer on a round serving platter. If there is any syrup left in the pan, pour it over the bread. Let cool for about 20 minutes.

Spread the cream over the bread, leaving a little of the edge showing. Sprinkle with the chopped pistachios and serve straight away. You can also refrigerate it, covered, in which case reserve the pistachio garnish until just before serving.

P.161
SHARAB QAMAR EL-DIN
Apricot Leather Drink

Apricot leather is a speciality of Syria, and pretty much the lollipop of our childhood. My mother or Syrian aunt would give us strips of apricot leather to suck on whenever we wanted something sweet. It's a kind of "healthy" candy (or, to be more accurate, it's *slightly* healthier than proper candy). Another way to use apricot leather is in a drink; I like to serve it with a dash of orange blossom water and soaked pine nuts. (Slivered pistachios or almonds can be substituted, but I prefer the freshness and sweet taste of the pine nuts.) You don't really need to sweeten the drink as there is already enough sugar in the apricot leather, but if you prefer it sweeter, simply add raw cane sugar to taste. Serves four.

3 tablespoons Mediterranean pine nuts
3½ cups boiling water
12 ounces apricot leather (qamar el-din),
 cut into medium squares
4 teaspoons orange blossom water
Few sprigs of fresh mint (or another herb),
 for garnish

Put the pine nuts in a small bowl and cover with some of the boiling water. This rehydrates them and makes them taste as if they are fresh.

Put the apricot leather in a large heatproof measuring cup. Add the remaining boiling water and stir with a whisk until the apricot leather is completely dissolved. Add the pine nuts and their water together with the orange blossom water. Transfer to a serving jug and serve warm, tepid or chilled, garnished with mint leaves.

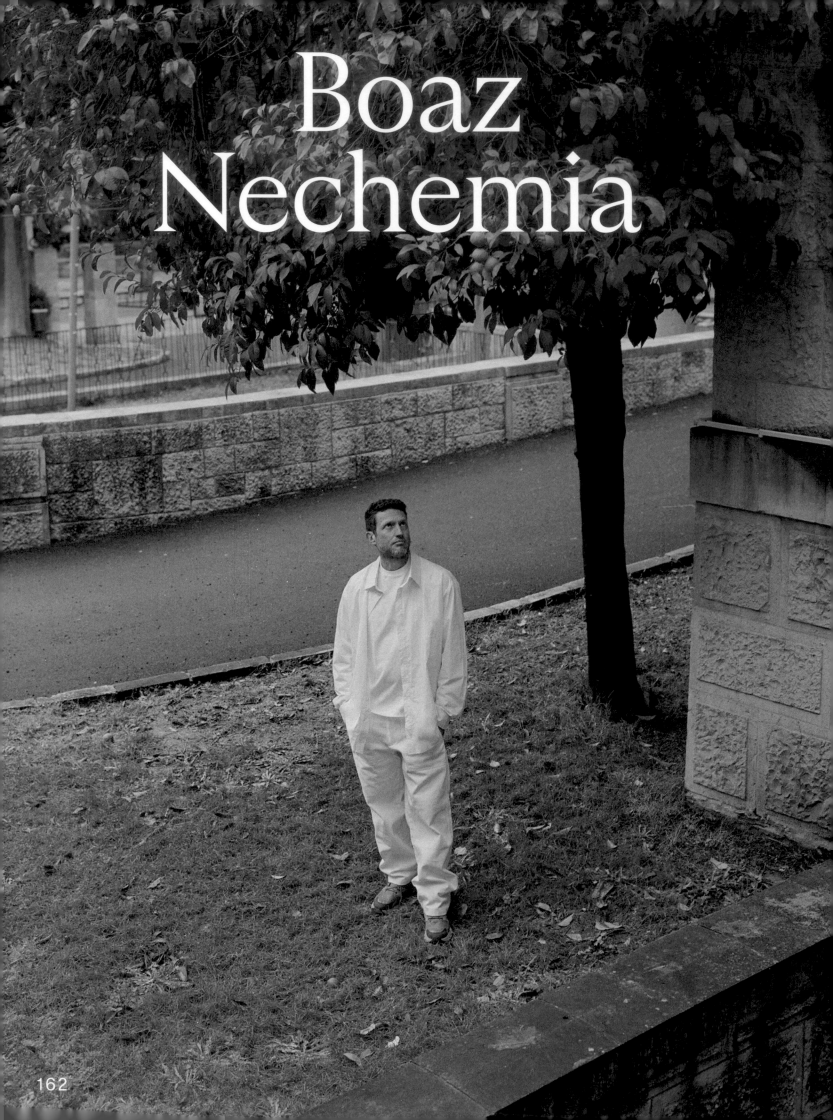

Boaz
Nechemia

(FORECASTING)

A detail-oriented weatherman is not a typical candidate for a cult following, but Israeli meteorologist Boaz Nechemia has managed to amass one thanks to Yerushamayim, his wildly popular independent weather forecasting website and app.

The name combines the Hebrew for Jerusalem, "Yerushalayim," with the word "shamayim," meaning sky, and reflects the hyperlocal focus of the project; as far as Jerusalem native Nechemia is concerned, there is no need to cover, or even mention, anywhere else. Yerushamayim has a casual style, peppered with humorous local references and in-jokes, and prides itself on accuracy and a participatory format, with lively discussion forums, photo submissions and users voting on how they experience the weather. It has become a cultural phenomenon in the city.

When we met at the café on the upper floor of the Jerusalem Theatre, I understood why Nechemia had chosen this spot: We sat by a huge panoramic window looking out over an overcast Jerusalem skyline. Above, rainclouds rushed across the sky, while in the plaza below people dashed across puddles, wearing glistening coats and grasping broken umbrellas.

TAL JANNER-KLAUSNER: How did you first become interested in the weather?

BOAZ NECHEMIA: It began at a very young age. I looked at the sky and it interested me: *What is this cloud and how does it arrive?* I would listen to forecasts on the radio, waiting for the end of the program to hear it every few hours. I would go out and measure the rain in a cup, then record it in a sort of diary. It was clear to me that this was what I would study at university. I finished my degree and went to work at the Israel Meteorological Service (IMS) as a forecaster. I came full circle because I read out the forecast on the radio instead of listening to it.

TJK: How did you get from there to Yerushamayim?

BN: I decided that there wasn't a real way to make a living in this profession in Israel because there are so few positions. But in 2001, I decided: Let's get back to my roots, buy a meteorological station and put it on the roof. This was the first stage, so I could see from the living room how much rain fell, or whether the temperature rose or fell. Data for geeks! Afterward, I made a

website so that I could see the data when I wasn't at home. It was just for myself. But I saw that more and more people were visiting it. In 2008, there was snow *twice* in the winter. I had already opened a forum on the website, where people had begun to write and ask all sorts of questions. I said, *Okay, I'll write a forecast.* The rest is history.

TJK: What makes your site different from traditional weather forecasts?

BN: There's a gap between what you hear on the radio and television and what someone in Jerusalem experiences. People want accuracy about the sensation of the weather and its timing. I said, *Well, I won't write a forecast as I did in the IMS.* It's the ivory tower of forecasting in Israel but gives a forecast that doesn't actually suit people—the most boring thing. *No, I'll make it more interesting.* I'll use more Jerusalemite language, one that speaks to people. That's the style. Then you can vote on how the weather feels, and the website becomes more personalized. So, you feel connected to the website, connected to the place, connected to nature. Weather is an experience, it's not something that just bothers you. It's possible to enjoy the rain too.

TJK: Why do you think the app has become a cultural phenomenon?

BN: I'm not sure it's reached that status. . . . At the end of the day, I make a weather website, and I hope that people will use it. I know that it has an impact, but I also know that there are a lot of people who don't know how to say the name properly. I recently had a technical problem with the English version, and many Arabs who use the English version got in touch. I've tried a few times to translate into Arabic, but it requires a lot of work. I don't speak Arabic and can't employ someone to

translate for me each time. It would be Google Translate and wouldn't look so good. But I do want to make an Arabic version, it's being planned.

TJK: Is there a difference in the weather between East and West Jerusalem?

BN: Yes. There's a big difference in terms of the amount of precipitation. There could be a decrease of even 20% in the amount of rain, or the snow could pile up in the west of the city and not catch in the east. But in terms of the temperature, it's not so significant.

TJK: The forums are hugely popular. What kind of questions do you get?

BN: Each person has their own hang-up; they ask about the topics that most interest them. There's someone who is very sensitive to dust, so she always wants to know if or how much dust there will be. The most popular question, you can guess . . .

TJK: Snow!

BN: Yes. People *always* ask me when there will be snow. And after there's snow, *Will there be snow again?*

TJK: Why are Jerusalemites crazy about the snow?

BN: In the snow, you suddenly go abroad. You go into a bubble, a totally different time frame. Everything is painted white, people are happy, smiling, and take time out. There are those grumpy people who can't stand snow—"it blocks my parking"—but they are the minority. I become, like, the busiest website in the country!

TJK: Do you come to the snow parties in the park or are you busy with the forecast?

BN: It's a painful topic. I'm less able to enjoy the weather phenomena because I'm a busy person. I have children, I have a family, I have other work.

> " Weather is an experience, it's not something that just bothers you."

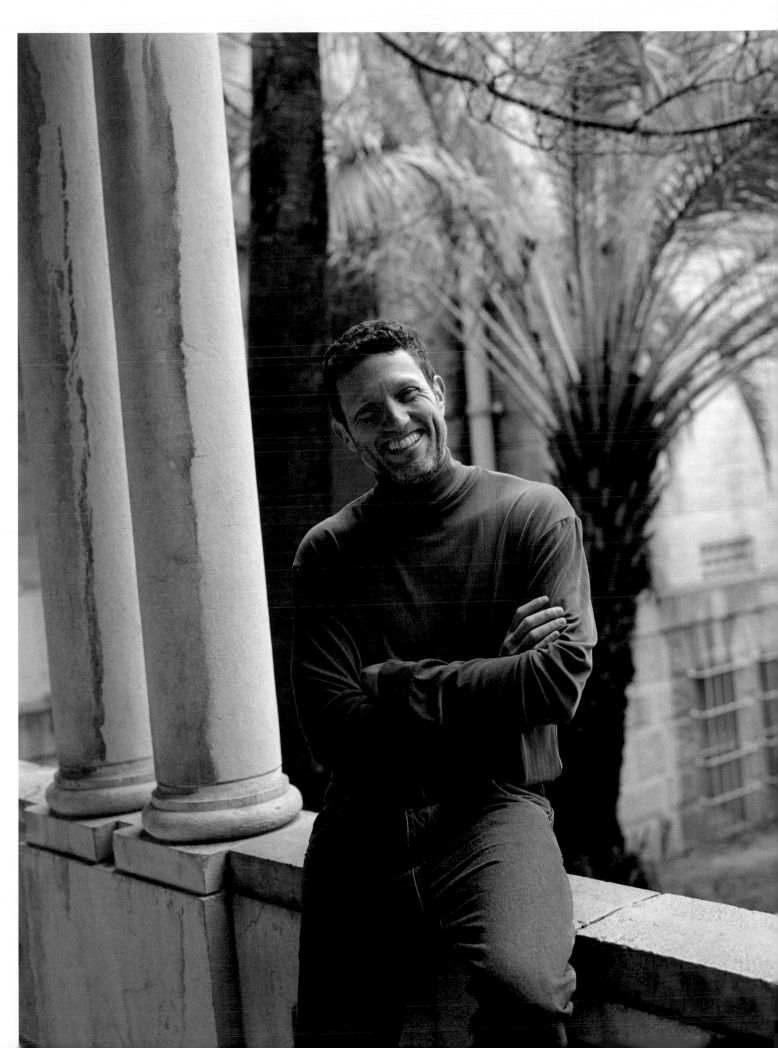

If I had all the time in the world, you would get 10 times more than what you get now on Yerushamayim.

TJK: What was the most remarkable weather phenomenon that you have recorded?

BN: The thing I remember most was before I set up the meteorological station. It was in March, 24 years ago; we were already in spring. There was a sandstorm, and the temperatures were above 20 degrees Celsius [68 degrees Fahrenheit]. And two days later, it snowed. Because of the sand, the sky was orange and there was a layer of 2 or 3 centimeters [about 1 inch] of orange dust on the ground—and then it snowed. So you had white, and underneath it, orange. It looked just like tiramisu! It was amazing, simply amazing. The final outcome was wonderful, and so was the way to it. That's what I love about the weather.

TJK: Tell me about a time that you really got it wrong.

BN: It's something that truly frustrates me when it happens. I get upset, to the point where I don't want anyone to talk

to me.[1] Last winter or the winter before it, the first rain of the year fell. It was a downpour, and I missed it. It really, really hurt me. This rain was scorched into people's consciousness, like, *If you miss the first rain of the year*, then what are you worth? There was also snowfall in 2016 that I said would be white and beautiful, and it didn't catch. This issue is very important to Jerusalemites. If the snow doesn't catch, then there's no snow, it doesn't count. It doesn't matter that it fell and that there were beautiful snowflakes. No. Afterward, I became the most hated person in town! What can you do? I used to get emotional about it, but now I don't. You learn from everything. People will take what they want to and that's it.

TJK: How does climate change impact your work?

BN: It's noticeable in Jerusalem. It has become hotter. It's come into people's awareness. It's also in my awareness as a forecaster. There are more phenomena that are outside of the usual. You see a scenario that doesn't fit the season.

And I think, *Wow, could it happen?* And then I say to myself, *Yes it could happen, because there's climate change.* Things that you wouldn't think of in the past can happen now, and do more often.

TJK: What happens if you want a holiday?

BN: There's no holiday at Yerushamayim. Even if I go on holiday, I take a laptop with me to the pool.

TJK: Is your relationship with nature connected to your relationship with the weather?

BN: Each time it rains, I feel physically how the rain that seeps into the ground quenches the trees. Each time people say, *I don't want this rain, what do we need it for?* I think about nature. We don't have the privilege not to want rain.

(1) The problem with a hyperlocal forecast is that people always expect it to be relevant to their precise location. "You can't give a forecast that is 100% accurate," says Nechemia. "It could be raining in Bet Hakerem [a western neighborhood] but not here. It's still the correct forecast, but whoever was here would say, *Where's the rain?*"

Words LYRA KILSTON

In this excerpt from her book *Sun Seekers:
The Cure of California,* author Lyra Kilston charts a fascinating scene from the
Golden State's vast counterculture mythology.

(SUN)

A black-and-white photograph from 1948, taken in a canyon near Los Angeles, shows a group of seven mostly bearded and bare-chested men holding long wedges of watermelon. Their faces range from beaming to contemplative, their physiques from ascetic yogi to muscled surfer, and their stance, as though emerging from a bush, invokes their nickname: "Nature Boys."

"We all had a common desire to abandon civilization and to live a natural, healthy life," one of them later reflected. Their needs were minimal: sun, water, fresh produce, and some companionship. Another photograph shows them beatifically playing mandolin, guitar, and drum, bare-chested on a sunny sidewalk. These are the only two known photographs showing this loose group of what might be called proto-hippies, or perhaps California Naturemenschen, together.

"We came from different cities, even from different countries," recalled Gypsy Boots, one of the younger members. "At times there were nearly 15 of us, living together in the hills, sleeping in caves and trees." Like their earlier counterparts in central Europe, these Nature Boys foraged for fruit and nuts, sleeping under the stars. In stark contrast to their gentle, pastoral ways, Los Angeles was growing exponentially during and after the Second World War, fanning out in neat grids of suburban housing, two-car garages, and flatly shorn lawns. When the free-wheeling, long-haired men emerged from their rustic hideaways, they must have made quite a spectacle.

Not much is known about the Nature Boys besides hearsay. They make a cameo in Jack Kerouac's *On the Road*, when "an occasional Nature Boy saint in beard and sandals" is glimpsed while passing through late-1940s Los Angeles. But we know they frequented the Richters' Eutropheon café, which drew such types toward it like bees to wild honey. Some of them even found each other there.

One of the Nature Boys, eden ahbez (born George Alexander Aberle in 1908 in Brooklyn), played piano in the Eutropheon's dining room in exchange for meals, sometimes joined by his brethren to form the Nature Boy Trio. His golden wavy hair, full beard, and dreamy, earnest eyes gave him a Christ-like appearance. ahbez, who wrote his chosen name in lowercase because he believed that only the words "God" and "Infinity" should be capitalized, claimed to have crossed the country eight times on foot by the time he settled in Los Angeles. He traveled with a sleeping bag, the clothes on his back, and a fruit juicer, scribbling song lyrics along the way. Sometimes ahbez slept in the Richters' backyard among their fruit trees. He also camped in various canyons near the city and for a time made his home in the shadow of the Hollywood sign. He continued this lifestyle with his wife Anna (acquiring a double sleeping bag) and their son named Tatha Om.

Then there was Maximilian Sikinger, a chiseled German who train-hopped to California in the 1930s, bringing along his

Photo: Security Pacific National Bank Collection, Los Angeles Public Library. Courtesy of Atelier Éditions.

homeland's mania for physical culture, nudism, heliotherapy, and natural healing (and also fleeing its rising fascism). One story goes that in San Francisco Sikinger met Gypsy Boots (born Robert Bootzin), and thus found an eager apostle of his Lebensreform philosophies. Boots was already halfway there, raised in a vegetarian household where his Russian mother baked dense black bread and taught her children to forage during Sunday hikes along the railroad tracks. Boots was especially keen to learn more about ways to strengthen the body, having lost his older brother to tuberculosis. Sikinger taught him about fasting and yoga. When the eccentric pair came to Los Angeles, their search for like minds led them to the doorstep of the Eutropheon.

Among the restaurant's most dedicated patrons, conversation likely turned to musings about leaving the city behind for good. The Richters knew of a certain German vegetarian hermit living about 100 miles to the east, in a hut near Palm Springs. Pester must have embodied a shining ideal, a vision of what was possible should city dwellers choose to fully immerse themselves in the natural life.

"We all had a common desire to abandon civilization and to live a natural, healthy life."

The sparsely populated desert appealed to the Nature Boys, who often headed out to the arid mountains and their hidden canyons. Tahquitz Canyon was a preferred oasis, a refuge from the heat where a rocky trail led to the rarest of sights: a thin waterfall rushing over massive grey boulders into a pool. It was an ideal place to camp, or even live for several months. Boots later recalled a conversation there with ahbez as they took in the calming beauty of the canyon, where redtailed hawks carved into the clear sky. "Someday there will be a million beards," ahbez predicted. It took nearly twenty years, but he was right.

If ahbez was in the canyon in the late 1930s, it's possible that he woke one sun-drenched morning to see a wild-haired man treading softly in homemade sandals. It was not a native Cahuilla man nor a sun-blasted homesteader, but a veritable nature boy—rather man, his beard now streaked with white. If ahbez met Pester at Tahquitz, the two certainly would have noticed each other, recognizing kinship.

Photo: Julius Shulman. © J. Paul Getty Trust. Getty Research Institute. Courtesy of Atelier Editions.

(below) The Nature Boys in Topanga Canyon, California, August 1948.

Their timelines don't line up seamlessly and both contain cryptic blanks. But it has been speculated for years that Pester was a source of inspiration for ahbez's one hit song: "Nature Boy." The original cover of the sheet music, self-published by ahbez in 1946, shows a drawing of a lone man walking in the desert amid prickly cacti, barefoot, bare-chested, and long-haired, with only a small sack thrown over one shoulder. Is it Pester? Is it ahbez himself? Or another, unnamed desert drifter?

As it turned out, the song itself, and its enigmatic lyrics about "a very strange, enchanted boy / they say he wandered very far, very far, over land and sea" reached millions of listeners. Through a windfall of good fortune, ahbez's song was recorded by Nat King Cole in 1947, rising to the top of the charts and living on as an enduring jazz standard. ahbez was profiled in national magazines and despite becoming suddenly rich, he had no use for the money. In a television interview after his song became famous (he entered the stage in sandals, riding a bicycle), he explained, "All the money in the world will not change my way of life, because all the money in the world could not give me the things I already have. Anna and I have learned that nature, and a simple life, will bring you peace and happiness."

The fates of the Nature Boys eventually diverged. Maximilian Sikinger published a slim diet book called *Classical Nutrition* with a picture of him on the cover kneeling naked on a boulder and reaching up toward the sun. He became an exercise trainer to celebrities and taught at an ashram into his seventies. Boots opened the popular Back to Nature Health Hut restaurant with his wife, Lois, in Hollywood in 1958. It lasted for three years and then he switched to fruit delivery. Eventually he did so in a brightly painted van with "Nuts and Fruits and Gypsy Boots" painted on its side (an echo of Otto Carque's "health wagon" some fifty years earlier). His antics attracted some healthminded celebrity clientele, and in the early 1960s Boots became a regular guest on a television talk show where he played the madcap nature man, swinging by a rope onto the stage in a loincloth, gulping down freshly squeezed juices and exercising with the host. As a beloved eccentric, Boots shared the stage with many psychedelic bands of the late 1960s, and was considered the "original hippie," passing the torch along to a new generation hungry for an alternative way of life.

As for ahbez, he continued living simply and writing music, including *Eden's Island* in 1960, now considered a proto-psychedelic concept album. He was photographed in 1967 holding a wooden flute in a recording studio, sitting next to a young Brian Wilson of the Beach Boys who—following a now-vaunted Los Angeles tradition—had also founded a short-lived health-food store, called the Radiant Radish. Around that same heady year of the Summer of Love, the song "Nature Boy" was given a shimmying, folksy treatment by Jefferson Airplane singer Grace Slick. ahbez's ardent lyrics: "The greatest thing you'll ever learn / is just to love and be loved in return" reached a new audience, reflecting the counterculture's purest idealism.

"Back to nature" was being reborn as "back to the land," as an estimated one million people dropped out of society to experiment with rural, communal living. They were driven by a sense that American culture was decaying, similar to the impulse that drove some to flee cities or emigrate from Europe at the turn of the century. It was no longer seen as fresh, wide open, and full of opportunity, but a fruit gone rotten. A new world would be built inside the husk of the old. The anti-establishment dogma, strange diets, and revolutionary badge of long, wild, natural hair returned, spreading more widely than ever before. It all felt radical, groundbreaking, and new.

Even the ravings of Arnold Ehret reappeared. "The beard of man is a secondary sex organ," he had written in the 1910s. The purified body, he believed, emits electrical "love vibrations" that could be received by "wireless," i.e. hair. When his books were discovered by a new long-haired generation in the 1970s, his publishers replaced Ehret's bearded-but-zealous author photo with a mellowed sketch that gave him a dreamy, prophetic look and a cloud of facial hair. He had found a new era of readers. They were returning to nature, again.

Excerpt from "Sun Seekers: The Cure of California" by Lyra Kilston. Copyright © 2019. Reprinted by permission of Atelier Éditions. All Rights Reserved.

Photo: Estate of Gypsy Boots. Courtesy of Atelier Éditions.

Part 4.
DIRECTORY
Astronomy, Wikipedia, and Garth Greenwell.
178 — 192

Words:
Shiromi Pinto

SHIROMI PINTO introduces MINNETTE DE SILVA, the Sri Lankan modernist who inspired her novel.

Minnette de Silva has been enjoying a bit of a resurgence. Sri Lanka's first modernist architect and the first Asian woman to be made an Associate of the Royal Institute of British Architects, de Silva has had conferences dedicated to her in rarefied academic institutions and retrospectives in magazines. This year, she featured in an exhibition on post-independence architecture at New York's Museum of Modern Art.

This would have been unthinkable even two decades ago. Back then, she was an anomaly one could scarcely believe had existed at all. I heard of her only by chance, through an old friend—a London architect who briefly worked with her in the 1980s. Over the course of long and spirited conversations, he'd tell me about this extraordinary woman who knew Picasso, Henri Cartier-Bresson and the father of modern architecture, Le Corbusier. *And* she was Sri Lankan.

I was intrigued. Through my mom, I secured a copy of de Silva's *The Life & Work of an Asian Woman Architect*. The book is a rich personal archive and contains her theories on modern regionalism—an architectural approach that synthesizes modern aesthetics with the most relevant aspects of traditional regional architecture.

It was de Silva who pioneered the inner courtyard, blurring the line between outside and inside. It was also she who integrated

traditional arts and crafts into her buildings' interior design. Today, Sri Lanka's Geoffrey Bawa is credited with these innovations, but de Silva got there 10 years before him.

It was this injustice that drove me to write my novel *Plastic Emotions*. I began that journey, fascinated by the fact that this woman from a tropical island was friends—and perhaps more—with Le Corbusier.[1] I ended it, certain that she had been done a deep disservice, particularly in her home country of Sri Lanka—a country she reluctantly returned to post-independence but which she later refused to leave, always hoping she would get her due in the end.

I'm humbled that my fictionalized account of her life seems to have spawned an interest in and respect for de Silva in Sri Lanka and beyond. I hope that it leads to practical efforts to preserve the few of her buildings that still stand. Perhaps she will finally get the recognition she deserves.

(1) *The Guardian* describes Pinto's novel as one of "romantic speculation." Pinto's inspiration was drawn from a photograph of de Silva and Le Corbusier standing in conversation, and from the letters they exchanged. As *The Guardian*'s review summarizes it: "She gives them trysts, meaningful exchanges, a separation and then painful longing, ending only with Le Corbusier's death in 1965."

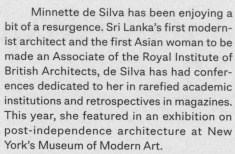

Photo: Brian Brake. Courtesy of Museum of New Zealand.

OBJECT MATTERS

Words:
Katie Calautti

The dazzling history of sunglasses.

The first people to wear sunglasses could have hardly imagined that, centuries later, they would be a glamour accessory whose function often bore no relation to the presence of harsh sunlight.

To cut the relentless glare of light on white in the arctic region of North America, the Inuit people carved slits in pieces of wood or bone to create snow goggles. To more opulent effect, legend has it that while watching gladiatorial events, Roman Emperor Nero shaded his eyes from the sun through an emerald. In 15th-century China, lenses were made from flat pieces of smoky quartz. Emerald-tinted Goldoni glasses were worn by gondoliers on the sunny canals of 18th-century Venice and, around the same time, blue and green glass eye-preservers were popularized in Britain to correct light sensitivity and vision impairment.

By the 1920s, Hollywood starlets started wearing shades on set to protect their pupils from the harsh lighting—then left them on to mingle unnoticed among the hoi polloi. The driving goggles of the 1930s—worn by women behind the wheels of cars without windows—signified rebelliousness and

independence and tipped the scales in fashion's favor.

Such glamorous associations kept stacking up. Bausch & Lomb made the classic Ray-Ban aviator frame to shade the eyes of World War II pilots flying at high altitudes, and they kept an air of adventurous cool through the 1940s. Those early prototypes proved that sunglasses both protected and quickly transformed a face—and so the pragmatic morphed into an aesthetic must-have. In 1956, Bausch & Lomb made what would become their signature Ray-Ban Wayfarer, and musicians fueled their mystique by wearing the style on nightclub stages.

Ensuing decades boasted their own iconic styles—the oversized lenses of the 1960s popularized by Jackie O, the round rims of the 1970s synonymous with John Lennon, the neon frames of the 1980s worn by glam-rockers, and the mini shades of the 1990s often associated with *Friends*-era Jennifer Aniston. Modern iterations run the gamut, adhering less to a single style and more to a reflection of the wearer's personality. Sunglasses, it seems, have done a 180—what once hid now firmly highlights.

Photo: Jerry Schatzberg/Getty Images

CULT ROOMS

Words:
Debika Ray

Jaipur's JANTAR MANTAR is an otherworldly playground designed for celestial gazing.

Jantar Mantar is a playground of epic proportions: 19 enigmatic structures made of yellow stone and marble are scattered across 4½ acres in the central Indian city of Jaipur. They are perfectly proportioned for youthful exploits. Visiting as children on a school trip, my friends and I clambered up and down the enormous staircases, darting from edifice to edifice and chasing each other between patches of grass under the open skies and baking heat of Rajasthan. The site's historical, scientific, mathematical and architectural significance was somewhat lost on us.

In the modern era, Jantar Mantar—roughly translated as "calculation instrument"—has become a tourist attraction and a UNESCO World Heritage Site, restored several times over the past 300 years. It was originally built as an observatory, a series of tools created to measure and predict the movements of the sun, moon and planets using just the naked eye. It was the largest of five similar sites across northern and central India, all conceived in the early 18th century by Maharaja Sawai Jai Singh II, ruler of the Kingdom of Amber, who broke away from the Mughal Empire later in his life to establish his capital in the new city of Jaipur. Each of these observatories incorporated influences from Islamic, Greek and Persian astronomy, but are said to be far greater in scale and complexity than those that came before. They were used to refine the Mughal Empire's astronomical tables and the traditional Hindu almanacs, both of which were used to plan religious festivals, agricultural schedules and social activities.

Today, four remain—the one in Mathura, Uttar Pradesh, was torn down in the mid-19th century—but Jaipur's is the most elaborate. At its center is the Samrat Yantra, the world's largest sundial. A gigantic 90-foot tall gnomon—a triangular wall with its hypotenuse parallel to the Earth's axis—is flanked by two quadrants, which lie parallel to the equator. As the sun moves from east to west, the shadow of the gnomon falls on the surface of the quadrant, indicating the local time. Elsewhere, the Jai Prakash, a pair of bowl shapes based on Greco-Babylonian designs from 300 B.C., and the Rama Yantra, two pillared cylindrical structures, track celestial movements via marks on their surfaces. On his website, jantarmantar.org, Barry Perlus,

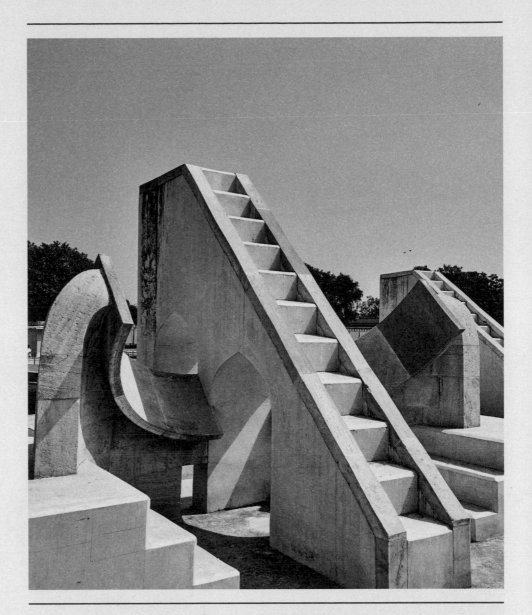

Photo: Apurva Madia / Getty Images

an academic and author of *Celestial Mirror: The Astronomical Observatories of Jai Singh II* (2020), describes these two instruments as "perhaps the greatest of Jai Singh's many contributions to sky observation."

In designing his ambitious projects, Jai Singh eschewed telescopes, which had long been used in Europe, instead embracing the craftsmanship and mighty presence of physical objects, modeled initially by hand in wood, stone, metal and wax. These forms have inspired architects, artists and photographers around the world: Japanese American sculptor Isamu Noguchi, for example, took a series of photos of them in the 1940s, and their influence can be seen in the simplicity of his artworks, as well as in his 1976 *Sky Gate* in Hawaii, designed to observe the moment, twice a year, when the sun reaches its highest point.[1]

After the British Empire seized control of India, the scientific value of the Jantar Mantars was downplayed or dismissed. Speaking at the launch of her 2010 book, *Jantar Mantar: Maharaja Sawai Jai Singh's Observatory In Delhi*, architect Anisha Shekhar Mukherji observed that "In actual fact,

Jai Singh's astronomers were able to take many useful observations, reveal new data, and correct the errors not just in older tables used in the Indian subcontinent but also in prevalent European ones." According to Mukherji, "No other instruments anywhere in the world can demonstrate the movement of the earth and the planets with such clarity."

As complex as they are, the lasting significance of these instruments lies in the fact that they were designed to be used even by non-experts. "Jai Singh wished to spur scientific interest amongst his people and to popularize observational astronomy, not limit it to an exclusive band of specialists," Mukherji said. "No other instruments are so easily accessible to an ordinary person."

(1) Noguchi first visited Jantar Mantar in both Delhi and Jaipur in 1949, as part of an extended tour of civic and sacred spaces in Europe and Asia. As he later explained: "India is a place that taught me something about the various fundamental problems of sculpture."

GARTH GREENWELL

Photo: David Levene / eyevine

Words:
Kabelo Sandile Motsoeneng

The *Cleanness* author on always being an outsider.

Garth Greenwell is not feigning humility when he says the critical reception of his books is still "bewildering" to him. "I was a poet for 20 years, and knew that nobody was ever going to read my work," Greenwell says.[1] When working on *What Belongs to You* and *Cleanness*, which both follow an American teacher living in Sofia, Bulgaria, he wrote without an audience in mind. The narrator is never named, but that does not suggest a kind of opacity. The world becomes knowable: the narrator's attempts to understand the nature of his relationship with Mitko, who he meets while cruising in Sofia's National Palace of Culture bathrooms; his struggle to become a better teacher and a better mentor; his efforts to maintain a relationship with R., his boyfriend.

Greenwell, calling from Kentucky, speaks to me about foreignness, desire and why his quest to make art that affirms doesn't mean writing a happy book.

KABELO SANDILE MOTSOENENG: In a previous interview you mentioned that being an artist requires a sense of foreignness. What do you find productive about that approach?

GARTH GREENWELL: I would revise myself if I made a universal claim that an artist has to be in some way a foreigner—for some artists that is true, and for me that's true. For me, being an artist means seeing things with a clarity that I think may require feeling oneself in friction with a culture. We are sensitized to things by being in friction with them. Certainly I have never felt at home in a place or a culture. There is a poem that's really a landmark to me by Philip Larkin called "The Importance of Elsewhere." Larkin says that in Ireland

he feels gratitude because all of a sudden the foreignness he's always felt makes sense. That's true for my experience in Bulgaria. One often thinks of foreignness as being a kind of punitive experience. On the other hand, fitting in is the absolute last thing I would ever want to do. I feel hugely grateful for this kind of adversarial relationship I've always had with the culture around me.

KSM: Is there a reason why your American narrator based in Sofia is suspicious of Americanness?

GG: In some sense, my narrator had felt insulated from some of the less attractive aspects of Americanness. His queerness, this kind of foreignness that he felt, cut him off from various aspects of Americanness. When he's in Bulgaria, he realizes to what extent he is bound up with his sense of his country, what that means, and I think that's disturbing to him. The sense of himself that is bound up with the idea of coming from a place that is "important," that is the center of things.

KSM: Would you say the narrator's foreignness informs his desire?

GG: The desire is where he feels least foreign. In *What Belongs to You*, his experience of descending to those bathrooms is the experience of entering into fluency—he can communicate even though he doesn't speak the language. The least foreign thing he does in Bulgaria is have sex with men and be part of this cruising culture.

KSM: I read that you're currently working on a Kentucky-based novel. What has that shift been like?

GG: Actually, the pandemic intervened, and because I couldn't travel and couldn't be in Kentucky, I started working on a different book that I think I will finish before returning to the Kentucky novel. Being in Bulgaria—and writing the middle section of *What Belongs to You* from Bulgaria—allowed me to reframe the sense of place that I came from. It's always mysterious to me, this relationship to place, which is how everything I've written has begun.

KSM: What do you hope people find in your work?

GG: One of the things we need from art is that we need art to say yes to life. This is a thing I've been thinking about a lot—affirmation in art. When we talk about a book being affirming, we mean it shows us an image of ourselves that makes us feel good or it suggests in a very easy way that life will triumph. By presenting an example of someone trying as best as he can and as honestly as he can to understand life, books affirm the value of that endeavor. I want novels that affirm a value in life without being propaganda for life.

(1) Greenwell trained as an opera singer before becoming a writer. He has described the structure of *Cleanness*—in which every story is a single narrative scene—as being akin to a song cycle. As he told *The Believer* in 2020: "A novel is made up of material of various intensities. And there's a way in which thinking of the book as a song cycle avoids that variation—each of the nine sections is its own center of intensity."

BAD IDEA:
CONTEXT COLLAPSE

Words:
Nathan Ma

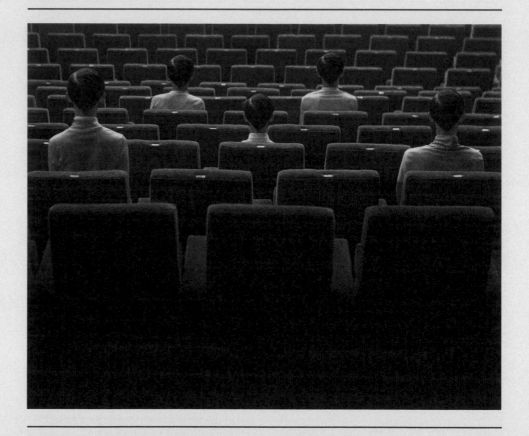

Photograph: Natalia Evelyn Bencicova

Why misunderstandings multiply online.

It is mortifying to be misunderstood. Politicians and celebrities know this well, crafting public statements with the care of a lace maker to avoid misapprehension. But what if we held each other's statements up to such scrutiny, imbuing them with subtexts so unforgiving that the speaker can hardly recognize their own speech? Would we speak freely, or would we self-censor to avoid our words being misconstrued?

On social media, these misunderstandings happen more than in real life. The idea of "context collapse" helps explain why. Coined in the early 2000s by the researcher Danah Boyd, context collapse refers to the fact that social platforms rob users of the ability to differentiate between varying audiences. Each communiqué must be read and understood (or misunderstood) by everyone in a network. The care needed to avoid misunderstandings

is exhausting: Writer Jason Bartz has compared it to his wedding, where every movement was measured against how it would be perceived by his family, colleagues and childhood friends, as well as by his wife's guests.[1]

In public arenas like social media—and at a time when screenshots outlive the posts they document—who is to blame for these communication breakdowns? The answer is simpler than it might seem. Though we might think we say what we mean, this is a false pretense: What we actually say is also a product of who we are, as well as who we're speaking to and how they know us. Think about how you'd describe a wild weekend to a close confidant. Now, consider how you'd describe the same weekend to your boss. If there is a difference between the two descriptions, this isn't deceit. In fact, it's often an extension of empathy: When you punctuate a sentence with a cheeky "If you know what I mean," you're trusting your sparring partner to, indeed, know what you mean.

The difficulty with social media is that it's impossible to tell who might know what you mean. But preventing context collapse is a duty we share as senders and receivers of messages: Until we can take each other's words with grace and good humor, we ought to just ask: "So, what do you mean?"

(1) Social media users are often quick to take offense in response to statements that don't encompass their personal experiences. For example, a casual comment about door-to-door groceries being a lazy option might lead to a response highlighting the experience of disabled shoppers, while an encouragement to drive less might lead to outrage from people who live in very rural communities.

GOOD IDEA: GROUP THINK

Words: Harriet Fitch Little

On Facebook, many users' "friendship" networks have become so large and diverse that meaningful communication is difficult. The platform has adapted by prioritizing special interest private groups, where users who don't necessarily know one another can connect over a single hobby, location or lifestyle.

The shift began after the 2016 presidential election in the US, at a time when Facebook was under fire for not doing more to prevent the spread of misinformation. Mark Zuckerberg, the chief executive, responded by promising a new emphasis on smaller communities: "Just as the social fabric of society is made up of many communities, each community is made of many groups of personal connections," he wrote.

This investment has paid off. In 2021, 1.8 billion Facebook users were connecting in groups every month, and over three-quarters of people surveyed by the Governance Lab in 2020 said that the most important group they were part of operates online.

Rather than trying to speak to multiple audiences at once, these groups allow people to reestablish context and shared meaning. "The only reason I wouldn't leave Facebook right now is because of the groups," one user told *The Washington Post* in 2020. "Everything else can be replaced."

STRANGE FORECASTS

Crossword:
Mark Halpin

ACROSS

1. Throw shade at something
5. Was sore
10. Some nasty bugs
14. Reply to a yodel?
15. Easter Island's nation
16. Santa's is presumably very long
17. Sagan or Sandburg
18. One might be past or present
19. Mind
20. Weather Alert: a downpour is coming that is absolutely horrific!!!
23. Angels vis-à-vis some projects, say
24. Perfect spots
27. Twist or misrepresent
28. Grifter's game
31. Peg on a golf course
32. Secret supplies
35. Impose a levy

36. Weather Alert: there's a very good change of fog; a very good chance indeed!!!
41. Mature
42. One gentleman of Verona
43. A male cat
44. Mythical Himalayan denizen
45. Bit of one's inheritance
48. *Fear of Flying* writer Jong
50. Some agricultural equipment
53. Weather Alert: bad weather is coming (but only briefly)!!!
57. The duck in *Peter and the Wolf*
59. Some highlights from 56 Down, say
60. *Hairspray* mom
61. Some whistleblowers, in brief
62. Foster in Hollywood
63. Messy type

64. Antes up, perhaps
65. To any degree
66. Puts in stitches

DOWN
1. Less potent coffee, for short
2. Legendary figure doomed by lofty ambition
3. Dwindled or contracted
4. Most stable and reliable
5. One in a cast
6. Compliment in a kitchen
7. Clue
8. Otherwise
9. Some forest dwellers
10. Deluge
11. Books for musicals and operas
12. Manipulate
13. Apt home for a 63 Across, perhaps
21. Experiencing for the first time
22. "What's the Frequency, Kenneth?" band
25. Like an undiluted cocktail
26. Hot, in a way

28. Game played on an 81-square board
29. Large Hadron Collider lab
30. "Speaking of (that)"
33. Recess in a cathedral
34. Expectorate
36. Partner or pal
37. Stravinsky or Sikorsky
38. Like Havarti, as opposed to brie or cheddar
39. Desires
40. Gratuitous
44. 7'6" NBA star Ming
46. Compass part
47. Previously, poetically
49. Game played on a 64-square board
50. Epitome of slowness
51. Automotive bomb of the '50s
52. Wild attempts
54. Indian eminence
55. Easy pace for a horse
56. An Egyptian princess onstage
57. Planet or eyeball
58. One that's both busy and buzzy
—

CORRECTION

Words:
Robert Ito

Wikipedia is good, actually.

Wikipedia is a great place to start if you need a quick primer on a topic you know next to nothing about, like, say, the cornetist Bix Beiderdecke, or the feeding habits of cuttlefish. The online encyclopedia is amazingly comprehensive, which makes it a godsend for harried students eager to flesh out an already late paper—or for journalists on a deadline.

Users are generally counseled to adopt a "trust but verify" attitude toward its contents. If anyone can edit Wikipedia, after all, how trustworthy can it be?

As it turns out, pretty trustworthy. According to Amy Bruckman, the author of *Should You Believe Wikipedia? Online Communities and the Construction of Knowledge,* Wikipedia can be one of the most reliable sources of information on the planet, particularly if you're talking about very popular entries that are viewed by thousands of people. (For entries about more obscure things, like the feeding habits of cuttlefish, buyer beware.) As she notes, peer-reviewed journal articles might get three pairs of eyeballs on them. The sheer numbers of viewers on

Wikipedia, on the other hand, keep the site honest. Informed people tend to win out over the misinformation spread by random liars and kooks.

Wikipedia's nonprofit status and scores of citizen volunteers also make the resource less prone to the bias and pseudoscience that routinely plague places like Facebook and Twitter.[1] Those social media sites make a lot of their money through politically divisive ads and fake news articles of every stripe—anything to keep viewers clicking. Wikipedia, on the other hand, has neither advertisers nor investors. They aren't selling anything, or trying to keep share prices high. Their main mission is to truthfully inform, a goal shared by their community of unpaid, eagle-eyed editors.

Not that Wikipedia is perfect. Mistakes creep in. But most of the errors on the most popular pages are speedily corrected. Less easily fixed is a company culture that skews white and male. Lately, there have been calls to diversify its community of editors, who tend to write fewer biographies about women, for example. Care to read a truthful and balanced overview of the topic? Go to the Wikipedia site and search "Gender Bias on Wikipedia."

(1) In 2019, Wikipedia founder Jimmy Wales launched the social media network WT Social. The platform positioned itself in opposition to the social media behemoths: It promised to never sell data, rely on donors rather than ads, allow members to edit misleading headlines and show articles in a timeline format rather than according to algorithmic popularity. The site has yet to take off.

Photo: Justin Chung

DIRECTORY

LAST NIGHT: TINA FREY

Words:
Bella Gladman

What did the San Francisco–based designer do with her evening?

Tina Frey has been making functional sculptural objects for 15 years. After stepping away from a career in finance, she started by making a line of hand-sculptured resin bowls and has expanded the collection from there.[1] Here, she talks about finding a slower pace of life post-pandemic.

BELLA GLADMAN: What did you do last night?

TINA FREY: I was on a plane returning from the Hamptons, having checked out our forthcoming pop-up site, and finally seeing my pieces in situ at a hotel project called Shou Sugi Ban House, whose mindfulness philosophy resonates with me. Once we got back from the airport, we picked up our dog from the dog-sitters, unpacked, settled and fell dead asleep. Up until COVID-19, I traveled internationally at least once a month. I've since realized I really enjoy staying in!

BG: Less travel means more time with your dog.

TF: She's still a puppy—a bit of a brat at times, but adorable. She senses when it's time for us to stop working and gets us to take her for a walk. Recently, we've been in Santa Barbara for our pop-up. The weather's warm and there are beautiful hikes in the hills or by the ocean.

BG: Does that walk mark the end of the day?

TF: I delve back into work sometimes. There's something about the beauty of the evening, when it's quiet and dark outside, you've had dinner and it's peaceful. Your mind's cleared again, so inspiration comes!

BG: What's for dinner?

TF: My husband and I love cooking for small dinner parties at home. The best part of being a designer is sharing fulfilling conversations with like-minded people. We're lucky because in California the growing season is all year round. Even in winter, you can find beautiful vegetables at the farmers markets. We're mainly vegetarian nowadays.

BG: Do you subscribe to other aspects of West Coast wellness culture?

TF: I've been into meditation for the last five years after reaching burnout; and through it, I've tuned in to how what you eat and drink affect you. We're about to go on a silent meditation. For that, I want to be completely clear of wine (I already cut out caffeine) beforehand. I'm not indulging until after! If you told me 10 years ago that I'd be into this, I'd have laughed—it's so stereotypically California hippie! But now I think I understand what it's about.

(1) Frey's designs resemble ceramics but are actually made of resin—which makes them hard-wearing and suitable for picnics and poolside gatherings. Frey says she knew from the very beginning of her practice that she wanted to specialize in an unusual material.

CREDITS:

COVER:	PHOTOGRAPHER	Paul Rousteau
	STYLIST	Giulia Querenghi
	MAKEUP	Ludivine François
	SET DESIGNER	Marie Labarre
	MODEL	Andréa B @ Mademoiselle Agency
	PHOTO ASSISTANT	Benjamin Beaufrère
	STYLING ASSISTANT	Alice Heluin Afchain
	SET DESIGN ASSISTANT	Charline Bar
AN UNMOVABLE FEAST:	MODEL	Louise @ People Agency
DRIP DROP:	PHOTO ASSISTANT	Benjamin Beaufrère
	STYLING ASSISTANT	Alice Heluin Afchain
THE FALSE MIRROR:	ASSISTANT	Lucas Aliaga-Hurt
SPECIAL THANKS:		Alessio Aldinucci
		Elena Braiato
		Lucia Antosova

STOCKISTS:
A — Z

191

A	ACNE STUDIOS	acnestudios.com
	AIGLE	aigle.com
	ANH JEWELRY	anhjewelry.com
	ARKET	arket.com
B	B&B ITALIA	bebitalia.com
C	CESAR	cesar.it
	COMME DES GARÇONS	comme-des-garcons.com
D	DIOR	dior.com
	DRIES VAN NOTEN	driesvannoten.com
E	ERES	eresparis.com
F	FINN JUHL	finnjuhl.com
G	GARIBALDI STUDIO	garibaldistudio.com
	GAUCHÈRE	gauchere.com
H	HAY	hay.com
	HERMÈS	hermes.com
I	ICICLE	icicle.com
K	KRUG	krug.com
L	LACOSTE	lacoste.com
	LEMAIRE	lemaire.fr
	LIDO	lido-lido.com
M	MAISON MICHEL	michel-paris.com
	MAISON RABIH KAYROUZ	maisonrabihkayrouz.com
	MARA HOFFMAN	marahoffman.com
	MATTEAU	matteau-store.com
	MAX MARA	maxmara.com
	MM6 MAISON MARGIELA	maisonmargiela.com
	MONCLER	moncler.com
	MYKITA	mykita.com
N	NANUSHKA	nanushka.com
O	OMEGA	omegawatches.com
	ONE & ONLY	oneandonlyresorts.com
P	PIERS ATKINSON	piersatkinson.com
	PRADA	prada.com
R	RAINS	rains.com
	RALPH LAUREN	ralphlauren.com
S	SHANG XIA	shangxia.com
	SOLID	solidstore.com
	SOPHIE BILLE BRAHE	sophiebillebrahe.com
	SPORTMAX	sportmax.com
	STELLA MCCARTNEY	stellamccartney.com
	STRING	stringfurniture.com
T	TINA FREY	tf.design
	TOD'S	tods.com
	TRICOT	tricotparis.com
V	VILEBREQUIN	vilebrequin.com
	VIPP	vipp.com
W	WILLIE COLE	williecole.com

MY FAVORITE THING

Words:
Emilie Murphy

This maquette inspired several projects for Giancarlo Valle, interviewed on page 84.

I love the models I build as part of the design process, and this one in particular. It's a dining room for a house in Chicago for a family originally from Detroit. The home was in a former orphanage and it had monumental rooms that were sort of institutional. We were going to commission the potter Matt Merkel Hess to take motifs from important milestones and elements from Detroit history and build an iconography around that through hand-painted tiles.[1]

This project has actually stalled and is no longer happening, but I've kept the model out because I'm so interested in the idea, and it's going to come back. We're renovating my house right now and Matt is doing something like this. And we also incorporated it into a house in Connecticut. One room had this old Federal-style wallpaper and we took all the motifs from the wallpaper and turned them into tiles and re-wallpapered the room. It's one of these ideas that's always stuck with me.

(1) Merkel Hess makes playful ceramics, including a Mr. Potato Head series and vessels designed to resemble Cheetos bags, tallboy cans and plastic crates. His work was part of the identity for Martha Hunt's New York apartment, which Valle designed.

Photo: Clément Pascal